Starting
Your Career
in

Art Education

Starting
Your Career
in
Art Education

BY

EMILY STERN

AND

RUTH ZEALAND

ALLWORTH PRESS
NEW YORK

Allworth Press books may be purchased in bulk at special discounts for sales promotion, corporate gifts, fund-raising, or educational purposes. Special editions can also be created to specifications. For details, contact the Special Sales Department, Allworth Press, 307 West 36th Street, 11th Floor, New York, NY 10018 or info@skyhorsepublishing.com.

15 14 13 12 11 5 4 3 2 1

Published by Allworth Press, an imprint of Skyhorse Publishing, Inc.
307 West 36th Street, 11th Floor, New York, NY 10018.
Allworth Press® is a registered trademark of Skyhorse Publishing, Inc.®,
a Delaware corporation.

www.allworth.com

Cover design by Mary Belibasakis

Library of Congress Cataloging-in-Publication Data is available on file.

ISBN: 978-1-62153-243-9

Printed in the United States of America

Contents

Acknowledgments

Great minds must be ready not only to take opportunities but to make them.
—Chinese fortune cookie

This book would not have been possible without the support, information, advice, and inspiration of the many people who generously contributed their time and expertise, and who shared our enthusiasm for gathering and providing career information to those who wish to become art educators.

Thank you to Maxine Greene, for her wisdom and contribution to the use of imagination in the arts. We are grateful to the artists and art educators who shared their experiences with us: recent graduate Emily Williams, and teaching artists Celia Caro and Ellie Balk. Dr. Quincy Egginton gave us insight into the curricula and strategies in schools and helped with the preliminary editing. Thank you also to Dr. Sandi Edmonds and Sarah Lofti-Hene for sharing their teaching philosophy and pathways to becoming experienced teachers, to Ada Leaphart, who is in the midst of her teacher education journey, and to Christina Miles, who is a beginning art teacher. Thank you Deborah Lothrop, for information about Waldorf Schools. To the New Rochelle High School Art Department, thank you for sharing your insights into the challenges of teaching art at the high school level; thanks to Marc Schneider, Director of PAVE, and to the art teachers, Alexi Brock, Scott Sieboldt, Grace Fraioli, Michael Fry, AnnMarie Funigiello, Moira McCaul, Joanna Schomber, Kerry Sharkey, and Amanda Tarantino. Thank you to Cathy Ramey, who provided us with insight into teaching young children and working at Studio in a School. For information about early childhood programs and insight into the parents' perspective, thank you Eugenia Miller, Board President of the New Rochelle Day Nursery. Thank you to Lori Pisani, Assistant Principal at Barnard Early Childhood Center in New Rochelle, for information on the schedule at this Reggio Emilia–influenced school. Thank you to artist Wennie Huang for discussing her career as an adjunct art professor in New York City. Thank you to Brooke Mullins Doherty, Adjunct Professor of Studio Art, and Scott Anderson, Associate Professor of Art and Art Coordinator at Cape Cod Community College in Hyannis, Massachusetts. We appreciate the time that you gave us while sharing your fascinating journeys to becoming art educators.

We were inspired by educators dedicated to founding nonprofit organizations. Thanks to artist and art educator Carmen Hernandez, who inspired us with her experiences in the nonprofit sector with Free Arts as well as her own organization, New York Gives Back (NYBG). Thank you to Dale Davis, Founder and Executive Director of New York State Literacy Center (NYSLC) in Rochester, New York and the Executive Director of the Association of Teaching Artists (ATA), for her passion for using arts to reach out to the underserved, and for her insights into the world of teaching artists. Eric Booth of Everyday Arts Inc. helped us to articulate the role of a teaching artist. Richard Lewis, Founder and Director of the Touchstone Center in New York, was an inspiration to us. We are grateful to Valeen Bhat for sharing her fascinating experiences as the owner of an art education business. Mark La Rivierre, Director of Creative Classrooms, was extremely helpful, as he shared so much about his journey as an artist and director, his philosophy, and the mission of this highly successful program, which serves 10,000 inner-city schools throughout New York City.

For the museum education chapter, our deepest appreciation goes to Sharon Vatsky, Director, School and Family Programs at Solomon R. Guggenheim Museum, for sharing her time and expertise, providing introductions, and answering many, many questions about museum education. We are indebted to Kent Lydecker, Director of the St. Petersburg Museum of Fine Arts, St. Petersburg, Florida, for reviewing the chapter. We would also like to thank Marcos Stafne, Director, Education & Visitor Experience at Rubin Museum of Art, New York; David Bowles, Manager, School Programs of the Rubin Museum; and David Stark, Interim Woman's Board Endowed Executive Director of Museum Education at the Art Institute of Chicago. Karen Stein, Education Director of the Katonah Museum in Katonah, New York, explained their wonderful program to us. Cape Cod Museum Executive Director Elizabeth Ives Hunter and Head of Education Linda McNeill-Kemp gave us invaluable insights into their interesting careers in a regional museum and the programs that can develop from them. Alexa Rose Miller opened our eyes to new careers in art education that use art to teach medical professionals.

We would like to thank Michael B. Schwartz, Executive Director of the Tucson Artist Brigade, Tucson, Arizona; Hawley Hussey, Director of Contemporary Education at BRIC Rotunda, Brooklyn, New York; Pearl Schaeffer, Chief Executive Officer at Philadelphia Arts in Education Partnership, Pennsylvania; Nick Rabkin of the Teaching Artists Research Project at NORC at the University of Chicago in Chicago Illinois; and Eric Siegel, Director and Chief Content Officer, New York Hall of Science, New York. For their business and nonprofit expertise, we would like to thank Caroline Holley, Brooklyn-based business professor and eco-

entrepreneur, as well as Tom Schoenemann of Northwest Connecticut's SCORE, and CPA Ed Busse. Thank you to Susan Acampora, from Gill Library, The College of New Rochelle, for her many contributions to the resources section. Thank you to Cameron and Brody Leo, and to the elementary and middle school students at Sacred Heart School for sharing their opinions on what qualities are most important in an art teacher.

We would like to express our appreciation to Tad Crawford and Delia Casa of Allworth Press for their help in seeing this book through to publication. Finally, we want to thank our husbands, Bill Moakler and Peter Coe, Emily's mother, Carol Stern, Emily's son, Clive Coe, and Ruth's stepdaughter, Blossom Kravitz, for their support.

Introduction

A few years ago, we were in a museum looking at some paintings by an artist who was unknown to us. We both remarked on it from different perspectives.

> Emily: *Look how the artist used complementary colors to focus our attention on the main figures.*
> Ruth: *I wonder who the woman is looking at beyond the frame in the distance?*

After our brief discussion, we wandered out of the room. Suddenly, a group that had just entered the gallery with a leader diverted our attention back to the painting. We couldn't help but eavesdrop. The leader was telling the story behind the painting, and the group was discussing their reactions. We whispered our own responses to each other.

The group then got out sketchbooks and began to draw their interpretations. As the leader asked them to come up with three adjectives to describe their own piece, we looked at each other and said: *What a creative way to engage the group with the painting.* Neither of us had discussed the idea of narrative before, nor whether it could be translated into visual form. We had never seen this type of activity in a museum.

What happened next?

The story of this book began here, because that night we were so engaged with the day's discussion that, unbeknownst to each other, we both looked up the painting on the museum's website to find out more information. The next day at the college, Emily had her students critique their work by writing down adjectives, and Ruth had her students brainstorm different ways they could teach a lesson in a museum.

Since that day in the museum, we have sought out a variety of art education programs, not only in museums, but also in schools, public spaces, and community-based organizations. We found that there was a paucity of resources for the increasing number of students considering this career, from high school juniors and seniors, through college and continuing education students.

As professors in a liberal arts college, we are often approached for information on careers in art education by a growing number of individuals, including current students, alumnae, prospective students, and community members. In our quest to help them, our research revealed no single reliable resource on this topic. We are always looking for new teaching methods and information to augment our knowledge and experience. We talked to art educators of all levels and types, including those from museums, community-based organizations, and schools. We investigated many resources across the country. We learned a great deal in the process. This book is the result of our efforts.

What Does an Art Educator Do?

Art educators are responsible for more than just giving students materials and telling them to make something. Art educators' responsibilities are complex and varied, depending on the place of work, but they have many traits in common.

Effective art educators teach students how to interpret events, develop critical-thinking skills, imagine the future, and forge links across cultures and time periods. Their teaching embodies multiple perspectives and transcends specific topics. They encourage the learners to be creative while teaching foundations of art concepts, skills, and media. Their students leave with an appreciation of the arts accompanied by an awareness of their environment, both local and global.

Who Is This Book for?

This guide is invaluable for those who are interested in launching a career in the arts, have a passion for art, or would like to be a teacher in a classroom, museum, or other location. The way you develop your art education career will depend on how you view yourself as an artist and realize your goals in practicing art.

Artists who are interested in teaching do so from two main standpoints. One group views themselves primarily as practicing artists who teach as a way to share their ideas and to supplement the income from their artwork. They view teaching as a way to leave their studio and work with people. The other group considers themselves first as teachers, and then as individuals who love art and want to teach it. Chances are, you fall into one of these categories, whether or not you are a studio artist, designer, art historian, or in another profession altogether. These two categories are not mutually exclusive, but nearly everyone falls somewhere within this artist–teacher spectrum.

Starting Your Career in Art Education is written for audiences at a variety of educational levels, from young people beginning to explore ideas, to seasoned professionals without higher degrees who are seeking a career change. It will appeal

to those considering college, those who are currently undergraduate or graduate students, recent graduates, and those who have been out of school for a long time. This book will provide guidance and inspiration for people who "would like to do something with art," and who wish to spark creativity and imagination in others.

How Will This Book Help You?

This book will help you to explore whether a career in art education is for you. Learn about the range of opportunities that exist in art education, including jobs you've probably never heard of before. Find out what these positions are really like. Figure out which aspects of art education appeal to you and what steps are necessary to obtain them.

We will answer the questions most prospective art educators have in mind:

- What type of education do I need?
- What skills should I have?
- Do I need certification or a license? If so, how do I get it?
- What types of jobs are out there?
- How do I prepare for the job search?
- What opportunities are available outside of a classroom setting?
- Which type of position would be the best match for me?
- Do I have what it takes?
- How can I be an effective teacher?
- Can I still be an artist?

THE FIELD OF ART EDUCATION

To consider the future of art education, we must look at the field of education as a whole. With the changes in theories and practices of education, educators must adapt to increasing shifts in technology, budget, curriculum, and assessment. Art education is moving into a world of progressively complex digital tools that no one would have dreamed of a decade ago. Budgets in schools and organizations are in constant danger of being cut, greatly affecting curricula. The recent focus on literacy, mathematics, and science in response to standardized test scores squeezes the time available for art instruction. These constraints result in new opportunities for integrating the arts into other subjects, thus opening new doors for ingenuity and creativity. With the push for quantifiable assessment in all areas, art educators encounter new ways of measuring effort and performance, while instilling excitement and appreciation for art. A variety of research studies have shown that engagement in the visual arts improves overall learning and intelligence. In this

current climate, art educators must become advocates for the arts, whether or not they have a full-time position, are teaching artists, or have their own business.

The field of art education reflects the general movement toward independent contractors and freelancers, as opposed to full-time salaried employees. An attitude of innovation and risk-taking, as in other fields, will soon infiltrate every area of art education. An entrepreneurial spirit and effective communication skills, accompanied by good business knowledge, will allow art educators to thrive with confidence in this changing landscape.

A career in art education utilizes the creativity you have as an artist. In art education, as in all careers, be prepared to adapt to further changes: do not count on circumstances staying the same. Make opportunities for yourself. If you do not see jobs advertised that are what you want, think outside the box and create them for yourself. New avenues of art and art education have yet to be determined. You do not need to focus on just one of the topics discussed in this book because your career may take you through many of these areas sequentially or simultaneously. All of the people we interviewed forged their own career journeys. Sometimes they were linear, but more frequently, they followed divergent pathways. Unanimously, they all used their imagination and ingenuity, and one experience led to the next.

This book introduces a variety of jobs that involve teaching art and it helps guide you through the paths of employment. Each chapter includes a description of the job, educational settings, what you will be doing, essentials to include, what's needed to get there, and recommendations and requirements. In Chapter 11, In Their Own Words: Interviews with Art Educators, educators discuss their careers. Finally, the resource section at the end of the book will show you how to access more information regarding any of the topics covered.

This is a timely moment for art education. With so much current interest in infusing art in education, this book offers you the career information that will help lead you down your own path to success.

1

Working with Very Young Children (Birth–Age Four)

Do you want to teach art, but don't know which age group you would choose? Preschool teachers offer an array of activities for young children. They include art as a central theme in their programs. Are you a warm, friendly person interested in teaching brand-new concepts to a receptive young audience? As a pre-K art teacher, you will be encouraging spontaneity in young children and will witness something spectacular: preschoolers creating art with complete joy and freedom.

It is the process of exploring new materials that is so exciting to them—not the end result. As you work with very young children, you will see that your instruction and the way you respond to their art will guide children to embrace and sustain this passion. During this time, students develop their aesthetic sense, or perceptions toward art in all that they experience. This is a wonderful time to see motivated young artists, and the enormous satisfaction from their work will be something you share with them.

Children draw, paint, and sculpt what is familiar to them in their natural world: their families, themselves, where they live, the people or animals in their lives, the sun, the moon, and what they have seen, or feel curious about, such as dinosaurs in a museum or a boat they have ridden. When in the art room, they are also using their innate creativity in their art. A preschool art teacher should encourage this curiosity, inventiveness, and motivation with the type of lessons designed and the projects provided. The students, in turn, will show you what motivates and sustains them, and the teacher is there to guide them.

Preschool children also have gaps in understanding, which is typical for very young children. Yet, they logically fill this gap with imaginative logic and percep-

tiveness. Developmentally children show contradictions in skills. They can be both agile and clumsy. While working with them, you will see their rapid development; you don't have to wait a school year to see them grow and mature—it happens right in front of you.

WHAT IS EARLY CHILDHOOD?

In the United States, Early Childhood is defined as birth to grade 2. Historically, in the United States, formal education has begun in grade 1. By grade 1, children are usually between the ages of five and seven, depending on birth date and the school policy for admission. Almost all elementary schools include kindergarten. In this chapter, we refer to "preschool" as the education of children before grade 1.

EDUCATIONAL SETTINGS

Preschool can run from a few hours a day (such as 8:30–11:30 AM or 12:15 to 3:00 PM) to a full day (8:30 AM–2:30 PM). Some operate daily, while others are two or three times a week. The usual structure, set by the teacher, includes organized activities geared toward socialization and pre-academics, along with art, music, and physical education. Snack time, play time, and rest time are interspersed throughout the sessions.

As an art teacher, you may be working alongside a certified head teacher and staff. In other places, you will be the sole teacher in the room. Most pre-K classes have between fifteen and twenty students in them.

Day Care

For working parents, day-care facilities offer a relatively inexpensive solution to taking care of their children while they are at their jobs. The standards and responsibilities vary greatly from state to state, and even within a city. Day-care teachers often include art as part of their ongoing curricula, or art teachers are hired to come in for special projects, such as introducing colors or shapes within the context of studying a specific culture.

Federal and State Programs

Traditionally, federal and state governments have sanctioned preschool programs. This legacy continues as children receive an early boost in their education that will contribute to academic readiness at this stage, as well as success in later years.

Head Start, Even Start, and Universal pre-K

Head Start provides children ages three to five from low-income families with specific lessons to prepare for kindergarten and beyond. Almost half a century since its inception, it remains a highly successful program.

Even Start blends literacy projects with other programs for local low-income families. It serves children from birth through seven years old and their parents.

Universal pre-K offers half days four or five times a week and for some, full-time programs. Individual states address this initiative. It has gained more attention recently with the push by President Obama for every child to attend preschool.

Public School

Public school pre-K programs can be housed in their own school with kindergarten, grades 1 and 2; or be part of an elementary school, comprising pre-K through grade 5 or pre-K through grade 8. During half-day or full-day sessions, children are taught hands-on skills to reinforce emerging literacy in English and mathematics. They are taught specific skills such as socializing, collaborating, sharing, and playing, and also have activities that build gross motor and fine motor skills. Art is an integral, essential part of the subjects.

Some charter schools are expanding within the public school arena to include early childhood students. They offer more academically focused programs in mathematics, English language arts, and writing for their very young students.

Private and Parochial Nursery Schools

Almost every town has a private school, or a parochial preschool attached to a church program. The mission of each determines the curriculum. However, many offer preliminary academic preparation for the next level in school: kindergarten. Some of these programs include goals for good citizenship and life skills.

Private schools have specific philosophies of education for young children. Montessori, Waldorf, and Reggio Emilia schools are examples of private schools that have specific views toward art and art-making, which hold a special place in their curricula. See Chapter 10 for more information.

Parochial schools

The goal of parochial schools is to teach children about their religion and help form their faith, while simultaneously teaching the required standards-based skills that start in kindergarten and continue through all grade levels. Often, one art teacher is hired for the entire school. The job responsibility may include teaching pre-K students.

Hospitals

Although hospital teachers may teach art, artists or art teachers provide a necessary service when they work in hospitals. Teaching in a hospital can mean working with students from a few days to a few months. You would work bedside with the children or bring them to the classroom where you can do art together. Teaching in a hospital takes much imagination as your choice of medium, materials, and instruction must take into account the children's health issues, stamina, and mobility restrictions.

Home Schools

These offer a comfortable environment in which students can grow and experience learning on an individual basis. Students are either taught in their own homes or another nearby location. Some home schools are usually taught by a parent, a group of parents, a contracted educator, or religious organization. Usually companies supply the art curriculum to the parent or home-school teacher. Yet, there are some opportunities to freelance as an art educator in home-school programs.

Teaching Artists in Nonprofit Organizations and Businesses

There are other opportunities if you want to teach young children. As a freelance teaching artist, you can work for an organization or business which will place you in schools, day-care centers, and community organizations. Rather than working at the same place full time, most freelance teaching artists work one to two days a week per school, and may be teaching at several locations. In New York's metropolitan area, for example, Studio in a School sends teaching artists to underserved organizations and they include pre-K art in their programs.

There are also independent businesses, or franchises, including Gymboree and Playspace, that offer a variety of programs to preschool children. Business franchises specializing in art education, such as Abrakadoodle and KidzArt offer pre-K art programs. The aim of their programs is to encourage students to develop new concepts, solve problems, and build confidence. Another option would be to start your own business teaching preschool art classes.

Maybe you've considered working at a museum, science center, or zoo. These sites provide unusual teaching opportunities. You have to do some investigating to see which places have special pre-K curricula and which have openings for an art teacher. You would be working with the education department within each organization. Once you begin to teach, usually part time, you may have the

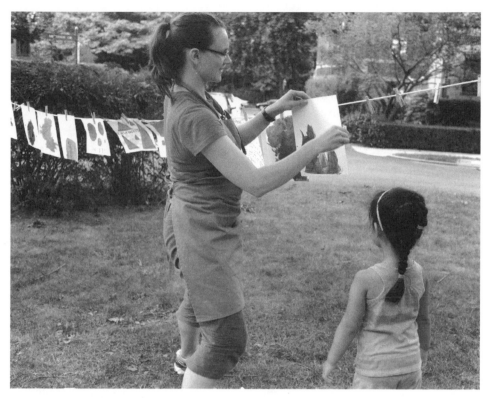

Art educator Emily Williams-Campbell has her own business teaching art classes to pre-K students. Photo by Fang Wang.

opportunity to offer your input on the lessons, following the themes and units that have already been set. Alternatively, you could work collaboratively on each project with the other education staff.

STAGES OF LEARNING

There are books on curriculum that you can reference that have specific sections geared toward early childhood learners and will help you clarify what to expect at this level. In addition, you can check the developmental stages of typical children by reading the works of learning theorists such as Swiss child psychologist Jean Piaget (1896–1980), Viktor Lowenfeld (1903–1960), and Russian psychologist Lev Vygotsky (1896–1934). Apply their theories as guides, not rigid indicators, of the different phases of childhood development.

As you watch children between eighteen months and three to four years of age scribble, they seem to do so without hand–eye coordination. Lowenfeld, not

surprisingly, called this stage the scribbling stage.[1] These young children will hold or clench a crayon or pencil with a fist, or in different positions and directions, and not necessarily with their dominant hands.

Often, children at this age produce indiscriminate lines of varying lengths. Perhaps after making one or two lines they are ready to begin a new sheet of paper. They sit, stand, move around, or sprawl out while creating these scribbles. When they make art, they interact with their environment. For example, paper, if it is given to them, walls, or floors make wonderful canvases—although not to the adult in charge. Their entire body may become part of this process. This movement is crucial to art and to their development psychologically and physiologically. This is not the time to draw a simple object and teach the children to copy it. They are not able to do that yet. Instead, children at this stage use what we call the "smear method" with paint. Arbitrary color combinations are smeared in basic rainbowlike, large strokes across paper.

If you follow Piaget's theories, the development of children's art at this stage is sensorimotor, and lasts until children are about two years of age. His theories focus upon children and their experience spatially with their environment and the use of all of their senses. Their readiness affects their level of interaction with their environment.

Later, children are still scribbling, but they can control their drawing a little more, and their work takes on intentional meaning. This movement of scribbling is an important activity that melds visual with kinesthetic or motor perception. They may abandon a picture well before completion or do a series of pictures with single scribbles or scratches on them.

You begin to see these seemingly random marks turn into recognizable shapes (although sometimes you may have to tilt your head to see it). These creations vary in size, color, and perspective. This change in work, from making symbols to representation, generally occurs between the ages of three and five. This is called the Preschematic stage, according to Lowenfeld, and lasts until the children are about seven.[2]

The amount of time that children spend on their art can also vary tremendously. Some may work for a few seconds or a minute or two on a piece. As they get older, or are at the representational part of their developmental stage, they can sustain their focus for up to twenty minutes or so.

[1] Viktor Lowenfeld and W. Lambert Brittain, *Creative and Mental Growth*. Macmillan, 1987, p. 48.
[2] Ibid., p. 48

Self-Expression

Expressing themselves through description is part of the process of their creations, and children may begin with a monologue while they speak to themselves, and then move to a dialogue with the teacher or their peers about what is going on in their art piece. As students create and share their stories about their artwork, they become more literate in the English language, just as when they become familiar with visual arts, they develop visual literacy.

Dr. Sandra Edmonds has taught art for over twenty years in the classroom and on the college level. She teaches at the Daniel Webster School in New Rochelle, New York. She describes this early time as crucial for children's development, and describes young children as they go back and forth from creating to sharing, by talking, or "writing," about their art, alternating with their creations.

As students attain more advanced skills, they become more involved with fantasy in their creations. For instance, they may draw all of the little details of a circus, and draw all of the animals, or they may build a castle with special rooms for the members of an imaginary kingdom. They may also wish to write elaborate stories about their art pieces.

They don't stand still

Watching young students as they create their work is incredible. Sometimes, they will sing or give commentary or even dance around as they work on their piece. Their happiness is evident. This movement in itself is part of the process of creating art, and may also create a new vision for them.

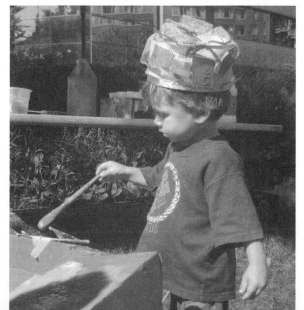

A pre-K artist enjoys movement and play while painting a cardboard sculpture.

WHAT YOU WILL BE DOING

By the time children reach first grade, many educators and theorists believe that their path toward intelligence and achievement is already set. This time of development, more than any other time in a child's life, should support all types of learning in a stimulating way, and you should strive to create an environment that instills the love of the new within every student.

As an art teacher, you will teach students to be problem solvers through art challenges. As compared to a sequential progression of teaching material commonly found in later grades, the early years should focus on the introductory phase of basic art concepts. It is a very exciting endeavor, for educator and students. Give children the basics, and they will run with them! Let them experience how to make their creations—from building a sand castle to modeling a pet from clay to making a paper collage. Let them enjoy the process of creating!

As children's fine-motor skills increase, and they render the same themes in pictures, you will see slight variations that are repeated over and over again, and you can add suggestions. Gradually, they will include fingers on hands, buttons on shirts, and landscapes with trees and flowers of different shapes and heights. As a teacher, you will also foster language-building activities in art class as your students increase their vocabulary and terminology of art. However, putting too many specific expectations on these children can curtail their interest at a young age.

Materials

You will be choosing materials for your students. Remember that their muscular development is not that of older children, therefore, think of what students' small hands can use: safety scissors, glue sticks or glue in containers, washable paint, and brushes they can easily hold. You will be using nontoxic, easy-to-use materials for modeling, painting, drawing, making collages, and other two- and three-dimensional work. Computers and other forms of technology can also be introduced as tools to create new art.

Themes

When you create lessons for very young children use general themes. Common unit theme choices include: nature, plants, animals, colors, life activities, the seasons, the family (a sensitive subject for some children), their home, and sports. Teach these themes for a few sessions or up to a month.

Teaching

This is the age of exploration, especially in art. You can plan the lessons so they are open-ended, and prepare different contingencies depending on which way the students react to the lesson. Suddenly, one child is painting her birthday cake, although her birthday is months from now; another tells you he is painting a kite, and would like some string. Be flexible and go with the direction the art takes them. As you observe the children and appreciate the aesthetics of their art, you will see that they are, in their own way, noticing details, patterns, textures, and shapes.

Read to the students as you show them the pictures in books. Let them tell you the patterns they see and the connections they make with their daily lives, their senses, and other creative activities and topics. For instance, you could ask the students to describe something that they saw outside the day before, and then ask them to draw a picture about it. Guide them to easels already set up with paper and tubs of paint, and ask them to respond to what you read. Take them on trips to common places in their environment (i.e., the firehouse, the post office). Cook with them with their classroom teacher. Encourage them to describe what cake batter looks like to them. Making designs on cookies or creating their own shapes from the batter feeds their creativity. (Pun intended!)

As they begin to appreciate the aesthetics of their own art, they also begin to appreciate the art that you show them.

Dr. Sandra Edmonds had been a weaver before she began her teaching career. Her first grade classes were studying early-American cultures. She taught the first grade students to weave while they studied the fabrics that the Native Americans and Colonists wore.

Cathy Ramey, a teaching artist has worked successfully in different capacities within Studio in a School, New York for over twenty-two years, loves working with early-childhood students, and describes giving children the skills they need by breaking down the information into manageable steps. She uses her background in drama to include songs and kinesthetic components so that kids will have a physical engagement with the process. She moves around the room, offering simultaneous action and including as many modalities as possible. As she teaches, Ms. Ramey addresses the students' wide range of developmental levels so that everybody in her classroom can be successful. She introduces her young students to the proper way to use brushes and to a variety of mediums such as clay and wood. She teaches drawing, cutting, and other basic components that build to figuration. She uses the manipulation of shapes and collograph prints to teach

her students about the shapes that occur in nature. She shows them how to cut shapes and organize geometric forms on their own, as she prefers to see students producing work that gives them an opportunity to make creative decisions.

It is never too early to teach your young artists to respect their art materials and tools by teaching them how to take care of the materials and to clean up after themselves. This is part of the learning process.

Parent Support

Encouraging parents to be part of their children's education will almost guarantee that the arts will be supported at home. Ask parents to come to "art openings," bid on their child's work at an auction, or buy it outright. Ask parents to donate supplies such as egg cartons, boxes, and containers that you can use in the classroom. Some schools will encourage you to invite parents to come in and do a project or activity with the children. Fund-raisers are other effective ways to involve parents.

Standards and Grading

Standards are constantly being developed and updated throughout the country for this age group (see the resources section for links to the most up-to-date versions). In terms of assessing the students, the school or organization sets the parameters. In pre-K, evaluations usually consist of written descriptions of behavior or rubrics that use specific terms (such as unsatisfactory, satisfactory, good, excellent), or facial expressions (smiley face, sad face), to show how well students performed.

WHAT YOU NEED TO GET THERE

How the Classes Are Organized

Most preschool classes are run by a head teacher who has at least a bachelor's degree. The teacher is usually certified or on a teaching certification track for early childhood education. There may be one or two assistant teachers in the class who support the head teacher in providing instruction and classroom management. They will have a number of college credits in early childhood and usually have a bachelor's degree. At a minimum, classroom aides have a high school diploma, and offer supportive help. Sometimes, the class will include a paraprofessional or two, unless it is a special education classroom. Each "para" works directly with one child who has significant health or management needs that require one-on-one assistance. With approximately fifteen students to a class, the ratio is usually one adult to seven or eight children.

Certification

There is a large range of requirements necessary to work with preschool children, and it is contingent on the policies of where you work. Depending on the school or the state, special training and certification may be required. Check the state education website where you wish to work, or the website of the private organization. In most states, you need a bachelor's degree to teach, and if you wish to work in a school and teach in early childhood classes, you must attain a time-limited extension to your state certification in another area, for example, childhood education. You can enroll in a college that offers an early childhood teaching certificate or program that leads to state certification. In some states, you can add to your bachelor's or master's degree by taking several additional courses in early childhood development and emerging literacy. Usually, this also entails completing about fifty hours of fieldwork experience in an early childhood site. To work in Montessori or Waldorf schools, teachers must complete comprehensive training, after which they receive a credential specific to their respective school. States have different requirements, even within the same state; regulations can differ depending on the district.

Check with the state to see what the requirements are. If you are working in a day-care facility, museum, private facility, or parochial school, check your state's Office of Health or Department of Education to determine what requirements are needed. Some heads of day care, for instance, do not have advanced degrees; instead they have a certificate of day care, demonstrating a completion of practical coursework and experience they have had with young children.

Assessment

In most states as a teaching candidate, you also have to pass a series of tests before you are certified. These assess general skills, educational knowledge, and specific content as part of your certification process. You may be asked to submit a video to the state as part of your teacher evaluation. (See www.edtpa.aacte.org/ for more information on this component in teacher assessment.)

What if you aren't certified?

If you do not have state certification, there are still many early childhood centers where you can work. Investigate them, place by place. If you want to work at a specific site where certification is needed, begin as an assistant teacher, or come in as a visiting artist. Volunteer as often as you can. These experiences will be helpful when seeking future job opportunities.

Fingerprinting

For all of these positions, you must be fingerprinted before working with any of the students. Check with your job, the state's Department of Education, and your district for more information on their fingerprinting process. When you have gone through the process, keep your receipt, you may need to show your potential employer that your fingerprints were processed.

Recommendations and Skills

- Connections: avail yourself of professional development opportunities. Once you are working, the opportunities for professional growth are abundant. Look in professional journals and on new websites.
- Check out lesson plans online or in art teaching books that are geared toward preschool students.
- Check if there are small grants available or discounted tickets to special art events or exhibits.
- Enjoy the process of learning rather than solely the result of their efforts.
- Have patience.
- Respect your students, and their feelings.
- Be organized.

2

Teaching Kindergarten through Grade 12 in Schools

An art teacher in grades K–12 has the opportunity to become a model and mentor to students. They decide what students should learn, and have the control over the concept, materials, and time frame for the completion of every project. Motivating and nurturing students so they will explore and immerse themselves in art is part of the fun and responsibility of being an art teacher. It is up to the teacher to provide new arenas for students' intellectual, physical, social, perceptual, and aesthetic growth. At the same time, stretching the skills of the students, guiding them to perceive art in new ways, and fostering their imaginative awareness are the desired goals.

As an art teacher, you will see students' day-to-day development, such as increased fine motor work and attention, and a shift from the literal to the abstract. Unlike classroom teachers, who have students in their classroom for one year, you will have these same students for at least two to three years. During that time, you will witness significant social and emotional changes as they mature. It is exciting to see their overall skills in making art progress—because of your influence. It is through your guidance as a teacher that the students develop artistically, based on the foundation and subsequent topics you teach. What a powerful incentive to teach!

EDUCATIONAL SETTINGS

Different types of schools and their settings have their own qualities that affect your teaching of art. There are many types to choose from: large or small, public or

private, charter or magnet. Consider the number of grades in a particular school, how large the facility is, and how many students you will teach at once.

Organization of Grades

The way schools are organized can determine the grades you will teach. Elementary school may be structured to include kindergarten through grades 2, 5, 6, or 8. Middle school, or junior high school, can include a combination of any of the grades 5 or 6 through grade 9, and the typical high school contains grades 9 through 12, although some have only grades 10 through 12.

School Size

The size of the school should be a factor in your decision-making process. The hustle and bustle of a large school can be exciting, but so can the nurturing, intimate environment of a small school. Larger schools often have more art facilities and specialized electives. Small programs may run more efficiently and rigorously. However, with less staff, teachers often wear many hats. As a result, art teachers can be advisors to students or coteach humanities or social studies with art, or even teach an additional subject.

Class Size

Class size can fluctuate in a public school from as few as twelve students to as many as forty, but the national average is twenty-five students in a class. Larger classes may have an assistant teacher or a parent volunteer to help out.

Public Schools

Public schools in the United States are supported by public funds and provide free education for children. Most full-time positions for art teachers are in the public schools, and these jobs generally provide higher salaries than private schools.

The hierarchy in public school districts begins with the school board. A school board can have different roles, but usually governs the school district, often setting the curriculum and implementing the guidelines and standards set out by the state and national governments. The superintendent is the chief administrator and educational leader of the district. He or she may run the district office operations, which is in charge of supplies, books, state exams, and teacher evaluations for every school in the district. The superintendent may have an assistant superintendent who shares some of the responsibilities of the office. The superintendent

supervises the principal, who is responsible for the daily operation of the school and supervises the assistant principal, teaching staff, school secretaries, teachers' aides, and custodians. The assistant principal often handles specific behavioral issues in the school, attendance issues, and testing.

Some school districts have a director of the arts program or a district arts supervisor. This person is in charge of all of the arts in the district from elementary through high schools. All issues related to the arts programs go through this person. The arts director may hire, supervise, and mentor the art teachers, and provide professional development for its teachers. Often, he or she has previously been a teacher in the arts.

Magnet Schools

Magnet schools are types of public schools with a specialized curriculum that draw students from a larger geographical region than neighborhood public schools. Some magnet schools specialize in fine and performing arts—an ideal situation for an aspiring art teacher.

Charter Schools

Charter schools are run independently, but are publicly funded. Typically, a charter must be accepted by the local school board and/or state education office, which generates a contract between the state and the school. Like magnet schools, charter schools may offer specialized curricula, follow a particular mission for success, or even strive to enroll special populations.

Hospitals, Homeless Shelters, and Incarceration Centers

Hospitals, homeless shelters, and incarceration centers offer other opportunities to teach art. The schools in hospitals are part of the public school district. Students have academic instruction, if they are well enough, for a few hours a day. The curriculum followed is what is taught in the children's home school. Art teachers would be additional staff.

In hospitals, you would provide one-on-one art instruction bedside or in the classroom with small groups of students ranging in age, physical ability, and stamina.

Art teachers are a vital presence in detention and incarceration centers as well as in homeless shelters. These can be publicly or privately run facilities. Art educators are recruited to provide instruction for a few hours a day. Additional coursework in counseling, art therapy, or special education is advised.

Private Schools

Private and independent schools receive funding through tuition, private funding, loans, and other nonpublic funds. They can also receive federal and state support. Students may be carefully selected. Some private schools may be exempt from following certain state education regulations, thus resulting in more leeway to make curricular decisions. Generally, they have fewer faculty and students than in public schools. They may have smaller classes, less discipline problems, and better facilities, especially in high-priced, selective schools. The down side for these benefits is that the salary may be less than in public schools.

Parochial Schools

Parochial schools are privately run by religious organizations, and provide a religious education in addition to basic curricula. Tuition is affordable because the cost of running a school is subsidized by the religious organization. Although the expectation is that you will teach typical art themes, religious ones can be included as well. For example, in a Catholic school, you may be asked to incorporate a lesson on specific saints. You will be paid less as a teacher in a parochial school than in a public school and some private schools.

Homeschooling

Almost two million students are homeschooled in the United States. Traditionally, families have chosen to instruct their children at home for religious, moral, or personal reasons. There are several models of homeschooling. In one, local school districts, private companies, or agencies provide the students' curriculum. Students' work is mailed to an accredited institution, graded by a teacher, and then returned.

Another option is that the parents have sole responsibility for materials and instruction. A growing trend in the United States is based on a cooperative model. Several families share the teaching for various subjects to provide more socialization for the children and to ease the burden on each family. The art teacher sets up regular visits to the home schools or provides instruction online. This is a unique opportunity to work with small groups of students and very committed families, in a comfortable setting.

Boarding Schools

If you want to work in a beautiful rural location, and on a campus, you would love working in a boarding school. You have the opportunity to work intensively with students during class times and daily living activities. Boarding schools have

extensive art facilities, better than many colleges. Living on campus with super-visory responsibilities will enable you to be a role model as an artist, art teacher, and advisor. It is also an excellent way to save money: you are given a very nice apartment or house, and can eat in the dining hall for free.

Special Education Schools

There is always something new awaiting you when you teach in a special education school. At first glance, the classes may seem identical to a private or parochial school. However, a special education school is a facility for students whose disabilities are too significant to be included in a regular public school. These disabilities may include the following: physical, behavioral, learning, and vision impairments, as well as deafness, deaf-blindness, autism, and other developmental and multiple disabilities. Additional coursework or certification in special education is important so that you can address the myriad of behaviors exhibited by these students. Tapping into their hidden art talents and honing students' art skills are thrilling adventures—both for the student and you.

TEACHING OPTIONS

Teaching offers a flexible schedule, which allows for many options: full time, part time, or short duration. In contrast to an office job, there is time off during school vacations.

Full Time

Full-time teaching means teaching Monday through Friday for the full school day. In many elementary and middle schools, a teacher will teach four to five art classes each day, and the length of each period can range from thirty-five to fifty-five minutes. High schools' classes have a similar duration, with the addition of blocks of longer periods. Depending on the school, classes meet either once or twice a week. Amazingly, you will learn all of the students' names in a short period of time. You may have breaks and preparation periods, and will probably have some noninstructional duties as well. For example, you may be asked to help in the lunch room or with recess. As an art teacher, you will probably not have a homeroom or advisees.

As a full-time art teacher, you are entitled to full benefits including health insurance and retirement plans. In many schools, after three years of successful teaching, in which two to four yearly observations are conducted, you will earn tenure, a controversial topic at present. This means that you can keep your job until retirement; you will not get fired unless you demonstrate egregious behavior.

Part Time

Part-time teachers work from one to four days a week, or may work half days Monday through Friday. Although some schools offer a proportional health plan that can be subsidized by the employee, usually extra benefits are not included in this position.

Substitute Teacher

The art teacher who substitutes regularly can have a cool reputation. You are the fun, new person coming into the school. In addition to the lesson planned by the full-time teacher, you can always infuse your own teaching style, and integrate one of the ideas you brought with you. Substitute teaching is an excellent way to break into the art teaching field while you are looking for a full-time position. You can be a long-term substitute teacher if you take a position as an interim leave or maternity leave replacement.

Unions

You will be required to join the union if one is in place in the school where you work. The union has strong bargaining and negotiating power involving contracts and tenure. Many member benefits include insurance, dental and vision provisions, legal and financial services, travel, entertainment and shopping discounts, scholarships, and loan-forgiveness programs.

The National Education Association (NEA) (www.nea.org), and American Federation of Teachers (AFT) (www.aft.org) are the most common unions in public schools. The teachers of private, parochial, and independent schools are sometimes unionized as well.

WHAT YOU WILL BE DOING

Once you have your job, it is time to teach. Now the creativity begins. What's exciting about teaching art is that *you* decide what students should learn. You have control over the concept, materials, and time frame for the completion of every project. Here's your time to shine: everything you have learned as an artist will come into play.

Standards

Art teachers in schools are expected to align their curricula to general standards. Standards are guidelines articulating the artistic skills and concepts that all K–12 students should be learning. Standards are created by professional, state, and federal

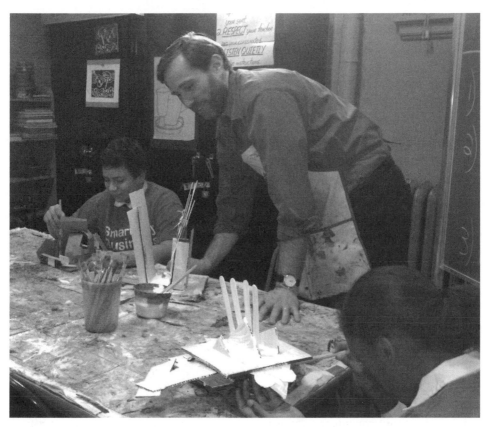

K–8 art teacher William Moakler teaches a middle school sculpture project.

organizations. As part of the nationwide movement to increase positive student outcomes in schools throughout the country, standards are continuously being created and modified. The standards provide expectations to follow in your unit and lesson plans.

Fortunately, professional, national, and state standards for art are very general. They cover topics you would want to teach anyway. For example, the Consortium of National Arts Education Association (CNAEA) (www2.ed.gov/pubs/ ArtsStandards.html) specifies learning requirements that every student should fulfill in the arts for grades K–4, 5–8, and 9–12. Most states adopt standards as well in the arts, which include music, theatre, dance, and visual arts.

There are also standards for the teachers. The National Art Education Association (NAEA) (www.arteducators.org/research/naea-standards) sets expectations for art education programs. These norms include theory, content, and practices of the program, so that graduates will all be able to provide excellent art instruction for their students.

The Interstate Teacher Assessment and Support Consortium (InTASC) brings together several state education agencies with national organizations. Their mission is to standardize what all teachers should know and be able to teach across subject content and grades. *The InTASC Model Standards: A Resource for State Dialogue,* from April 2011, is the most current revision of the standards. The full current InTASC standards can be found at: www.ccsso.org/Resources/Publications/ InTASC_Model_Core_Teaching_Standards_A_Resource_for_State_Dialogue_ (April_2011)-x1025.html.

Unit Plans

These standards become the foundation for creating a curriculum, which is based on unit and lesson plans. A unit plan is a series of lessons on a specific topic. It can be as short as three class periods, or last for a month or more. When you decide on a theme, think about how much time you will need, keeping in mind the ability and attention span of your students. Write down the purpose; this will become your rationale. Divide the content into manageable, sequential chunks of instruction. These will become the individual lesson plans.

Consider a unit on the subject "nature." The first lesson of this unit provides an introduction to art created from natural materials, followed by a video on Andrew Goldsworthy. In the second lesson, students create environmental sculptures. Depending on how much time you want to spend on this topic, supplementary lessons could include paintings based on fall leaves, or rubbings from found natural objects. For the final lesson, the students could critique their finished projects, or install an exhibition in the hallway.

There are many other ways of developing a topic. For example, a holiday such as Cinco de Mayo could be used to introduce Mexican crafts and culture. Students could learn how to make a version of Amate paper, and paint it using yarn painting as an inspiration. Another theme could be simply using a material such as clay or found objects. A unit could examine a historical time period such as ancient Egypt or an art form such as artists' books. An element or principle of art (i.e., line, shape, or balance) can be developed into a unit. A unit topic could integrate subjects covered in other classes, or by the entire school, such as a school-wide project on global warming. Depending on the grade level, supplementary reading and writing can support each of your unit themes.

Lesson Plans

Lesson plans outline what you will teach each period. They provide the framework for your ideas that will result in well-organized sessions. This is important for

many reasons: chiefly, as a new teacher, your self-confidence will be developing as you go forward. Articulating your ideas on paper provides you with a foundation from which to work. Within this structure, you will figure out the length of the project, what materials you need, and what you want to accomplish.

Although lesson plans vary, they follow a basic format. Each lesson plan generally begins with the title and main idea, followed by two or three objectives that students will learn during the class session. It also includes the amount of time needed to complete the project, and a list of materials. The main body of the lesson plan is a summary or step-by-step description of the procedure, followed by assessment and reinforcing activities for completion outside of class. Modifications and enhancement of the lesson integrate appropriate methods to reach all students.

Depending on your principal, you may have to hand in weekly lesson plans for each class. These can include general topics and objectives, or a detailed plan for when you are observed by an assistant principal or principal.

Dr. Quincy Egginton, an art teacher who has taught all grades, engages the students as they enter the art room. For one lesson on the beach, she dressed up with a sunhat, wore blue, and brought a pail of water, pail of sand, tray of shells, beach ball, and beach chair. She invited students to touch all of the objects, and recall their experiences of being at the beach. This type of motivation sets the tone for a lesson that contains a number of options for all students.

Objectives

Objectives are what you want the students to accomplish during the class period. They are written in tangible, quantifiable terms, such as, "Students will create a portrait using primary colors." They are linked to specific ways to assess whether the students reached these expectations. When you grade the finished project, you can see to what degree students attained those objectives.

Materials

A complete list of all needed materials is crucial. Think of materials which are safe, practical, and fit in your budget and classroom space. Make sure you have enough for the entire class, and a little extra. This will help avoid last-minute crises, such as beginning a watercolor project and realizing there is no water in the room.

Procedure

The procedure describes how you will implement the lesson. It could be as general as an outline or as specific as a script, with a beginning, middle, and end.

A hook or motivation begins the activity. This hook could be, for example, a cartoon or painting that you show to the students when they first arrive in class. It is a strategy to motivate the students because they will anticipate that something exciting and different is just about to happen.

Assessment

Assessment is how you evaluate whether or not the students have achieved the objectives of the lesson. Will you observe their work? Will you rely on their finished product to determine if they "got it"? That is assessment. Your points of assessment should match the objectives written. So, if your objective is that a student will draw a triangle, your assessment is that the student created a triangle correctly, or that you observed the student creating a triangle. You will do critiques no matter what the age group; this is the time for you and your students to analyze the strengths of their work, and give suggestions for improvement and future development.

Rubric is another term commonly used in assessing students. A rubric is a chart with the different components of the lesson outlined. It shows how well students complete each level. There is a scale with different terms evaluating "unsatisfactory" to "exceptional" for each part. Some of the components may be "effort," "participation," "preparation," "clean up," "organization," "understanding concepts," and "handling of materials."

Follow-up

At the end of the lesson plan, add a homework or a follow-up. You have a huge range of assignments that you can have students do outside the classroom, or during the next class, to reinforce the material. Typical homework could be working in a sketchbook, going to see an art exhibit and reflecting on it, or doing a project that reinforces what was done in class. Perhaps you want your students to write an essay based on their research of an artist or art movement. Outside assignments should supplement what you do in the class and not be something entirely foreign to the students.

Grading

Art teachers, like other teachers, must evaluate their students. Grades, the most common method, summarize student performance. Even though you are consistently evaluating their progress during each class, there comes a time when you must assign grades. This is a greater challenge than you may expect. The system

of assigning numbers or letters to an artwork seems alien to the complex creative process, and involves difficult decisions.

Portfolios

There are different types of portfolios that you will be exposed to during your career. As a teacher, your influence will be evident in the work of your students. From kindergarten through high school, the art teacher and every student in the art class will stockpile specific examples of students' individual artwork. The portfolio is not just a present for parents at the end of a school year; it also shows development, progress, and achievement in art skills and is a way to demonstrate accountability for both the teacher and student.

Grade 8 students prepare portfolios for entrance into specialized art high schools in parts of the country. These portfolios are organized into different subject matter and materials, and demonstrate student skills in a variety of media. High school students also need an art portfolio to get into their college of choice. These include more sophisticated artwork and more varied media. Writing samples and recommendations may also be part of this high school portfolio.

Other Opportunities in and out of the Classroom

As a teacher, you have many more opportunities to be creative. Bringing guest speakers or guest artists into the classroom broadens your students' experience and also initiates connections with members of the broader community. You can also be a guest speaker in other teachers' classes. This will help you form relationships with your students' teachers. Collaboration is a wonderful opportunity to use your art skills for projects that transcend different subjects. You may love exploring new adventures in teaching art/humanities, art/science, or even mathematics. You can find out what other teachers are doing, and integrate their subjects and current themes into your art classes. When there are school-wide events, take the initiative to talk to the principal to see if you can coordinate and contribute art projects.

Bulletin boards and art displays in the school lobbies are great for showing everyone how important art is at your school. You can display pieces on the wall or suspend them from the ceiling. You can exhibit students' 3-D masks or display their latest attempts at pointillism. Quilts from paper, cloth, or tiles are wonderful class projects achieved independently or in groups. Murals are other fun and rewarding student endeavors that others will enjoy. Reach a larger audience by creating an online art exhibit, or a website for your art classes.

You can plan and implement student exhibitions for all of your art classes in the community as well as the school. This is easier to do than you think. Contact

local businesses, government offices, libraries, and hospitals to see if they have space you can use. Organize a window decorating event/contest at Halloween. Join a local arts organization, so that you can cochair events with other artists and art teachers.

Your enthusiastic students will want more time to do art. Consider running a lunchtime or afterschool program. Your school may have an art club. If not, start one! If you run an art club, you would find that you are giving extra attention to those who are passionate about art, as well as developing all of the student involvement. These are the students who want to work independently, and appreciate the guidance and mentoring you offer. With smaller numbers of students, you can show them projects that are more complex. With this additional focus, club members will become more confident in their work, and that will translate into leadership skills within the classroom. They will thrive and their artwork will flourish.

Grant writing is another rewarding activity. Investigate businesses and organizations that support the arts and see if they will donate equipment and supplies, or funding for a special project. Local merchants, such as art supply stores, may donate prizes for an art contest. Many companies have programs to support educational programming, and they get publicity from being an official sponsor.

Parents can be great assets to your teaching. Ask them to help chaperone field trips. Those interested in the arts can help or even present projects of their own. They can be a wonderful source for getting guest lecturers, and they know many helpful people in the community. Parents can help with fund-raising—perhaps auctioning children's artwork to raise money for a special project or trip.

Encourage students with a special interest in art to consider careers in this area. If you teach middle school or high school students, keep them informed about college art programs and art professions. These students will need to develop and present portfolios for summer programs, specialized high schools, and for college. Part of your mentoring will include guidance on how to document their work and decide what to include.

Eventually, you may have students who become professional artists. These alumni may want to reach out to the school and mentor current students. You can encourage those who are established in their careers to be guest speakers, offer internships to older students, judge art contests, and find other ways to be involved.

Don't forget you have an important position as the school's artist. There are many other extracurricular activities you may be asked to take part in such as coordinating the school's yearbook or literary magazine, or designing sets for drama productions, and working with students to produce them.

ESSENTIALS TO INCLUDE

Differentiation

Lesson plans include modifications of your instruction to accommodate the variety of ways students learn most successfully. Students process instruction differently, so include verbal, written, and hands-on instruction. In a single class, you may have one student who can't manipulate scissors and another whose skills far exceed what you planned for the class. The necessary strategies that you will incorporate to address students' learning styles is differentiation. As Quincy Egginton says, this "can be as challenging as designing an alternative method for students with special needs, English language learners, or students exhibiting special talent."

English Language Learners (ELL)

Art reaches all students, no matter what language they speak. If you have students who are emerging English speakers, there are many techniques that you can use to transcend the language barrier. A visual arts class can give these students a comfortable place to begin to practice skills such as reading, writing, and speaking.[3]

Special needs

Regardless of children's disability status, everyone can participate and learn from the creative experience. The nature of art is that it is an individual process. With this in mind, adaptations of materials can be made, and when needed, assignments can be modified. For instance, if fine motor control is an issue then change a crayon or a paint brush to a thicker one, or use special scissors. If students have physical or sensory challenges, modify the physical environment—arrange the desk or lighting, for example, to accommodate their needs. Students with cognitive delays may work more effectively by doing one step at a time, rather than having many components of a lesson to grapple with at once.

Students exhibiting special talent

You may have students who draw all the time, and from the moment they step in your class, they want more. For students who finish work quickly and exhibit exceptional ability, include an enhancing project or add a challenging level to the

[3.] *Learning in a Visual Age: The Critical Importance of Visual Arts Education*, (Reston, VA: NAEA), 8 alumniconnections.com/olc/filelib/NAEA/cpages/9004/Library/NAEA_LVA_09.pdf (accessed September 2, 2012)

assignment. For example, if the class is making coiled pots, these particular students can add textures, or form a complex structure using multiple pots. Give these students extra time, more material, and encouragement.

Advanced students

Acceleration is a term used when students are in a class with students in a higher grade, and learning a more advanced curriculum. Some high schools offer Advanced Placement (AP) art courses, which expose students to a college-level curriculum. The resulting portfolios are evaluated by The College Board. If students' AP exam scores are high enough, they may be eligible for college credit. Some students are given special opportunities to delve into art outside the typical classroom structure. This is called *enrichment*. It can take the form of a special class, extracurricular activity, or even summer program.

Diversity instruction

Incorporate diverse cultures into your lessons, rather than as add-ons or special events. Instead of focusing exclusively on mainstream artists, include examples that represent students' racial and cultural backgrounds. Spend time investigating artwork that corresponds with the backgrounds of the students, and present it with your lessons. In this way, you are modeling excellent educational practice and affirming the contributions from all cultures.

Learning styles

Everyone has strengths in the way he or she learns best. Some learn best through visual information; others remember what they have been taught by processing what they hear; still others learn best by having hands-on experiences. Utilize a variety of mediums to convey the lesson plan.

Modifying for Multiple Grade Levels

The task of teaching a wide range of abilities in multiple grade levels may seem daunting, but you can modify a single topic for many of your students. For example, consider the subject of collage: kindergarten students can create a collage using simple shapes or pictures, and high school seniors can make a digital collage using Adobe Photoshop. You can show Jacob Lawrence's collage work to your students of all levels. Younger students will enjoy seeing an artist's work and hone their fine motor skills of cutting and pasting. While they will interpret this process on a literal level, older students can explore abstract con-

cepts and sophisticated techniques, as well as drawing upon a larger repertoire of knowledge.

Classroom Management

You will need to understand and implement classroom management. The most common behavioral issues in teaching art are excessive talking and socializing. Students look forward to art class because they can express themselves, but they often want to talk to one another while working. Sometimes they take advantage of this informal environment and distract themselves from making art. You may be okay with socializing as long as students are all working on the assignment and no one gets distracted. Make sure you have specific rules for each class with consistent consequences, appropriate for the level of infraction. Give clear instructions. You don't have to be harsh, but you do need to be consistent with rules and follow-up.

FURTHER IDEAS TO EXPLORE

Materials and Budget

As an art teacher, you will need materials besides paper and pencils. In a public school, for example, the money for your supplies comes from local, state, and federal monies, sales tax, income tax, lotteries, gambling revenue, property taxes, and grants. So, general economic factors greatly affect your budget. However, no matter what your budget, you are a creative person, and can do fantastic projects with recycled materials and donations from parents and local business.

Art-in-a-Cart

Many art teachers are called "art-in-a-cart" teachers. They do not have their own classroom due to lack of building space—instead they have an art cart that they wheel into other teachers' classrooms when it is time for art. This is an opportunity to show off your organizational and creative skills. You will get to know all of the staff and faculty, and the students will wait eagerly for you to come in with exciting new materials and projects.

Don't forget to wear comfortable shoes!

Twenty-First-Century Skills

According to the Partnership for the 21st Century, a national educational advocacy organization, certain skills are needed to compete globally in the workplace in the next generation. These basic and advanced skills include attaining core

knowledge in different subjects and being able to transfer that knowledge into critical thinking.

As part of addressing these skills, local and state organizations focus on student learning outcomes (SLOs), or what students will learn and what learning they can demonstrate. Expectations by state and federal standards have facilitated the arts in school environments to join forces with other departments or subjects. The Common Core Standards (www.core standards.org) articulate the expectations of student performance that most states have adopted.

STEM + ART = STEAM

As part of the movement to make U.S. education globally competitive, art is being integrated into what is known as STEM subjects (Science, Technology, Engineering and Mathematics), to create a new emphasis of learning. It comes with the acronym STEAM: Science, Technology, Engineering, Art, and Mathematics. The recent integration of art into these subjects develops and encourages creative and innovative thinking.

DEVELOPMENTAL STAGES

You will need to understand child development and the changes that children undergo. Teaching a skill or concept beyond the level of the children will result in frustration for them, creating a gap between what they are supposed to know and what they actually know. Teach within a progression of skills tailored to their developmental ability. For example, you may teach the youngest students how to do simple prints by painting and stamping an object, and then potato prints or linoleum cuts as a precursor to comprehending higher forms of printmaking.

Students undergo dramatic changes during this time. As their guide, you will support their individual process. You will be teaching students in all or many of these grades in the school, and in each grade—and each class—you will see much variation of skills. Some individuals will labor over basic skill work. Some are so advanced, they are hungry for more art to do, and fill up sketchpads in their free time. These same students have also developed their ability in the process and have the discipline to spend a great deal of focus and time refining their works of art.

Elementary School

Early elementary school is marked by a progression of rapid changes. As children go through developmental stages, so does their art. Jean Piaget and Viktor Lowenfeld first described these stages of artistic development in the early- to

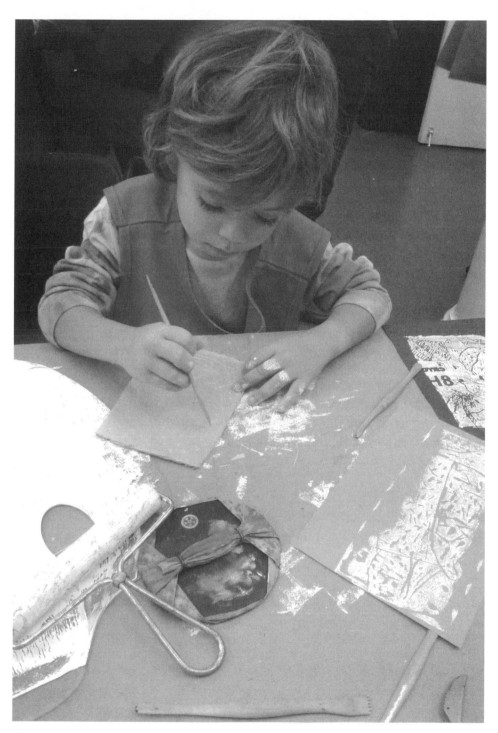

Elementary school printmaking

mid–twentieth century. Reading and understanding these studies is a valuable introduction to these early years of artistic development. Observing and working with children in this age group will show clearly how they move in and out of the described stages.

Readiness for specific materials, such as scissors, will depend on their fine motor control, maturity level, and sometimes on school regulations. Learning about basic shapes and colors, and using brushes, paint, and crayons, as well as doing a collage or modeling from clay or Play-Doh are common instructional methods and materials used with young children.

As you read in the last chapter, young children's first experiences with visual art begins with scribbling. Eventually, they move from scribbling to creating recognizable objects in their work by the time they are in elementary school. As they focus their interest on these objects, they tend to repeat them over and over, without variation. Figures, objects, animals, and trees will all look identical except for the position on each new piece of paper. When they start to draw people, they are drawn in a similar way: a large head with dots for eyes and nose, semicircles for ears, and sticks for legs.

As children gain knowledge, their drawings change at different rates, although it will seem as if this occurred in a blink of an eye. Some children will intentionally add hands, fingers and fingernails, knees and ankles, shoulders and waists, eyebrows, and hair that is no longer perpendicular to the head. Their understanding of anatomy changes as children explore what is important to them during the process. Representing proportion, spatial relationships, and sensory knowledge are introduced and practiced.

As students progress from grades 3 through 5, their art environment can encompass all mediums. They become adept and more accomplished at using materials, as their fine motor skills increase. This is reflected in the increasing complexity of both realistic and abstract work, and perhaps a sophistication of the work. The art teacher can reinforce the step-by-step learning students have been exposed to in the curriculum presented in each grade.

Middle School

In grade 6, children go through a transition, where they look at the world in a different way from when they were in elementary school. Students use this time to make further explorations in mediums and subjects of their art. Peer pressure, the influence of advertising and media in their community, and the desire to conform can stifle creativity. Students become very self-conscious and can lose confidence

in their ability. However, enhanced self-knowledge and fine motor-skill coordination can lead to an artistic blossoming. More than ever, an effective art teacher can help bolster student doubts and encourage them to hone their skills.

High School

Older students can take a topic, and with your guidance and sometimes leadership, challenge themselves to new levels of imagination. Ironically, having learned throughout elementary and middle school to internalize certain emotions, reaching these levels is more challenging than when they were young students. Their confidence is less assured, and you become their counselor as well as their teacher to encourage them to express themselves.

High school students do not necessarily experiment more with medium and subjects. Instead, they develop their personal style and technique. They gain the ability to understand abstract concepts and can focus on the content of their artwork, articulating its meaning and making it more technically polished. They may develop very specific interests in a topic or medium, and usually spend hours working and reworking their pieces.

WHAT YOU NEED TO GET THERE

There are many pathways to become a K–12 visual arts specialist, depending on your educational level, experience, and interests.

Requirements

Certification and licensing

To teach art in a public school, and in many private and parochial schools, you must have authorization from the state in which you will be working. These credentials are called teaching certificates. With an art teaching credential, you can teach students in grades K–12 or in pre-K–12, depending on the state. In cities, such as New York City, you will also receive a license in addition to the certificate given by the state. Each state has its own requirements, so it is important to make sure that you are following the correct program. States change the prerequisites for a teaching certificate on a regular basis, so you must have updated information, which is found on the website for the state's government.

For instance, New York State is moving toward changes in assessments for initial certification. These will include measures of general literacy, knowledge of educating students, content knowledge in visual arts, and an assessment

(called edTPA) consisting of a twenty to thirty minute video of the candidate with demonstrated evidence of planning, instruction, and assessment (approved thus far in twenty-five states). Due to the variation in certification requirements amongst the fifty states, there is a movement for teachers to gain additional National Board Certification to standardize the profession. For private and parochial institutions, you should check with the particular school because again, the requirements vary by state and school.

Interstate reciprocity

Many states have reciprocal agreements, so if you would like to teach in a state other than the one for which you are certified, most will accept all of your credentials. A few will require taking their state exams and even fewer may require taking another course or two at the most. If you decide to get certified in another state, carefully read the other state's Department of Education website.

Visual arts specialization

States grant specific certificates for different grade levels and subject areas. Art education certification allows you to teach grades K–12, or pre-K–12, and the subject area is called visual arts. To gain certification, you must either complete a program or attain certification through an alternate pathway.

For both, you must take a series of tests, usually three. The first covers general information; the second, education; and the third, the arts. The tests consist of multiple-choice and essay sections. Each state's education site has links to practice tests. Also, your neighborhood bookstore will have preparation books to examine.

Many states have requirements in common. States require a bachelor's degree, and completion of an art teacher education program. Student teaching is an integral part of a teacher education program. Under the guidance of an experienced teacher, called the cooperating teacher, it is a full-time experience. A professor from the educational institution will supervise the student teacher throughout the semester. All states require a minimum grade point average (GPA).

Fingerprinting

In most states, you are subject to a background check for criminal history before working with children. You must have fingerprinting clearance to be able to teach. In some school districts, you cannot even enter the school without having your fingerprints processed. Follow the guidelines of your state educa-

tion department. Your fingerprints will be sent to the state as well as stored in an FBI database.

Types of certificates

States offer different levels of teaching certificates. The first is an initial certificate, which is usually awarded upon completion of a bachelor's degree program in art education. This certificate is valid for a few years, depending on the state regulations. After a few years of teaching experience, you can enter a master's program, or in some states, take additional courses. Then you can apply for the next level of certification, usually called a professional or permanent certificate. Your master's degree can be in art or another school-related discipline. Technology and special education are common choices. After reaching this level, and after additional years of teaching, many states require continuing education courses to renew a certificate. This will help you keep abreast of current methods in the field.

Alternative routes to certification

States offer an accelerated route to attain your certificate and get into the classroom. If you have experience in the visual arts, you may be eligible for an alternate route to be certified. Check with your state education department to see what you would have to do. Usually someone will review your portfolio and experience, and may waive specific requirements for certification in exchange for your past experience. Sometimes, these alternative routes require teaching in high-need schools, often in urban or rural settings, for a couple of years.

High school students seeking a bachelor's degree

If you are in high school, or if you have a high school diploma, look for accredited undergraduate college programs in the state where you would like to teach. Seek a state-approved teacher education program. Most programs in art education offer a BA, BS, or BFA in Art Education. The BFA degree is a more intense program, requiring more art electives. Whatever your choice, make sure that the program offers a full range of art courses and opportunities.

Some universities offer programs that combine undergraduate and graduate degrees in art education. Some degrees, especially BFA in Art Education programs, can take more than four years to complete. Some schools have accelerated programs so you can earn a bachelor's degree and a master's degree at the same institution within five to six years.

College graduates seeking graduate study

If you have a bachelor's degree in art, or a bachelor of fine arts degree, you can apply for a master's degree program in art education from an accredited university with a state-approved teacher education program. Coursework will include methods and materials of teaching art, philosophy of art education, historical foundations of art education, aesthetics and art criticism, child and adolescent psychology, and art instruction for special needs and exceptional students. Master's programs require a written thesis.

If you have a bachelor's degree in a subject other than art, do not fear: you can enroll in a master's program to earn both the initial certification and graduate work necessary for the professional certification.

Teaching art as a second career

Many states offer options for professional artists with extensive education and experience in art. You can have your previous coursework evaluated, and you can complete the requirements for certification without obtaining an additional degree. For example, if you have an MFA in Visual Art, you may need only the education courses and student teaching. Most states have "alternative routes" to certification, which will allow you to work while obtaining your certification. They often waive some requirements in exchange for your prior work or educational experience. These are usually in geographic areas in need of teachers, or in subjects that have teacher shortages.

Sarah Lotfi-Hene trained as a graphic artist and had a successful career in an advertising company. However, she worked alone and wanted the interaction with other people. She went back to school, enrolled in a teacher training program, and has been an art teacher in New York City for students in kindergarten through grade 5 for many years. She also has been able to implement many of the skills she used in her previous career.

Recommendations and Skills

Remember the first art teacher who had an impact on you. Remember the best art teachers you had. Think about the characteristics they had and how you can make those traits your own. Did they have well-rounded skills? Were they charismatic? Were they funny?

First and foremost, you should enjoy working with others, especially children. You must have enthusiasm for all aspects of art and a strong desire to inspire others. You should also have plenty of patience, flexibility, and a sense of humor.

In addition to coursework and student teaching, there are many activities that can help you gain important skills for a career in art education. Because many schools depend on one to two teachers to instruct all areas of art, it is very important to learn as many techniques as possible. Knowledge of ceramics, kilns, clay and modeling materials, traditional photography, printmaking techniques, and graphic arts software programs will give you an advantage over teachers with knowledge of painting and drawing only.

Learn as much about current classroom technology as you possibly can. Knowledge of graphic arts software may set you ahead of other applicants. If you know how to create a website or blog, that will also be useful. Familiarity with traditional slide projectors and carousels may also come in handy.

With the recent emphasis on STEAM (Science, Technology, Art, Engineering, and Mathematics) in schools, you will benefit from being able to understand those subjects and to apply art skills and concepts to them. This can work either on a basic level or at an advanced level; for example, this can include combining art and geometry, or art and physics.

You can learn about lesson planning and integrating standards by reviewing the many resources available online. Museums are a trustworthy source of lesson plans for art. This is an excellent way to learn about the themes, materials, and approaches that art educators are engaged in.

Proficiency in another language can be another valuable asset to a teacher, as is competency in teaching another academic subject. Sometimes the art teacher position at a school is part time. To be a full-time teacher, some art teachers may be asked to teach another subject. Familiarity with history, social studies, mathematics, and literature may open up more doors for you.

Another useful skill is learning how to present artwork in an exhibition. Gain experience by showing your own artwork, either in school or in local places. Volunteer for local arts organizations and help install artwork for exhibition.

Any experience working with children is very valuable, especially with art. If you have any young relatives, friends with children, or children of your own, practice by giving them art materials and projects. You can also volunteer for a local arts organization. In the summer, you can get a job working with children as an arts specialist at a summer camp. You can also tutor students on art projects or on developing an art portfolio, depending on their age.

You must have or develop good oral communication skills because you will need to express yourself clearly and effectively explain ideas. The ability to communicate in writing is essential, too, as you will write comments about your students' work and will have to put in school-wide grades.

Being well-organized and planning carefully, including doing the necessary research for your lessons, will be beneficial to your work. You should have strong time-management skills, as often there is very little transition time between class periods. Sensitivity to the needs of others and emotional maturity are other traits of a good art teacher. A sense of humor is essential. Lastly, make sure you have the passion to instill your love of creative thinking in others!

❧3❧

Teaching Post-Secondary Art

The word "college" brings to mind images of students playing Frisbee on a leafy quad amidst ivy-covered buildings and swirling fall leaves. However, this is just one of many collegiate scenarios taking place across the country. Some colleges have urban campuses, consisting of one building. They may offer classes only at night and on weekends for working adults. Still other colleges have a virtual campus, existing entirely online. However, despite these variations, they all offer an opportunity to teach students with a high level of commitment to education.

The rewards of teaching college are many: the affirming experience of working with students who are interested in art as a career, and having colleagues who are professional artists, as well as accomplished scholars in other disciplines. You may enjoy the campus facilities, taking part in college life, and having a flexible schedule. If you enjoy college life and the campus environment, you will find satisfaction in post-secondary teaching.

Most people think of college teaching as an outgrowth of teaching grades K–12. In actuality, it is an entirely separate system with little relation to secondary school. It is true that the content of the classes may be similar, especially to Advanced Placement (AP) and other higher level courses in high schools with developed art programs. However, the university system offers a very different teaching experience and has its own culture. It offers full-time careers for artists, art historians, and art educators, plus many part-time opportunities, which can supplement teaching-artist positions, or full-time jobs.

EDUCATIONAL SETTINGS

In seeking a college art teaching position, your initial considerations may reflect the time when you were searching for a college to attend as a student. For example,

there are geographical considerations, such as whether you would like to teach in an urban area or a small town. In full-time college teaching, you have the opportunity to live in places you may not have thought about otherwise. The type of school is also a consideration: Would you like to teach in an art school or a liberal arts college? These factors will deeply affect both your personal and professional life. The possibilities seem daunting, but eventually something about a college just "clicks" and you feel comfortable with its environment and philosophy.

When you delve deeper into understanding the way higher-education institutions operate, there are many other aspects to bear in mind. For example, what are the differences between an art school and a liberal arts setting? What exactly is a "teaching institution"? The following sections will help you to determine which setting is right for you.

Location

In post-secondary teaching, the geographical location will greatly affect your experience. Full-time college teaching can involve moving to new area of the country, or even a different country. You may stay there for a long period of time, perhaps for the rest of your professional life.

One of the advantages of teaching in a college or university is that you can work and live in many types of geographical areas. You can settle in an area where, in other circumstances, you might not otherwise find a full-time art job, or even have an opportunity to visit. Whether you want to stay in a familiar region, or embark on the adventure of living in a new area, the university gives you a community where you will instantly meet colleagues who can become lifelong friends.

As an artist, the location will have a significant impact on your career. For example, living in a large metropolitan area with an international art scene can be very exciting. You can see contemporary work firsthand, rather than online or in magazines. The intense competition with many other artists is stimulating and will keep you on your toes and up to date. A multitude of museums, both large and small, provide inspiration and enhance your knowledge of contemporary and historical art. Galleries, both commercial and alternative, provide opportunities for professional advancement. You can easily take your students to see exhibitions, artists' studios, and design companies.

On the other hand, living in a small town allows you to get to know other artists in a friendly, close-knit community. You can participate in galleries without difficulty, and be involved in a local art scene. If your college is one of the few in the area, then you and your colleagues will enjoy a reputation in the town as community art leaders. Living expenses will be lower, and you can have room to

work with fewer distractions. You may even be able to afford your own art studio. Many locations offer a distinctive heritage and culture that you can investigate. Some offer beautiful natural surroundings that can be an important influence on your work. The local heritage, environment, and arts community will also broaden your teaching experience.

Teaching abroad

If you seek an international experience, opportunities abound. Many American universities have branches in other countries. Some foreign universities, especially in Asia and the Middle East, hire American professors to join their faculty. Countless American universities have study-abroad programs, in conjunction with schools in other countries, where you can teach American college students in English. There are also short-term opportunities for summer, or semester-long exchanges. The Fulbright International Educational Exchange Program, sponsored by the U.S. government, allows you to apply for teaching and research opportunities abroad.

Types of Higher Education Institutions

Liberal arts

Most full-time teaching opportunities are in liberal arts universities. In this type of college, the Art Department is one of many academic departments, such as English, Anthropology, Biology, Sociology, Foreign Language, History, and more. In large universities, the art department is often big enough to be called a School of Art. The School of Art will have many specialized areas within art, while existing within the context of a larger university. For example, the University of Michigan's School of Art & Design (A&D) is one of the nineteen schools and colleges at the University of Michigan, Ann Arbor, Michigan.

The cross-fertilization of ideas that results by having professors from a wide range of disciplines working on the same campus can be exciting and may inspire new approaches to teaching and creating art, including collaboration. Imagine working with a computer programmer, a linguist, or an anthropologist for your next art project, or team-teaching a course that combines art with religion or astronomy. The students also partake in the full offerings of the university, taking courses in many academic areas, not only in art. It is fascinating to see how these areas inform the content of their artwork.

Liberal arts universities have excellent resources, including libraries with access to printed and online resources, in addition to art facilities. They may also have a gym and even inexpensive, high-quality child care.

Art school

An art school is specialized exclusively in the teaching of art and for educating professional artists. Most art schools have some general education course requirements, but they are not as extensive as in a liberal arts setting. These classes are for art students only, rather than for a mix of majors, so they can be tailored toward their needs. These institutions offer a wide range of art media and subjects, and specialized courses within each area. They have the flexibility to develop cutting-edge courses and even departments as new technologies and practices emerge. They have specialized studios and resources such as an art library. Art schools are exciting places, creating a world where art is the most important aspect of the life of the community. It is stimulating to be surrounded by artists, both as colleagues and students. Here you will find many occasions for sharing and collaborating within art specializations.

College or university

In the United States, the terms "college" and "university" are often used interchangeably. College can refer to any higher education institution. However, there are some differences. "College" usually refers to small, liberal arts institutions offering four-year undergraduate degrees. It can also include two-year undergraduate programs, such as technical and vocational schools, and junior and community colleges. A college can offer graduate degrees, which are usually master's degrees, rather than PhDs. Universities, on the other hand, offer four-year undergraduate degree programs, and graduate degree programs, including master's and PhD programs, and professional graduate schools.

Research institutions versus teaching institutions

Some universities identify themselves as research institutions. In general, research institutions are more established and prestigious than teaching institutions. However, they are fewer in number and highly competitive, with few openings. Tenure can be very difficult to obtain. The research institution's primary mission is to encourage the scholarly, artistic, and creative work of the faculty. You will be expected not only to participate in your academic specialization but also to achieve recognition. Studio artists should be involved in ongoing creative production and exhibition. Professors in video, design, and other digital arts are required to participate in film festivals, have their own design business, or engage in other appropriate professional work. Art historians and art educators must publish articles and reviews, and write books. Having your work reviewed in publications,

writing for scholarly journals or art magazines, curating exhibitions, and participating in conferences, are also important.

A teaching institution is a college or university primarily concerned with the instruction of the students. In general, there is greater focus on and support for teaching over research. Although the administration will expect that you will continue artistic creation, participation in exhibitions, and other professional activities, they will concentrate on your teaching ability when it comes to contract renewal or promotion. They will usually require you to teach more courses than in a research institution.

Public and private universities

In the United States, universities can be publicly or privately funded and, occasionally, operate for-profit. The public colleges are run by individual states. Every state has at least one state university, and some have state university systems. Some states have more than one system. These universities have a lower tuition rate for in-state students, and charge more for those coming from out-of-state. Some benefits of working for a state university include comprehensive medical and retirement benefits, and often a state pension.

Private institutions are mainly supported by tuition, endowment, and donors, and usually receive some public funding. They have higher tuition rates than public universities. They are not subject to the state budgets. Some private colleges serve a specific population, such as black colleges, women's colleges, or religious colleges. In general, less red tape is involved in planning and determining procedures. In many cases, private colleges have smaller class sizes than public universities.

Community college and junior college

Community colleges and junior colleges are two-year colleges. They are part of a state's higher education system, but are usually separate from the four-year college system. They have an open-admissions policy, and the students commute from the surrounding area, rather than living in a dorm. The two-year college forms a bridge between high schools and four-year universities. Many community or junior college students transfer to a local university after they have finished their two-year associate degree program. In art, the programs are usually similar to the first two years of a four-year college program. Often, the students have significant commitments outside their studies, such as full-time jobs or the demands of a family.

Technical schools

Technical colleges, also known as vocational colleges, specialize in teaching practical skills for a career. Some examples of related art specialties are digital video editing, graphic design, and web design.

School Size

The size of the post-secondary institution can have a greater effect on your teaching experience than you may realize. To begin with, smaller schools usually have a lower student-teacher ratio than a large university. In a small liberal arts class, you may have ten to fifteen students in a studio art class, while in a larger school, you may have twenty-five to thirty. Your approach to group discussion, critiques, and group activities will vary according to the class size. Institutions serving a large number of art students may have several sections of the same course, especially with introductory, or foundation courses. If you are teaching a section of a course that was set up by another professor, then you may be following a set syllabus rather than designing your own.

In art schools or art departments with specialized programs within art, you may be teaching specific courses within that area. For example, if you are hired to teach graphic design, your concentration may be in one aspect of design, such as typography. You might teach "History of Typography," and "Typeface Design." However, if you teach at a smaller art department, you will be teaching more general courses, such as "Intro to Graphic Design," and "Advanced Graphic Design," and possibly art foundation courses for freshmen, covering design basics such as elements and principles of art.

ACADEMIC ORGANIZATION

Universities and colleges are organized according to a strict hierarchy, which varies only slightly from one place to the next. Professors are ranked according to their experience and accomplishments. Each college may define each rank slightly differently, but the basic structure remains the same.

Lecturers and instructors, at the lowest level, are generally nontenure track, and have not completed a terminal degree. A terminal degree is the highest degree offered in a discipline, so a PhD is the terminal degree in art history or art education, but an MFA is the terminal degree for studio art. Tenure track means that the position is eligible for tenure in a specified number of years.

In higher education, usually after five to seven years, you will be eligible for tenure. Tenure means that you are granted job security despite your professional views and opinions. Once you have tenure, you can still be dismissed with certain actions or if your university downsizes, but that is uncommon.

The beginning of tenure-track positions in higher education is usually the assistant professor level. Usually, after receiving tenure, you can apply for promotion to associate professor, the next rank. The highest rank is professor, which is awarded after many years of teaching and a strong record of professional achievement. A professor emeritus or emerita is a professor who, upon retirement, is recognized for service to the university and accomplishments in the field. A visiting professor is appointed for a short period of time, often coming from another university. An adjunct lecturer or adjunct professor is hired to teach individual classes.

There is also an administrative structure: the art department will have a chairperson who is responsible for managing the daily activities of the art faculty, programs, and facilities. Above the chair is usually a dean, who runs a larger unit within the university, such as a school of communication and fine arts. Depending on the size of the school, associate deans and assistant deans assist the dean in running his or her particular area. Academic support services, such as a media center, library, or writing center, are run by directors or deans. The college or university is run by a president or chancellor.

TEACHING POSITION OPTIONS

Adjunct

As an adjunct, you will be paid for each class that you teach, probably one to two per semester, with no health benefits. Usually, you are not expected to do any administrative or other work.

Adjunct teaching has many advantages: you can concentrate purely on teaching, and not be so involved in meetings and politics. The schedule is flexible, and can be coordinated with work in your art studio, as well as with other employment, such as teaching-artist positions or art teacher specialist positions. The drawbacks include the salary, which usually does not take into account the extensive preparation time or other departmental activities, such as student art openings, or meetings. It might be difficult to find how the department or college operates, even basic information like the code for the copy machine can be hard to acquire. It may take quite a bit of time and effort to become an integrated part of the department or college.

Full Time

Another option is full-time faculty member with a certain number of courses and other duties spelled out for you. There are many benefits to full-time teaching: health insurance and retirement plans, use of the university's facilities such as the library or gym, stipends for travel and research, tuition waivers for children, paid sabbaticals, as well as summer and other university vacations.

As a full-time faculty member, you are in an environment where you can find like-minded people in the arts and other areas. You benefit from a large support system, including a library, technical support, and facilities. You get a steady paycheck and paid vacations. You have a flexible schedule. If you are on a tenure track, you are on a path toward promotion and greater pay. However, there are disadvantages. Most people see academia as an easy, stress-free support job for a studio artist. However, there are many responsibilities besides preparing and teaching classes. While tenure is a near-guarantee of steady employment, once you have received tenure, it is unlikely that you will get another academic position elsewhere. Also, art and teaching practice can get stale unless you actively engage yourself in staying up to date and seeking new opportunities.

Part Time

Part-time appointments are less common. They usually entail teaching two classes with prorated benefits and some duties in addition to teaching.

Types of Appointments and Contracts

Full-time appointments include tenure track, nontenure track, and limited term. Each university has somewhat different requirements for tenure, but they will include professional activity, teaching, and service, or participation in committees and other work of the university. If you are not given tenure, you will have to leave the university.

A nontenure-track appointment means that you are given a new contract each year, or sometimes every two to three years, but you will not be working toward tenure. Your contract could end after a given academic year. You may be offered a limited-term contract, for example, for one or three years. Professors may be hired for a sabbatical, medical, or maternity leave replacement, and for only a semester or one year, without the possibility of contract renewal. However, some limited-term contracts may be renewed providing teaching evaluations are strong, you get along well with colleagues, and you continue working as a practicing artist.

WHAT YOU WILL BE DOING

Types of courses

You may be teaching undergraduate courses, graduate courses, or a combination of the two. Undergraduate courses can include foundation or introductory classes taken by all art majors, such as an introduction to drawing, painting, sculpture, and computer design, and courses that involve the elements and principles of art in two and three dimensions. Intermediate- and advance-level classes may also be part of your teaching load, and will include electives for upper-level students, such as advanced figure drawing or ceramic sculpture.

In a liberal arts university, you may be teaching art classes as part of a general education requirement for nonart majors. If you are an art historian, you will be teaching either general art history survey courses to freshmen and nonart majors, specialized advanced classes and seminars, or a combination of both. Both art historians and studio artists teaching in a liberal arts college may be asked to teach art appreciation, usually for nonart majors.

A first-year college student works on a foundation design project about "texture."

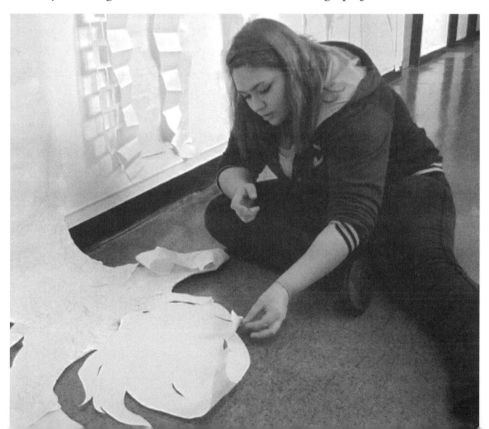

As you might expect, teaching graduate students has its own set of considerations. For example, graduate students must be held to higher standards than undergraduates. In most cases, they will already have a background in art foundations, art history, aesthetics, critiquing, and general technical skills. They will be focused on their own media, conceptually and technically. However, depending on the program, you may have students who have majored in a different area as undergraduates and they will have to catch up. If you are teaching in a graduate program, you will be teaching seminars, engaging in one-on-one critiques, doing studio visits, or teaching advanced classes.

You may be teaching in a certificate program or noncredit-bearing continuing-education program for adults. Although many graduate students, as well as community college and other college students, are balancing their education with a job and a family, all are serious and committed.

Distance learning

Many institutions offer online courses and degree programs, known as distance learning. Some institutions are devoted exclusively to online teaching. Many traditional colleges and universities offer hybrid courses, which have both classroom and online components. This is an excellent way to be involved with post-secondary education because you do not have to commute and the schedule is flexible. Distance learning opens many doors if you are homebound or live in a place with few educational institutions. You need to have a fast and reliable Internet connection, an up-to-date computer system, and knowledge and facility with online tools. This is a growing area and will offer many opportunities for you in the future.

Course load

If you are teaching full time, the number of courses you teach each semester is called a course load, or teaching load. The number of classes you will teach varies from one institution to the next. Research institutions usually give you fewer teaching responsibilities so that you can concentrate on your work as an artist. Teaching institutions have a higher course load, and community colleges generally have the largest. In general, you will have between twelve to eighteen contact hours (hours spent in the classroom) each semester. Some colleges will offer you a reduced teaching load in exchange for administrative work, such as department chair, or other duties. Each college-level studio art class usually meets for four to six hours a week. It can meet once a week, or for shorter periods twice or even three times a week.

Schedule

Some colleges arc on a semester system, while others are on the trimester system, with courses of shorter duration. Some offer courses during the summer and winter breaks.

The syllabus

In college teaching, the course planning begins with the course syllabus and calendar. The syllabus is essential for your course planning, thereby obligating you to articulate exactly what it is you are doing and what students are expected to learn by the end of the course. It helps to plan the activities, materials, requirements, and procedures for the semester. The syllabus is considered a contract between you and the students: it details the responsibilities for you both to complete the course successfully. The major components of the syllabus are the course title, meeting times and location, the instructor's contact information, a course description, goals and objectives, assessment and outcomes, a topical outline and course calendar, a list of assignments, a materials list, instructional methods, grading, and college and course policies. The syllabus includes the course schedule, which shows the students at a glance what topic they will be covering, as well as the assignments due each session.

Most colleges have a specific format for a course syllabus that they require you to follow. Some departments may have specific goals, or course content that you have to cover, but they give you freedom to create your own activities and assignments. Others may wish you to follow a detailed syllabus, where you carry out predesigned projects. The content of your course must fit into the curriculum of the department and college as a whole. For example, your course may fit into a multiyear sequence, or be part of a foundation program. If you are teaching a course for nonart majors, there will be other goals and requirements specified by the university, often to fulfill general education requirements. In any case, if you are new to a college, ask to see any syllabi for courses if they have been taught before.

Project descriptions

Most colleges do not have any particular format for project descriptions, or lesson plans, for art projects, or other classroom activities. A project can be assigned in one class and be due the next; it can last for the duration of the entire semester, or anything in-between.

The project description augments the syllabus, filling in details such as step-by-step procedures, materials, intermediary deadlines, such as "mock-up due in two weeks" or "sketches and ideas due next week." It should include the title of the project, the date it is given and the date it is due, the purpose, any technical instructions, and materials. It can include any additional reading assignments or where to go for further information. It will include any intermediate stages.

Documentation

Documentation of the students' work is necessary for both you and your department. All university departments keep examples of a range of their students' work for assessment and accreditation. Document the work before you hand it back to the students. This will be useful to you if you are applying for other positions, or going up for promotion to the next academic rank. It is helpful to include the process from beginning to end, including sketches or models, as well as the work of weaker students for comparison. Take notes on what went on during each class period because the next week, you may forget exactly what you went over, or the students' progress.

Grading

Assessment and evaluation of your courses will be an ongoing process. You may wish to use rubrics to evaluate the students' performance. Some professors prefer to grade portfolios of work, while others grade individual pieces.

Teaching Assessment

Toward the end of the semester, you may receive college course evaluation forms created by the school, which you will need to hand out to the students and have them fill out while you leave the room. A chair or dean will review the results of these evaluation forms with you. You may have a colleague or administrator observe your teaching and write an evaluation. If they are positive, ask for a copy to use when you apply for tenure or promotion, or apply for jobs elsewhere.

You may want to consider getting student feedback for your own use. If you get feedback early in the course, you have time to make adjustments before the class is over. In addition, because the results are for your eyes only, you do not have to worry about negative comments counting against you in any way. Ask the students about specific aspects of your course, such as the pacing, level of difficulty, clarity of presentations, and interest level. Self-reflection can be an important part of the evaluation.

Teaching Assistants

You may have the opportunity to have a graduate teaching assistant, who will work with you in your course. You will meet with the graduate student before the course begins to go over course policies, content, and his or her role as your assistant. Usually, the assistant takes part in critiques, helps students individually, sets up the studio, takes care of facilities, and sometimes grades work. He or she may teach classes alone without your presence. You may be training and supervising graduate teaching assistants charged with teaching sections of an introductory course.

Team Teaching

Collaborative, or "team teaching," presents many opportunities for creativity in your pedagogy. You may teach with another art professor, or, if you teach in a liberal arts university, with a professor in another academic area such as science or English. Many schools encourage interdisciplinary teaching, especially when it deals with cutting-edge technologies or current topics.

Online Tools

There may be an online component to your courses. Many colleges have an online course management system for you to upload your syllabus, readings, course calendar, and links to websites. You can manage attendance and grades on it, and have blogs and Wikis. It will help you save time by allowing the students to access information around the clock, and it may also be an important skill for your future career.

Responsibilities Outside of Instruction

There are many opportunities to get your students involved in their future professions outside of class. For example, you might organize field trips to local museums, art galleries, graphic design or animation studios, and artists' studios. These could be for just your class or include an entire department or school. You may bring in guest artists who can give a lecture on their work, critique classes, and give demonstrations.

Mentoring

You will be asked to mentor students on their exhibitions and advanced undergraduate or graduate projects. If you are an art educator, you may supervise student teachers. If you are an art historian, you will advise their theses. Sometimes,

students will sign up to take an independent study with you. You may be working with students on their undergraduate or graduate thesis exhibitions. There are also many other student art shows and receptions that you will be organizing. These responsibilities may or may not be part of your teaching load.

Internships

Most college programs include internships, which are often required to graduate. You will help the department build relationships with local artists, museums, and businesses to place students. You may also be supervising, mentoring, and evaluating the student during the course of the internship.

Office hours

Every university requires that the professors maintain regular office hours. A specific number of hours are required, usually three to five, but you can choose when to have them. Office hours are times when you are in your office with your door open, ready to assist students with course work, answer any questions, or give advice on careers.

Equipment and art studios

Because an art department has specialized equipment and art studios, you may be involved in overseeing the maintenance and purchasing of equipment for your area, especially in a smaller college. Your duties may include supervising student workers, graduate assistants, and studio assistants, making recommendations for supplies, and making sure everything fits within a set budget. You may need to ensure that the studios are cleaned and organized, that the students have a secure place to keep their work, and that you have sufficient supplies. You must be sure that all safety requirements are being met.

Advising

Advisement is part of the full-time faculty's responsibility. A list of advisees will be assigned to you. You will help these students chart their academic course, as well as helping them choose a graduate school and make other career decisions.

Another opportunity to be involved with students is to advise a student group. There are many activities such as art club, yearbook, literary magazine, or newspaper, all of which could use the expertise of someone with your talent and skills. It is also a fun way to get to know students outside the classroom while working toward a common goal. There may be a student chapter of a professional associa-

tion, such as AIGA (American Institute of Graphic Arts) or NAEA (National Art Education Association). If the school does not already have a student chapter, you can help to start one. As advisor to a student organization, you can help students gain valuable leadership skills as well as contribute to the community.

Recruitment

Art faculty are closely involved in recruiting new students. You may be asked to talk to potential students about your department and school at recruitment events on- or off-campus. You will also review and critique the portfolios of prospective students. You might be in charge of recommending talented students for scholarships. This is a wonderful opportunity to stay in touch with the work that young artists are doing in high school, and you can learn about their interests. You can also help to shape the future of your department by encouraging the prospective students whom you would like to teach. You may also be involved with designing admissions brochures and a website for your department.

Participation in the university or art school

Full-time faculty are expected to serve the university, or participate in faculty committees, and perform research. For an artist, research means engaging in creative activity and exhibitions. For an art historian or art education professor, this means publications. The amount of service and research you do will center around whether you are an adjunct (no service required), full-time, temporarily appointed, or tenure-track teacher. It will also depend on whether you are at a teaching institution or research institution. However, all full-time, and even some part-time, faculty have these responsibilities in addition to teaching. Keep an ongoing list of committees, community service, and professional activities because when you apply for tenure and promotion, or apply for positions at other institutions, it may be hard to remember everything you did during your first year or two. And again . . . make sure you document everything!

Service to the university

If you are a full-time college professor, you will be expected to contribute to your department, division, and college community. Universities have a unique system called faculty governance, in which faculty participate in setting procedures, policies, and curricula for their institutions, and even in hiring their own colleagues. This is not only part of your job, but it will also help you learn how the university works, and meet and get to know other faculty, staff, and administrators. Some

committees are involved with setting policies for the entire institution, and others, just for your department. You will be expected to be involved with both types. You can be appointed or elected to a committee, or volunteer. You can also initiate your own committees. Some committees meet weekly, some monthly, and others only once a semester or once a year. Some do short-term projects, and others are ongoing over a period of years.

Community service

Most colleges prefer that you be involved with the external community. This could be jurying a local art exhibit, volunteering in a local school, giving lectures, or creating pro-bono design. This also includes maintaining active membership in a professional organization in your field.

Research and professional activity

Research in an academic context means professional work in your discipline. One of the benefits to college teaching is that your work as an artist is actually recognized as part of the work you do for the university. However, it is a significant challenge to prepare for classes, teach a full schedule, join committees, and still have time left over to create work and participate in exhibitions or publish in scholarly journals. As with your service, make sure that you document all of your exhibitions, fellowships, lectures, residencies, and other professional work thoroughly, because you will need it for contract renewal, promotion, and applying for other positions. You may be able to apply for external and internal grants to support your projects. You are expected to stay updated in your field, by attending conferences, reading art magazines and reviews, visiting museums and galleries, and understanding current technology.

WHAT YOU NEED TO GET THERE

Education Requirements

In general, post-secondary institutions require an MFA for Studio Art, Design and Digital Arts. For Art History or Art Education, a PhD is required, however, if you are ABD (all but dissertation) you may be hired with the expectation that you will finish your dissertation with a set time period. Occasionally, professional experience can be substituted for some educational requirements. Some institutions, especially art schools, might hire you without an MFA if you are a very well-known artist, with a strong exhibition record. Alternatively, if you are recognized in the design field, you may be considered for a position if you have a prestigious

list of clients and awards, rather than an MFA. In some institutions, a master's degree is satisfactory for adjunct positions with sufficient related experience.

Community colleges usually require a minimum of a master's degree, with a certain number of credit hours taken in an area of specialty. Technical or vocational colleges generally value professional experience, such as running your own successful design business for many years, or having an impressive client list.

Professional Experience

Colleges and universities will prefer, and sometimes require, professional experience in your particular area. That could mean exhibiting artwork, maintaining an art studio, professional experience as a designer, museum work, or other expertise in what is directly related to the teaching position. They will also value any published writing or presentations at conferences and other events.

Teaching Experience

Like other types of teaching positions, post-secondary teaching presents a quandary: most positions require teaching experience, even for the entry-level. Many ask for teaching experience beyond a graduate teaching assistantship. Full-time positions nearly always ask for a professional track record.

If you are interested in teaching college-level art, and considering enrolling in a graduate program, check out the graduate-teaching and teacher-training opportunities beforehand. Graduate art programs granting an MFA see their primary responsibility as educating artists, rather than teachers of art. This is in spite of the fact that many artists attend graduate school to earn a degree, which will help them land a teaching position. Most graduate art programs offer little, if any, teacher training, although this is gradually changing. If there is preparation for college teaching, it varies greatly with each program: some offer teaching experience with coursework and mentoring, while others have seminars or workshops.

A graduate teaching assistant position will give you the opportunity to gain valuable teaching experience, and a paycheck as well. The amount of supervision and mentoring you receive depends on the program. It can include regular meetings with the faculty, information on writing syllabi, and classroom management techniques. Some programs have required courses or workshops for teaching assistants.

Whether or not you are in graduate school, volunteering to teach will help you gain a foothold in college teaching. Try to gain experience working with older teens, college students, or adults. You can volunteer with local community-based organizations, museums, continuing education programs, and community

colleges. Take the initiative to look for jobs that are not advertised in your graduate program. You can also look for a paying job with these organizations.

If you seek a full-time college-level teaching position, an adjunct position is a good place from which to launch a full-time career. An adjunct faculty position is not necessarily a stepping stone to a full-time position at the same institution, but don't rule it out. It is excellent experience toward a full-time position at another place, and opens doors for other adjunct positions. If one of your colleagues knows someone at another school who has an opening, they will recommend you for it. Once you obtain an adjunct position, participate in outside activities as much as possible, including field trips and student art exhibitions. Be as visible as you can and act as though you are a full-time faculty member.

Recommendations and Skills

Oral and written communication skills are of utmost importance. You will need to maintain contact with students, colleagues, and members of the community. In a liberal arts school, you will need to communicate the purpose of teaching and learning art to colleagues in nonart areas. Writing is crucial for syllabi, course proposals, course descriptions, and reports. Grant-writing skills and experience can make your application stand out amongst the others.

Technological skills, such as knowledge of course management systems, as well as the ability to utilize current computer art software, will also help to place you ahead of other applicants. Even rudimentary knowledge of web design and web-design software will be helpful. Creative use of social-networking and other current technological trends will make your application appealing.

You should be self-motivated and a team player, but also able to take initiative and work independently. You will be expected to work with others, but also be able to stand up and advocate for your area and what it needs to be successful.

4

Outside the School Setting: Museum Education

If you've always enjoyed museums and wondered what it would be like to work in one, then working as a museum educator might be the perfect job for you. As a museum educator, you can share your passion for learning, teaching, and the arts with the public. Museum educators interpret the collections for all visitors so that their experience is rewarding, memorable, inspiring, and enjoyable. They help connect visitors' experience with their daily lives, stimulate further thinking, and foster a deeper understanding of the works on display.

Museums educators work with visitors of all ages from all walks of life, including families with small toddlers, children, teens, adults, and older adults. They welcome people from all cultures, abilities, and educational backgrounds. Educators help make new visitors feel welcome, rather than intimidated. They also inform highly educated audiences, who are very knowledgeable about the collection. Museum educators engage the surrounding community and local schools. They include visitors with mental and physical challenges by offering special programs.

In the past, the museum visit was a formal one, separate from daily living, and seemed daunting or dull to many potential visitors. Today's audience anticipates an interesting, fun, and educational experience. They expect to find objects they can touch, activities they can participate in, and events they can attend. They want to understand what they are looking at and connect their museum experience to their daily lives. The museum educator helps shape their visit into a fulfilling learning encounter.

Despite the state of the current economy, museum education departments are thriving, growing larger and more sophisticated in recent years. New museums are including educational centers within their building plans, and older ones are adding them or enlarging previous spaces. Depending on the size of the institution, these centers may include classrooms, art studios, resource centers, exhibition spaces, auditoriums, and libraries. New technologies allow visitors to interact with the museum without even visiting the actual building.

Museum educators develop new audiences, ensuring that the museum will continue to grow and prosper in the future. Bringing in visitors, and articulating the educational goals for the museum, supports the financial development of the museum by attracting donors. They can understand how specific exhibitions are educating the public and enhancing their daily lives. This funding is crucial to maintain and augment the permanent collection, and bring in new exhibitions.

The role of a museum educator is important, rewarding, and complex, and requires you to wear many hats at once. If you love to learn, and thrive in the museum setting, this may be for you. While every museum education department has a different structure, size, and focus, one thing that can be assured: you will always be learning, as exhibitions are continually changing.

EDUCATIONAL SETTINGS WITHIN A MUSEUM

There are many types of museums, each offering its own unique visitor experience. In fact, museums exist for almost every subject, no matter how great or small. While art museums comprise the major employers of art educators, the other types may offer opportunities for you as well. Consider employment in a museum with a collection in which you have specific knowledge or interest.

Art Museums

Art museums are the largest employers of art historians, artists, and art educators in the museum world. Most of this country's most famous, largest, and oldest museums are art museums, such as the Metropolitan Museum of Art in New York City and the Chicago Art Institute in Chicago, Illinois. Some art museums emphasize traditional art forms, such as painting, sculpture, drawing, photography, and printmaking. Others include newer forms such as installation and video, and strive to break new boundaries in what is considered art. The museum educator enjoys the challenge of introducing unfamiliar and challenging new artists, and also finding new approaches to discussing historical works.

Museums show works from a variety of time periods. Some art museums survey art from all of art history, including most countries and time periods, such as the Metropolitan Museum in New York City. Others are very specialized, exhibiting works from a specific time, such as the Whitney Museum, whose collection is limited to the twentieth and twenty-first centuries. Certain art museums focus on specific countries or cultures, for example, the Rubin Museum is dedicated to Himalayan art, while El Museo del Barrio shows art from Latino, Caribbean, and Latin American cultures. The Visionary Art Museum in Baltimore, Maryland, exhibits "outsider art," by artists without traditional art training.

Art museums can focus on a particular media, such as The Drawing Center and SculptureCenter, both in New York City. The Massachusetts Museum of Contemporary Art (Mass MoCA) in North Adams, Massachusetts, is housed in a large, renovated factory space, and specializes in very large-scale art installations. The Corning Museum of Glass in Corning, New York, is dedicated to all aspects of glass, including contemporary and traditional works, technical aspects, and the culture and history of glass objects.

Regional Museums

Regional museums, usually small in size, are often established by a group of community members. They were founded to be the cultural center of a community, town, or area. Exhibits may range from well-known artists to children's work from a neighborhood school. These museums have close ties with other local cultural institutions and community organizations.

Regional museums may focus on subjects of local interest. They seek to establish and share the region's identity, which could be cultural, historical, or related to particular artists who lived and worked there. Some museums, such as the Museum of Fine Arts, in St. Petersburg, Florida, focus on global and local artists from throughout art history, including contemporary practice. Other museums have multiple specialties such as the Lakeview Museum in Peoria, Illinois, and the Hudson River Museum in Yonkers, New York. Their collections and exhibitions include art, science, and artifacts important to local history and culture.

Children's Museums

Children's museums differ from other kinds of museums because they invite visitors to touch and interact with objects and displays throughout the building. These museums are engaged with a particular age group, rather than with a culture, subject, or media, and they are less concerned with a collection than with

teaching and stimulating the minds of children. Subsequently, they offer many opportunities for artists, usually with a specialty in early childhood education and elementary school education. This is an excellent choice if you enjoy interacting with young children.

History Museums

Almost every town in the United States has at least one historical museum, site, historic house, or society. Like art museums, they can range from very specific to general subjects. They use historic objects and buildings to teach about the region's heritage. The Shelburne Museum, in Shelburne, Massachusetts, uses a collection of buildings in addition to objects to weave a complex story of the region's history. It even includes a train and a boat as part of its collection. While most of the staff at these museums have a background in history, they sometimes employ artists in their education departments.

Science Centers

Educators in the sciences fill a valuable role, translating complex scientific concepts into enjoyable and comprehensible activities for all ages. They usually have a science background, but if you have knowledge of science as well as art, you may find an opportunity here. Science centers are at the forefront of high-tech educational interactive displays, and are a good place for people with a specialization in design and technology. Some are actively involved in integrating art in STEM (Science, Technology, Engineering, Mathematics) subjects to create the acronym STEAM (Science, Technology, Engineering, Art, Mathematics).

Natural History Museums

Natural history museums generally employ people with experience and education in the natural sciences, but they can offer opportunities in developing art projects relating to the collection and working with educational displays.

Other Museums

There are many other museums in your community that do not fit into any specific category but may employ art educators. For example, a transportation or train museum may need an art educator to lead family art projects and family days, especially one who has experience in special education. Another example of a specialty museum is the Spy Museum, in Washington, DC.

Digital Resources

All museums are involved in using current technologies to expand their educational missions to an audience beyond the local one. You may be involved in developing the museum's website to include educational programming, including listing information about the offerings. Many museums have teacher guides, lesson plans, curricula, and online courses for educators who may not ever visit your museum in person. They are increasingly involved in producing online activities, games, and apps. The National Gallery of Art in Washington, DC, has online tours, including a web tour of the week. They have many lectures and events available in audio or video podcasts.

Museums are increasingly active in social media to publicize their programs, and to encourage visitor participation outside the museum walls. The museum staff, including the education department, can participate by writing blogs about their work. For example, the Rubin Museum, New York, allows you to view all aspects of their educational process through their education blog.

Digital processes are not limited to the online world: you may work with digital producers on creating an educational game, film, or kiosk you've designed for the exhibition gallery.

School Programs

One of the primary functions of a museum education department is coordinating programs with local schools. Even the smallest department will have tours for school groups. Most museum education departments have a coordinator of school programs, and larger departments have a group of educators working in this area.

These school programs can range from a one-time tour for a school group to an in-depth program involving multiple visits to the museum. The museum educator strives to connect the museum visit with other aspects of learning, rather than it being an isolated experience. He or she develops a curriculum and other educational programs to tie the school visit to the museum's collection. These activities can be on a subject or theme. Or, they can cover topics specific to art: art materials, techniques, art history or aesthetics. They can integrate another subject, such as science or history.

As a museum educator involved in school programs, you will work closely with local schools, including administrators and individual teachers. You may create curricular-specific lesson plans. Knowledge of state educational guidelines and standards is crucial so you can tailor the lesson plans to the teachers' curricula.

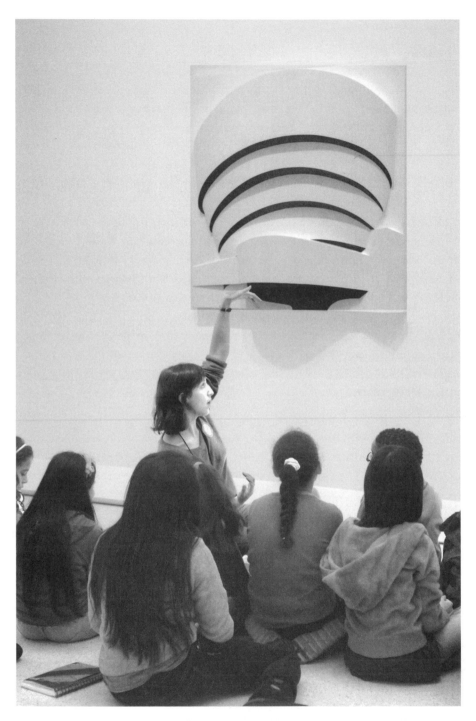

Fourth grade students from PS 86 discuss a work of art in the galleries of the Solomon R. Guggenheim Museum. Photo by Tanya Ahmed.

Museums offer outreach programs where a specially trained teacher goes to the school. These programs can take the form of individual presentations, workshops, and a short-term course. Some offer a long-term studio art program, involving eight to fifteen sessions, by a specially trained teaching artist. The Guggenheim Museum, in New York City, pioneered this in-school residency model, with its program Learning Through Art. Many other museums have developed programs based on this model, often with a similar name.

You will also prepare activities for the school visit. Often, there are kits or "trunks" that the museum educator can bring along to the classroom. You may create materials that you will send the teachers before the visit, and afterward, as a follow-up. You may be developing resource packets, including background information, vocabulary lists, and CDs or websites of images. Activities using the museum's collection can be done for homework, such as having them research objects and present them to the class.

Home-School Programs

Many museums have special programs exclusively for homeschooled students. These can be workshops, classes, and online activities. Some schedule programs for homeschooling cooperatives. Usually structured around a theme or subject, the programs last about ninety minutes, and include a museum introduction, gallery tour, and a hands-on activity. There may be follow-up projects to do at home.

Gallery Tours

Museum educators create tours of special exhibitions and permanent collections. You may be developing these tours, guiding tours, and overseeing tour guides. Museum tours can be designed for seasonal themes, or particular subject matter, such as portraits. They can cover certain historical time periods. In addition to interpreting objects and themes, tours can also include discussions. Depending on the time available, they may involve activities, such as games or art projects, presentations, reading, writing, storytelling, and objects for touching and close examination. Some museums offer brief "express" or "focus" tours, sometimes during lunch hour, for those with less time available.

Through tours, museums accommodate a variety of visitors. Nearly all museums offer tours for school groups in grades K–12, and many offer them for college and university students. If the museum is large enough, they hold regularly scheduled tours for general visitors at large. They may offer tours for specialized populations, such as families with children, or people with disabilities. Sometimes they offer tours in languages besides English. While most tours are guided, there

are also self-guided tours and audio tours. New technologies, such as iPods and smart phones, are becoming increasing popular for self-guided tours.

To develop a tour, you may work with curators and other museum professionals to decide on the learning goals of the tour and which objects to focus on. If you have classroom experience, it will come in handy. Whether you are training others, or directly leading the tour, you will need to enforce proper museum etiquette, making sure people do not touch or get too close to the objects, do not make too much noise, or interrupt the flow of visitors.

Docents

In many museums, tours are led by special volunteers called docents. Docents are a great asset to the museum, and are very committed to the institution over the long term. They are often chosen through a competitive application process. In some places, they are often the only people who interact with the visitors, and can form the visitors' experience and their opinion of the institution.

You may be in charge of recruiting, training, supervising, and scheduling docents. The docents' training includes information about the collection, history, and mission of the museum, presentation techniques, pedagogical instruction, and more mundane issues such as the location of the bathrooms and cafeteria.

In return for their enthusiastic commitment, the docents expect their training to be a learning experience for them. In addition to special lectures and workshops, and free tickets to events, museums also offer recognition programs, such as a reception for the docents.

"Ask Me"

Educators, who can be paid staff or docents, stand at strategic locations around the museum to answer questions or offer information about the objects. They are available for casual conversation and engage the visitor in a dialogue with the museum and its exhibitions. They are specially trained to make the new visitor feel welcome, or help with especially challenging content.

Classes

Museums have courses for all ages: preschool programs, children's programs (ages five to twelve), teen programs, college programs, family programs, and adult education. There are also summer camps for students on school vacations. Some courses are multisession, sequentially based classes on a media or theme, and others are day or weekend-long workshops. As a museum educator, you may be developing

the curriculum for these programs, instructing the teaching staff, and teaching the classes. Teaching artists are often hired as independent contractors to teach these classes.

Family programs are informal drop-in sessions, usually involving a hands-on activity encouraging both parent and child participation. These courses incorporate learning about the permanent collection or a special exhibit through making art. Often the students go to the galleries to view, discuss, and learn about the works, followed by a related project.

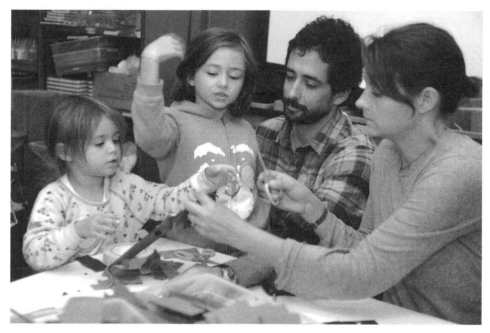

Family Tour and Workshop at the Solomon R. Guggenheim Museum. Photo by Enid Alvarez.

Many museums offer adult courses, such as studio art or art history. Usually they are not for a degree, but some museums do offer degree-granting programs, sometimes in conjunction with a local college or art school.

Adult Programs and Events

You may also be involved in organizing events for adults, such as concerts, lectures, films, symposia, and performances, many of which are outside regular museum hours. Most of these relate to the museum's collection or a special exhibition. Museums offer social opportunities such as singles events. Some organize travel

programs with tours by museum staff. Although the museum educator may be presenting some of these events, his or her main role is in organizing them.

Professional Development Opportunities

A common role of a museum education department is professional development. Museums have workshops to teach school educators how to lead courses effectively involving the interpretation of their collection. These teacher institutes or teacher workshops usually take the form of weeklong seminars in the summer, or weekends or weeknights during the school year. Participants can come from the local community or beyond.

In many states, certified classroom teachers must take continuing-education courses to renew their teaching certificate or get to the next level of certification. They can get points toward certification or recertification through these workshops. Some workshops can be taken for academic credit.

These courses may combine lectures, guest speakers, discussions, hands-on activities, and gallery talks. In addition to planning the workshop itself, you will need to prepare materials for the participants to take home, such as sample lesson plans and curricula, as well as resource kits, which include images from the museum's collection and brochures. Workshop planning should allow plenty of time for questions and reflection, and allow participants to try the methodologies you have introduced.

Innovative practices outside the art community

A growing avenue in museums is using art educational strategies to increase competency in professions outside of art and education. Inquiry-based learning strategies, used in conjunction with museum collections, are employed to teach observational skills, creativity, critical thinking, team building, visual literacy, communication, and even healing. These programs are taught either by museum staff or freelance specialists. These educators usually have a strong background in art history.

One innovative practice partners museums with medical schools to use the art collection for training medical students and professionals. Enhancing observational skills by using works of art helps medical professionals in the clinical environment. Their enhanced ability to observe patients increases their diagnostic skills. This program began in 1999, at the Yale Center for British Art by Curator of Education Linda Friedlaender, in partnership with Professor Emeritus Irwin Braverman at the Yale University Medical School. Their controlled study was published in the *Journal of the American Medical Association* in 2001, inspiring other collaborations between museums and hospitals.

Museums and educators have created other applications for using art strategies to enhance professional development. Lawyer and art historian Amy Herman utilizes the collection of the Metropolitan Museum to train New York City police in observational awareness. The Chicago Art Institute offers The Discerning Eye program for detectives as well as medical professionals. They also have the At-Work program, in conjunction with a local organization, Catalyst Ranch, for training business corporations in team building and creativity.

Family Days

Popular family days are special daylong events that include activities for children and adults to enjoy together. Based on the museum's collection or mission, they celebrate a special exhibit or holiday that pertains to the museum. For example, the Rubin Museum has family day in observation of the Tibetan New Year in February. The Asia Society in New York City celebrates the Hindu Festival of Lights (Diwali).

Family days take place once or twice a year, often including theatrical, dance, and musical performances, and art activities for children. Some performances are for watching, while others include participation. Even the cafeteria gets involved by offering special food. These events need extensive planning to coordinate the theme and activities, and to work with other community, cultural, and arts organizations.

Access Programs

Museums have specialized tours and art-making programs for individuals with disabilities. If you have training in special education, or an interest teaching people with physical or mental challenges, you may be particularly interested in this area.

Large, well-funded museums have specific programs targeted for different types of individuals with special needs. Some even have Access Departments devoted to developing and implementing these extraordinary programs. The Museum of Modern Art, which has one of the largest access departments, offers programs specific for individuals who are deaf and hearing impaired, visually impaired, or have developmental or learning disabilities, or dementia. The Guggenheim Museum also has specialized tours and activities, such as a sight and sound tour, and painting workshops for the blind or partially sighted. Some museums work with individuals as well as groups. If museums are not able to offer tours and activities, they accommodate a range of abilities through their regular offerings for individuals wishing to explore the museum independently.

Museums have special learning tools, called touch objects. These can be models of works from their collection, including models of sculpture or models of paintings that have a raised surface. Museums have sample materials for touching, such as sculpting, painting, and craft materials, and artifacts from the collection. Large print materials, magnifiers, and audio tours will facilitate access. Tours led by guides, or audio tours, can include verbal descriptions to aid individuals who are blind or visually impaired.

Museums have recently discovered the potential of art education programs for individuals with Alzheimer's disease to unlock long-term memories, provide stimulation, and promote supportive, social activities. New York City's Museum of Modern Art (MoMA) pioneered these popular programs, with its "Meet Me At MoMA" series. MoMA has inspired other museums, individuals, and organizations on how to use the museum's collection for Alzheimer's patients, their caregivers, and their families.

Other specialized programs include sign-language interpreters, sign-language tours, and FM-assisted listening devices for the deaf and those with hearing impairments. Individuals who have mobility impairments can be accommodated by special tours and materials which clearly indicate accessible galleries and facilities. Self-guided tours, available online or in the galleries, can assist individuals, including those with hearing impairments, to learn at their own pace.

Educational Spaces

Learning galleries

Exhibitions often include learning galleries within them. These spaces, set apart from the exhibition, provide educational materials with more detailed information than in the galleries. These can include books, exhibition catalogs, computer stations, videos, and children's activities.

Activity stations

Carts may be set up around the museum with objects to touch and examine, or activities to engage in. Docents or interns often staff these stations. You may be involved in creating them, designing their purpose and function, and managing the staff.

Libraries and resource centers

Libraries and educator resource centers, which are open to the public, or to local educators, are housed in museums. These facilities are often run by the education department.

Working with Others

Working with artists

When artists have exhibitions at a museum, the educators there may work with them to develop workshops and lectures to augment the exhibitions. Some museums invite artists to come in and discuss how a piece of artwork, an artist from the museum's collection, or the mission of the museum influenced their work. Certain museums host artists-in-residence who create artwork in situ in the museum and provide educational programming during this time.

Working with museum staff

You will be working under the guidance of the head of the education department, who is either called the director or the curator. He or she oversees all educational programs, projects, and staff. The director works with curators, directors of development, and other department heads at the institution.

You may also have the opportunity to work with other departments, for example, curators, marketing and communications departments, editors, development, and visitor services. You may meet with exhibition designers and graphic designers, either in house, or from other companies. Exactly how often and with whom depends on the size and organization of the museum's staff. For example, you might attend a meeting held once a month to share information, or work on a team to create a new exhibition.

Working with partnering organizations

Museums have partnerships, or agreements, with many other institutions, such as universities, and other art and cultural organizations. For example, you may join forces with other museums to create programming and events on a particular theme. You may collaborate with libraries to share resources, or launch literacy programs. Partner with the parks department and city government for outdoor art events or to be included on a tour or a citywide event. Collaboration with a symphony can infuse a regular music series into your programming. You can work with a local university to develop a lectures series, conferences, courses, and internship programs. Partner with public schools to take part in long-term or regularly scheduled residencies in school. Community-based organizations partner with museums for cultural festivals and other community and cultural events both at the museum and off-site. This engagement encourages visitors who might not otherwise come to the museum.

Grant Writing

Although the museum's budget will support most of your educational programs, it may not cover everything that you would like to do. Often, the museum educator must seek additional support from grants and donors. You may be working with the museum's development office in fund-raising. Reach out to local businesses for sponsorships and donated supplies, and be sure to let them know about the exposure and positive publicity they will gain from their generosity. Local, state, and federal governments are excellent sources for funding.

Evaluation and Assessment

Museums need to evaluate their educational programs. This informs donors and other sources of funding on how well their money is being spent. More importantly, it is necessary to see if the education strategies are effective and how the design and content of the exhibition can be improved. There are many methods you can use, such as visitor surveys and focus groups. Observations will indicate which aspects of the exhibit draw their attention, and where they get frustrated, lost, or bored. Museums sometimes implement visitor studies in observing visitors as they go through the museum, view a particular object, or interact with exhibition material. There are also outside agencies which can implement visitor research studies, and strategies for evaluation and assessment for museums.

ESSENTIALS TO INCLUDE

You will be developing educational resources and programs in a museum to reach a diverse range of visitors.

Learning Strategies

Museum educators employ a variety of strategies in discussing the works with the public. This can range from lectures to informal discussions. The amount of visitor participation depends on the setting. For example, an auditorium does not lend itself to discussion. Other factors in determining the educational strategies include the type of collection, amount of time available, purpose of the activity, and philosophy and mission of the museum as a whole.

Object-based learning

Museum teaching is object-based. This means that actual objects, and their materials, form, and structure are the foundation upon which all educational programs are based, whether it be a tour, discussion, or other activity.

Inquiry-based learning

Museums commonly implement inquiry-based learning strategies. This method stimulates the visitor's thought process by posing open-ended questions that do not lead to a particular answer. Facilitated conversations actively engage the visitors to form personal connections with the objects. For example, it might start out asking the group to take a few moments to observe the artwork. Then you might invite them to describe what they are seeing. Next, you might encourage the group to delve deeper into their description toward grappling with the meaning of the work, by welcoming all ideas, suggestions, and responses to others' comments. The background information that you have about the art and its context can intensify their discussion and deepen the interpretations they uncover as the meanings emerge.

Visual Thinking Strategies (VTS)

Visual Thinking Strategies (www.vtshome.org) is a type of inquiry-based learning method that does not include any contextual information about the object. The meaning is constructed entirely by visitor observation, questioning, and discussion.

Learning styles

Incorporate a variety of learning styles into your programs. You can incorporate writing, drawing, lecture, discussion, and even music. Your activities can include handling objects and movement exercises. You can use your creativity. Of course, be aware that not all activities are appropriate for every space.

Informal learning

Museums specialize in informal learning, or learning outside of a structured environment. Visitors explore and learn at their own pace, their interests arising from whatever objects strike their particular interest. The visitors choose to pursue the avenue most interesting to them and learn from their own experience rather than from someone else's.

Reaching Visitors with Special Needs

Museum educators utilize the power of art to reach people of all abilities. As a museum educator, you are an advocate for all visitors. People with disabilities form a significant portion of the general public. Visitors include individuals who

are mobility-impaired, hearing-impaired or deaf, visually impaired or blind, or mentally challenged. They participate in all aspects of museum programming, not just access programs. People rarely identify themselves as belonging to a disability group when they enter the building. Disabilities occur in a wide range from mild to severe, and many individuals have a combination of disabilities and do not fit neatly into a particular category.

Museum Manners

You will not have extensive classroom management issues as an art teacher in a school because the participants attend by choice, and sessions last for a limited time. However, your visitors will include first-time museum goers, young children, and student groups, who are not familiar with museum etiquette and rules. You will have to make sure that the collection does not get damaged and that activities do not disrupt others visitors. You will have to monitor this without turning people off from their museum experience.

FURTHER IDEAS TO EXPLORE

Museum educators are often given responsibilities outside the immediate realm of education. For example, you may be charged with assisting visitors and working at the front desk. You may find yourself involved in marketing and managing volunteers. Be prepared to travel to conduct programs off-site, such as in local art centers, or schools. With the exception of school tours, most programming occurs when visitors have free time, such as weekends, holidays, and evenings, so that may be part of your regular schedule. You may also need to warn parents and teachers of children about exhibitions with adult content.

Museums have full-time, part-time, and freelance positions, such as teaching artists and other independent contractors. Some museum educators work on a freelance basis at a variety of museums.

Pros and Cons

The museum environment provides constant intellectual and creative stimulation. You are surrounded by objects that inspire and challenge you. The exhibitions continually change, presenting a steady stream of fresh learning opportunities. There are always new people coming in, bringing new diversity. The participants in museum education programs are enthusiastic and appreciative. They have sought out the program and made an effort to attend. The work is flexible and varied. You do not have to grade projects.

However, you don't get to see the long-term development of the visitors over time, or engage in long-term relationships as you would if you teach in a school full-time. The positions can be very competitive and require relatively high educational standards. Salaries are generally lower than in public schools.

Large and small museums have different advantages. In a small museum, you may get the opportunity to work closely with other departments, and see what they do firsthand. You can initiate and develop your own projects and move into areas of more responsibility. You will gain a close relationship with the visitors, and forge relationships with the community. Advancement within a small institution may be limited, but once you have gained experience, there will be positions at other museums to which you can advance.

In a large museum, there are many opportunities to work your way up to a higher position within the same institution or enjoy a new challenge with a lateral move to a different but related job. You may also move to a different museum. In general, a large museum has more funding for exhibits and also for education.

WHAT YOU NEED TO GET THERE

Educational Requirements

The educational requirements for a museum educator are less specific than for a K–12 art specialist teacher in a school. Employers require a bachelor's degree in studio art, art history, art education, education, or any other degree related to a museum's particular collection or mission. You should have coursework related to the subject of a museum's collection, whether it be an art museum, or a museum of another subject area, such as science.

A master's degree is preferred, but often not required, for many entry-level positions. Master's degrees are usually in museum education, art education, education, art history, or studio art. Once you have an entry-level position, a master's degree is generally necessary to move up to a higher level in the profession. Universities offer online or hybrid master's degree programs in museum studies to accommodate working professionals. Others offer accelerated master's degree programs with classes on evenings and weekends.

Teaching Experience

The amount and type of required teaching experience varies with the individual museum, and the particular position. Most museum education jobs request teaching experience, either with children, adults, or other age groups, depending on the job description. Many call for knowledge of state standards in art. Positions

working directly with K–12 school programs expect the most teaching experience, including classroom experience and, occasionally, certification.

If you have at least some teaching experience, you will be in a better position to be hired for a museum education job. This can be student teaching, teaching in an after-school program, or through an organization such as Teach for America. A variety of experiences are useful; for example, teaching different students with different backgrounds, ages, and abilities will help you with the diverse nature of museum visitors. For many positions, working in a day care or camp offers valuable experience.

Art classroom skills are central to any position that requires teaching. Classroom management experience will help you to understand the dynamics of the group tours and art workshops at the museum and to handle difficult individuals or situations. Teaching strategies will help you to reach the wide range of individuals you will encounter. You should know how to create a lesson plan, and be knowledgeable about state standards even if you do not have art teaching certification. You can learn how to do this on your own through the many resources on the Internet and in print. See Chapter 2 and the resource section.

Knowledge of classroom art materials, where to purchase them, and how to set them up will be useful. You should be able to create a budget for your art studio projects. Time management in the classroom is essential because you will need to plan tours and art activities that can be completed in a very short period of time, without rushing or frustrating the participants.

Internships and Volunteering

For a career in museum education, the entry-level position is the most difficult to obtain. Without a doubt, the best route to this "foot-in-the-door" is through an internship. Although internships are the surest route to a paid position, you may also volunteer, or be a docent. These positions, usually nonpaid, may be very competitive, depending on the location, size, and reputation of the museum.

Each museum defines internship, docent, and volunteer positions differently. In general, internships are the most direct route to a career path and are considered to be preprofessional training. You work directly under one individual and are assigned particular projects. Internships usually take place for a semester, a year, or during the summer. They form an integral part of many degree programs. Most interns are exploring an area of museum work to see if they would like to pursue a career there. As an intern, you will learn about the museum's educational programs and make valuable connections that can lead to paid employment.

Volunteers and docents come from many backgrounds, and may be working in the museum for many reasons, such as wanting to give to the community or learn about art and what happens behind the scenes in a museum. Volunteers provide the broadest range of services and can work in any area of the museum. They often work in visitor services, such as staffing the information desk. Docents usually give tours, after receiving specific training from the education department.

Seek out an internship that is close to what you see yourself doing in your career. Apply to be an intern in the same institution as you might want to work—they may hire you when an opening arises. For example, if you have a college major, minor, or a special interest in African art, a museum that specializes in this region would be a good fit. The National Museum of African Art, in Washington, DC, exhibits both traditional arts of sub-Saharan Africa, art of the African Diaspora, and contemporary art by African artists living in Africa and abroad. If there is a museum you absolutely love, articulate why you feel so attracted and fascinated by that particular place, as opposed to a comparable one with a similar collection.

Internships and volunteer positions usually have an application form on their website. Do your research beforehand to become familiar with the organizational structure of the museum, so you can indicate a particular department, such as education, where you would like to work. If you are interested in working in a museum that does not have one of these programs, be sure to ask if they would consider you anyway. There are a number of ways you can contribute. See if you can help out with family days and school programs. They may allow you to "shadow" a tour guide or assist with a museum art project. Volunteer on weekends, evenings, or summers—whenever you are available.

Recommendations and Skills

For a career in museum education, oral and written communication skills are of utmost importance. You must be able to communicate with a variety of people, including curators and scholars, elementary school students, first-time museum visitors and sophisticated museum visitors. You will need to speak and write clearly and articulately with both visitors and your professional colleagues.

Strategic planning is another useful skill. You will need to plan programs, curriculum, budgets, and events, so being well organized and thinking ahead proactively is essential. You should be able to manage your time well, meet deadlines, and be able to work on many projects at one time. The ability to think on your feet and come up with solutions on the spot is also valuable. Grant-writing expe-

rience may help to distinguish you from other applicants. Assessment experience is useful for evaluating educational programs.

Digital skills, including graphic design, social media, web development, and digital photography are always needed and can set you apart from other applicants. Even if they aren't specifically required, be sure to mention if you are proficient in this area.

Research is another important skill. You will need to know how to use the Internet and library, as well as the resources of the museum. For online research, you must know how to distinguish scholarly, true, and respected material from myths or incorrect facts. Academic experience doing research in art history, or other subjects relating to the museum's collection, will be especially helpful.

People seek work in museums because they love to visit them, feel passionate about their collections, and enjoy spending the day there. They visit museums whenever they get a chance, on weekends and evenings, and seek out new museums when traveling. They seek the "insider's view" and wish to be an active part of the museums and the museum community. If this sounds like you, you will enjoy a career in the museum world.

If you are interested in museum education, you should be someone who enjoys working with the public as well as collaborating with museum colleagues, likes working on a variety of education-related projects, and enjoys an informally structured workday where many projects and programs may be going on at once. You must be able to take initiative and work independently.

❧5❧

Nonprofit Organizations and Art Education Businesses

If you wish to serve a particular population, or teach your art form to people in your town, an organization forms the bridge between you and the community. This chapter will guide you through the multitude of organization types and the opportunities they provide. These groups may be nonprofit organizations that work with artists to fulfill their missions. They include arts councils, social service or health organizations, educational organizations, museums, and community-based organizations. Franchises and small businesses also create and provide art education programs. Nationally or regionally based, nonprofits and businesses work in a range of locations, such as schools, libraries, or detention centers. They often work together, engaging in meaningful partnerships to deliver art education.

Nonprofit organizations and businesses connect the arts to people's daily lives within the school system or outside of it, building communities and enhancing learning skills for all ages. They provide countless opportunities for you, as an art educator, in preparing for your career, or developing an established one.

Organizations support you from the very beginning of your art education career. If you are a practicing artist, you may have already benefited from their services and resources. You may have taken a class or two at a local community school or private art studio, either as a child or an adult. You may have attended a workshop to augment your professional artist's skills, such as writing an artist statement or resume, and creating a portfolio. You may have reviewed an organization's website to search for jobs, training, or volunteer opportunities.

When you are ready to begin teaching, organizations clear a pathway to stimulating, rewarding, and challenging careers in art education. They have experienced directors and educators who offer volunteer and internship place-

ments, and mentoring and training. You may begin your career as a teaching artist there, integrating the arts into other subjects, and working in schools or other locations that interest you. If you are an art specialist teacher in a school, or a museum educator, you may partner with an organization to supplement your curriculum.

This involvement could last throughout your career. They will continue to provide information as you advance, such as advocacy information on pertinent issues, job banks, networking opportunities, research, studies, and other useful material for your professional growth. As you gain experience, you can train other educators, become an education or programming director, and, eventually, executive director. Alternatively, you can start your own organization or business as you define your pedagogical interests and mission.

EDUCATIONAL SETTINGS

Organizations and businesses exist everywhere, from rural towns to cities. Their missions reflect their location, mirroring the interests and culture of the people who live there. The communities themselves influence the programs and courses.

When you work with an organization, you will either be working at the main location, if it has one, or you will be sent to another site to teach. You may be traveling, working at a combination of places through a single employer, as well as working for more than one at a time.

Geographic Location

Urban organizations

Urban locations have the highest density of artists, and art and cultural institutions. Consequently, cities have the greatest number and variety of organizations that employ teaching artists, full- and part-time art educators, and arts education administrators. In an urban setting, organizations often work with art educators to address social issues. For example, they use art to engage at-risk youth with their communities, bridge economic disparities, and accommodate new immigrant populations. Art centers and community schools offer a variety of courses in many art forms, including the most recent technology, to everyone. Because cities have established museums, they are at the forefront with programs that introduce new audiences to museums and related institutions. Also, cities have many opportunities for starting a small business offering art classes and workshops.

Rural organizations

Rural communities, without physical access to large museums and sizable cultural institutions, have their own thriving art scene, thanks to organizations. They support local artists as well as pull in artists from other places. They have art centers that teach traditional art techniques as well as new ones.

While some groups work to support the contemporary art scene, others work to preserve and continue local art traditions. In rural settings, community-based organizations can be dedicated to preserving traditional art forms, which are indigenous to a community and are in danger of becoming lost. This fosters a bond between the community and its heritage, strengthening links to its past. Community organizations, sometimes in conjunction with specialists from another region, work to revitalize interest in the art form. They help to preserve it, and make it relevant for current and future generations. They might even modify the materials or forms for new generations to reflect current trends or needs.

Maine Indian Basketmakers Alliance (www.maineindianbaskets.org), for example, is dedicated to preserving the tradition of basketmaking from ash and sweetgrass, maintaining the art form of the Maliseet, Micmac, Passamaquoddy, and Penobscot tribes. They sustain this art form through documentation, education, and outreach. They host demonstrations, events, and festivals, which include markets, to integrate their work into the community, and additional native arts, such as drumming.

Suburban

The suburbs are often overlooked because of the attractions of famous institutions in a nearby metropolitan area. However, there are many advantages to teaching art in a suburban organization besides getting a parking space. Classes may be smaller than what you would find in a city, but the facilities may be more spacious. Art leagues or community centers present the traditional art offerings, such as photography, drawing, clay, painting, and sculpture. Courses may also be held in the evening, at a local YMCA, library, and school. You can enjoy the benefits of a smaller community as well as having access to the city.

Outside the United States

There are limited positions to work abroad as a teaching artist. For example, the U.S. Peace Corps (www.peacecorps.gov) has opportunities for teaching art. The Massachusetts-based organization ArtCorps (www.artcorps.org) places artists in a yearlong residency in developing countries in Latin America. They provide a

stipend, room and board, and information on obtaining grants for airfare and personal expenses. Barefoot Artists, in Philadelphia (www.barefootartists.org), works with teams of community artists in developing countries. The prestigious Fulbright Program supports teaching, research, and studying art abroad. You can also contact the alumnae association at your alma mater, or initiate your own project and find funding.

TYPES OF ORGANIZATIONS

Nonprofit Organizations

Do you believe that art has a crucial role in improving society? If so, seek involvement with nonprofit organizations. Nonprofits have a social mission: to fulfill a need in society that is not provided by government organizations. There are many nonprofits working with artists in the United States, each with their own distinctly individual mission.

To help them fulfill their mission, nonprofit organizations are granted a special category by the US government. Charitable organizations receive special tax-exempt status under section 501(c)(3) of the Internal Revenue Service (IRS) tax code. This designation comes with many benefits. Nonprofits do not pay federal income taxes and many are exempt from state and local taxes. They are eligible for grants. In addition, the government encourages individuals and corporations to make donations to nonprofit organizations by offering them tax deductions.

The nonprofit is overseen by the board of directors. The size of the board can vary, usually between nine to fifteen people. The board is responsible for the overall organization—the mission, planning, finances, and fund-raising. The board members should have a range of expertise that may include marketing, finance, education, community connections, technology, and law. The entire board meets once or twice a year, and if it is large enough, has committees and advisory groups, which may meet more frequently.

The daily operation is run by the organization's staff. The executive director oversees all employees and activities, and reports to the board of directors. Depending on size, the staff may include administrative and IT support, a financial director, a grant writer, a marketing director, an in-house counsel, human resources, and a development officer who works to obtain funding. There may also be a program director to coordinate and plan the activities, and a community outreach coordinator. In addition, a director of education plans and implements the educational programs, and works with teaching artists and volunteer teachers. These teachers deliver the instructional programming to the population served by the organization. A very small nonprofit may consist of a sole director, who

performs all of these roles and hires the teaching artists. The teaching artists may be part of the staff or hired as freelance contractors.

Arts and cultural organizations and museums

Many arts organizations offer a selection of art education programs, ranging from short- to long-term commitments. Some programs may consist only of one to two sessions, while others may have between ten and fifteen sessions. The organizations design the curricula, and then implement them in schools or other locations. These programs may include arts integration projects based on a particular theme, subject, or media. Alternatively, they may be centered on a single performance or event. Still other organizations work directly with a school or partner, and coordinate custom-designed programs with teaching artists, often collaborating with classroom teachers. Young Audiences New York (www.yany.org) offers all of these: forty-five-minute interactive performances, in-depth, collaborative multiweek artists' residencies, forty-five- to ninety-minute family performances, and workshops, field trips, a youth lab for teens, and professional development.

Arts education partnerships

Most art education organizations and businesses are involved with partnerships. They work with schools, schools districts, and community centers to coordinate and provide art education programs for K–12 students. Some organizations, however, specialize in partnering and are solely committed to this purpose. These partnership organizations work with a large number of schools, arts institutions, and teaching artists, often on a long-term basis.

Partnership organizations coordinate places that need art programs with organizations who offer them. They can offer the flexibility of a program tailored to each organization's individual needs. They determine exactly what the program will entail, and match these needs with a partner arts organization. They decide on the number of sessions, their length, and the art form, themes, and projects. Then they provide the appropriate teaching artists. These teaching artists can be from a roster—artists who have already applied and been accepted to teach—or, the organization can hire new artists for a particular project. Arts education partnerships can include a few schools and organizations or many partners and hundreds of teaching artists, while maintaining a small staff.

Arts partnership organizations, like other organizations involved in partnering, have staff members who are involved throughout the process of program design and implementation, and act as an intermediary between the teaching artist and the organizations should any difficulties occur. They hire artists, and

provide training and mentoring programs. Some offer professional development workshops, teaching-artist training workshops, and perform and publish research and assessment of their programs. For example, the Philadelphia Arts Education Partnership (www.paep.net) works with over thirty partnering institutions and hundreds of teaching artists, while maintaining a small core staff. Chicago Arts Partnerships in Education, or CAPE (www.capeweb.org), is another well-established educational partnership organization with an extensive list of partnerships and art programs. Big Thought (www.bigthought.org), in Dallas, Texas, has many complex educational partnership programs, in the arts as well as other areas.

Bronx-based art educator Carmen Hernandez just started up her own partnership organization called NYGB (New York Gives Back). Her organization's mission is to work collaboratively with organizations that are looking for an art program, or to help facilitate art programs where there are problems happening with one of the partners. While working as a teaching artist, curriculum planner, and education coordinator with community organizations, she found that this type of highly flexible, customized program would provide a valuable service that was lacking in her community. She decided to devote her efforts to address this need.

Community-based organizations

Whether they are in a neighborhood, town, or city, community-based organizations have this goal in common: to enhance the lives of the people of the community by engaging them in the creative art process. Community-based organizations are a growth area for artist-educators and offer an increasing amount of opportunities for them. They coordinate the placement and training of teaching artists to serve populations beyond the reaches of the school system, or established art institutions.

Community-based organizations actively seek to improve the community as a force for social change. Some strive to revitalize their neighborhoods by reaching out to underserved communities with collaborative and often experimental projects. They endeavor to empower marginalized people, providing them with a voice. These organizations seek to provide a creative outlet instead of violence.

Community art organizations

Like other community-based organizations, community art organizations are based on social activist principles, but their missions are realized through art. Community-based arts organizations introduce the arts experience for the participants to engage in the community, increase academic skills, gain confidence,

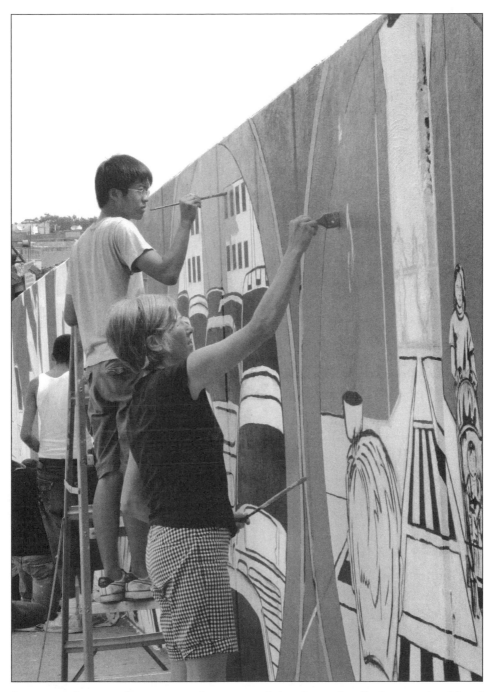

"Stop, Look, Listen" was created as part of the Groundswell Community Mural Project's flagship Summer Leadership Institute (SLI) in New York City. Photo by NYC DOT.

and find a voice for self-expression, rather than emphasize proficiency in a particular art form.

Some community-based organizations offer instruction in art forms besides visual arts, including music, dance, theater, and writing. Here there are opportunities to work with other types of artists, such as musicians, dancers, actors, and writers. For example, Community Word Project in the Bronx, New York has many programs in music, performance, poetry, and a range of visual arts, including painting and photography.

Some organizations seek to reach out to specific populations. Esperanza Art Studio, for example, in Chicago works with individuals with disabilities. Others work with specific age groups, such as Arts for Aging, in Bethesda, Maryland, which offers programs for older adults.

Some community arts organizations have collaborative projects that build leadership skills and strengthen a sense of community while improving the environment and developing neighborhoods. Their missions include creating peaceful environments while fostering nonviolent activities and providing an outlet for creative expression. For example, Social and Public Art Resource Center (SPARC) in Los Angeles has been working since the 1970s to transform the distressed urban neighborhoods and the lives of its inhabitants. One of its most famous projects, the Great Wall of Los Angeles, was a half-mile long mural project, representing the complete history of ethnic populations of California.

Community art schools

Community Schools of the Arts fulfill a different role from community-based organizations. While they are committed to the local community, they focus on traditional sequential, media-based curriculum, and teaching proficiency in a particular art form, rather than an introductory art experience. In contrast to the community-based organizations, they engage with "art for art's sake." They emphasize skill development in a particular art form, rather than integrating art with another subject.

Most community art schools are nonprofit and hire professional artists to teach individual courses. The admissions process is open. They strive to be affordable, by receiving grants or donations. The curriculum usually is not credit-based. Many classes meet on weekends and evenings to fit into the schedules of students and working professionals. Like other organizations, they partner with schools, including higher education, as well as other agencies, to broaden their reach.

A community arts school can be contained within another institution. For example, many universities have a special school or department for courses outside of its degree programs. Even though it is not a school itself, the Brooklyn Botanic Garden in Brooklyn offers noncredit instruction in botanical art. These courses are affordable and taught by artists practicing in the field.

Like the community-based organizations, community art schools vary widely in their offerings. Some specialize in a single art form, such as drawing or photography. For instance, the Drawing Studio in Tucson, Arizona, offers programs exclusively in that medium. Others, such as the 92nd St YMCA (92Y) in New York City, offer a wide range of art forms, such as drawing, pastel, painting, sculpture, photography, cartooning, collage, jewelry, and art history.

Religious organizations

Many churches, synagogues, and other places of worship have opportunities for teaching art. They often employ art teachers for Sunday school, Saturday school, and other programs.

Arts Councils

Arts councils support artists in all art forms, including art education. There are local, regional, and state arts councils. They provide many opportunities for a teaching artist or artist-in-residence. They list openings for artists on their website, along with other resources. Many have an artist roster of artists who are available for teaching. Some have online databases of artists and samples of their work for curators to see. They also have funding opportunities for art education projects or organizations.

Regional arts councils

The National Endowment for the Arts (NEA), an independent government agency, funds six nonprofit regional arts councils: Arts Midwest, Mid-America Arts Alliance, Mid Atlantic Arts Foundation, New England Foundation for the Arts, South Arts, and Western States Arts Federation. The amount of funding that the NEA gives is set by Congress each year. The regional arts councils support their member state arts agencies, arts organizations, and individual artists. They develop and manage arts initiatives on local, regional, national, and international levels. They offer both national and international programs.

State arts councils

Funding from the NEA and state governments supports state arts councils and arts commissions. Like nongovernment organizations, they seek to promote access to all arts and arts education. Each state arts council is governed by a council or commission appointed by the governor or state legislature. These councils oversee state arts agencies' policies and programs. The public can get involved with state arts agency planning, grant review panels, and community meetings to discuss the arts and local needs. Many state arts councils promote opportunities for grants, jobs, internships, and professional development on their websites. They offer resources for community development and partnerships.

Local arts councils

Local arts councils and arts commissions are financed publicly, from state and city funds, and some receive private donations. They are set up by the city, county, or state. They offer re-grants, or redistribution of grants they have received from the state arts council. They organize arts education programs in schools and offer professional development workshops to local artists. Like other arts councils, they often have rosters of teaching artists and studio artists. They support smaller arts organizations and individual artists. For example, ArtsWestchester (www.artswestchester.org), in Westchester County, New York, has training for teaching artists. Their website lists local arts organizations, a roster of teaching artists, and profiles of artists in all art areas.

Art Education Businesses

Art education businesses provide further opportunities for an art educator, with great potential for creativity and advancement. National franchises are a common form of art education business. You have the opportunity to start your own franchise, or to teach art in an existing one. Franchises such as Young Rembrandts, Abrakadoodle, KidzArt, and Monart follow the trend of popular tutoring franchises such as Mathnasium, Kumon, and Sylvan Learning Centers. In general, certification or a specific educational background is not required. The franchise headquarters provides training in their methods, which are based on National Art Education Standards. Many partner with local schools and community centers. While the emphasis is on two-dimensional media for children, many offer instruction for adults, and in other media, such as sculpture. They often host children's birthday parties in addition to multisession classes.

Small, independently run, local art education businesses are prospering. As an individual art educator, you can start your own for-profit art education business, in your home, a storefront, or in other locations, such as art or craft supply stores, or children's stores. Emerging technologies are making online teaching a possibility as an art education business. If you have an entrepreneurial spirit, use your imagination to envision how you might offer art instruction. You do not have to wait for someone to hire you—create your own teaching opportunities!

Valeen Bhat, who received bachelor's and master's degrees in art and design education, with a concentration in printmaking and a minor in art history from Pratt Institute, in Brooklyn, New York, started Private Picassos after gaining valuable experience in the nonprofit sector. Having started small, her business now offers classes in many New York City locations, including schools and stores. In addition, it offers in-home private and group art lessons, birthday parties, museum and gallery tours, and art workshops. She teaches classes, and also employs teaching artists.

Private tutor

Private tutoring is another option. You can provide students of all ages with individualized instruction at your home or art studio, or travel to their home. Middle school or high school students seek tutoring to prepare a portfolio for admission to a high school or college, respectively. Also, many parents are searching for programs for homeschooled children.

TEACHING OPTIONS

Full-Time or Part-Time

Organizations, including nonprofit and for-profit, offer both full- and part-time positions, although most teaching positions are part time. The full-time positions include the administration staff and education directors. The education directors are involved in program development, training, and managing educators, including teaching artists and volunteer teachers. Teaching artist positions are usually part-time, paid hourly or by project.

Most classes are offered after-school, in the evening, and on weekends, as well as during the school day. This scheduling is not only convenient for students, but also for the professional artist who wants some time in his or her studio as well as in the classroom. The flexibility might appeal to someone with a full- or part-time job or seeking summer employment. It can also accommodate artists seeking teaching experience without giving up their job.

Length of Employment

The length of a teaching project is flexible. For example, you may be involved in a short-term project that could be an afternoon workshop or a weeklong seminar. You may be working on a long-term community art project, which could last a year. If you are working in a school, you could stay there for a week, a few months, as well as returning to the same place for many years.

WHAT YOU WILL BE DOING

In arts organizations, most educators are teaching artists. As a teaching artist, you may practice arts integration, infusing art in other subjects. You will collaborate with other teachers to create projects and lesson plans. As you gain experience, you may be creating curricula, developing themes, designing projects, and training teachers and volunteers. In general, the educational goals are focused on the experience of art-making, rather than on the finished product.

In a community school for the arts, and in many art education businesses, you will be teaching mainly sequentially based curriculum based on a particular art medium. You may be incorporating thematic projects, but generally the curriculum will be technique-based rather than subject-based.

Planning Curriculum

You may be planning curriculum for the organization or business. Every organization has a different process: you may work individually or with a group. At the nonprofit organization Free Arts NYC (www.freeartsnyc.org), the educators work as a team. They come up with a new curricular theme each year, which is centered on a visual aspect of New York City, to which the participants can easily relate. One year, they chose Subway Series as a theme, and decided to design a curriculum based on the public art in the subway. They met to brainstorm possible art projects. From this session, the group decided on a couple of sample projects, and tried to make them. For example, they created a zoetrope project to introduce the concept of animation, based on the public artwork by artist and filmmaker Bill Brand. They refined the project by making it several times, fixing the problems that occurred. They decided on the materials, and figured out where to buy them. Then a teaching artist trained four to five volunteers in a three-hour session, which included the philosophy of the organization, rules, and guidelines for discussing art with parents and children.

Budget and Materials

You may be in charge of purchasing materials for your classes and programs, and organizing them for events. You will need to come up with a budget for materials if you have not been given one.

Standards

If your organization is involved with schools, you will need to know about educational standards, including art, and other subject areas that you will be using.

Developing Partnerships

Developing ongoing partnerships with educational, cultural, professional and social services, and other agencies is crucial for all organizations involved in art education. You will be working with established partnerships and initiating new ones. Through these long-term relationships, the organizations can build successful programs and implement new ideas through careful evaluation of their experiences over time. This type of affiliation frees up time to spend on teaching because the structure does not need to be set up from scratch each year. Partnerships can also increase resources for everyone involved.

You can partner with any organization whose mission interests you. Partnerships with public or private schools mean that you will collaborate with teachers in that school. Working with higher education can result in professional training and library access. Collaboration with a museum or art gallery can lead to school tours and other activities in the museum, as well as museum educators becoming involved in the school classroom. Joining forces with social service agencies will provide access to art for hospital patients, housing programs, and treatment centers. Partnering with public housing authorities, senior centers, and libraries offers many opportunities to engage underserved populations.

Professional Development

Many arts organizations, including nonprofits, museums, arts councils, and businesses provide professional development opportunities. They train classroom teachers, arts specialist teachers, teaching artists, and volunteers. They have workshops for their own teaching artists, as well as for art educators from outside the organization. The content can include: integrating art into the classroom, meeting core curriculum state standards, addressing diversity, multiculturalism, and classroom management. Conflict resolution and child abuse are other topics that may

arise. The workshops may include sharing lessons and student work with the other participants. Some training will include an orientation to the organization, a review of the goals and curriculum, and pointers on relevant teaching strategies.

Applying for Grants and Funding

You may be applying for grants and other sources of funding for your community projects, or you may be working with a grant writer or development officer to find opportunities and define the financial goals of your project. These may include local, state, and federal grants, state and local arts council grants, grants offered by local and national companies, and donations from local businesses and individuals.

Business Skills

If you decide to start your own nonprofit organization or business, obtain as much business knowledge as you can. You will need some basic business skills such as bookkeeping, and a basic understanding of taxes and marketing. You will begin with formulating your mission, creating a business plan, and finding sources of funding.

Luckily, you do not need to attend business school to start your own business. You can attend seminars, webinars, read blogs, and research online and in the library. Business incubation workshops offer valuable information on starting a business plan. Many sessions are targeted to women, minorities, veterans, Native Americans, and other minority groups, either for free or at reduced rates. The U.S. Small Business Administration (SBA) is an excellent starting point, and through its website, you can find local resources, as well as nationally based training, counseling, and information. SCORE, a nonprofit association supported by the SBA, provides free or inexpensive business mentoring, workshops, and other resources. The SBA and SCORE also serve as gateways to local resources such as microlenders, pro bono legal assistance, training programs, and networking groups. In addition, you can utilize your own personal and professional networks through friends and affiliation with your alma maters, religious institutions, professional associations, and more.

FURTHER IDEAS TO EXPLORE

Pros and Cons

Organizations are great places to start your career and get teaching experience, mentoring, and training with a flexible schedule. They also allow opportunities for advancement. Through creating an organization, for-profit or nonprofit, you can

be your own boss and have the great satisfaction that comes with entrepreneurship. Both for-profit and nonprofit businesses enable you to find a niche market. Because budgets have been cut in schools, there are opportunities to fill this need elsewhere. The nonprofit world allows you to put forth a social mission through your art education practice.

There are some drawbacks: much funding has been cut for nonprofits, and private individuals find less disposable income for art lessons. Part-time work does not offer health insurance and other benefits. Starting and running your own organizations are all-consuming endeavors, and do not allow much time (if any) for studio work.

Career Paths

Working with an organization prepares you for a variety of career paths in art education. As you progress from volunteer to teaching artist, and gain administrative skills, you may be ready to start your own organization. You can do this by yourself, or with like-minded individuals. Many organizations are grassroots organizations started by just one person or a small group who live in a particular neighborhood, or wish to serve a specific population. They can begin with a special project or idea, and then grow as they take on more projects.

Related opportunities can be found with higher education, museums, or large, national organizations and professional associations. At some point, you may wish to join a larger art museum or cultural institution. Along the way, you will learn more about a variety of organizations and how they operate. You will also evolve your own pedagogy and beliefs.

Theoretical Background

Organizations draw from the ideas of educators, artists, philosophers, and social theorists as a framework for their mission. To understand their mission, find out who inspires the organization you are working for. Continue to read and discover other theories and philosophies as you go along, especially if you aim to start your own organization. Organizations and businesses do not subscribe to a single theory—they are omnivores with many sources of inspiration.

WHAT YOU NEED TO GET THERE

Recommendations and Skills

In the nonprofit and business world, there are as many types, purposes, and missions as there are individuals. Each has a unique philosophy and pedagogical style.

Networking will help you to see what positions and opportunities are available, and to find out what others are doing.

If you do not have any teaching experience, find a situation that will offer you training and invest time in mentoring you. Apply to volunteer or intern, and then work your way to a paid position. If they have no formal volunteer or intern program, see if you can shadow or assist a veteran teacher. When the teacher sees your commitment and feels you are a good fit for the organization, he or she will invest more time and give you more responsibility.

Often, there is no particular background required for an entry-level volunteer position—it depends on the mission and work of the organization. In some cases, a background in social work, early childhood education, or special education may be appropriate.

To work your way up through an organization, and to start your own, you should have an entrepreneurial spirit and continually seek new challenges. Organization leaders are flexible. They evolve ideas and improvise as they go along. They are the type of person who has a "can do" attitude. They see the positive opportunities in challenging situations, and see them as ways to rise up, grow and learn. They are problem solvers, using the creative artist within themselves to look at issues in a fresh way. They are leaders rather than followers, and strong independent thinkers. If you have a social mission, and a drive to improve communities and enrich the lives of others, you will realize that the rewards are well worth the challenges.

❧6❧

The Teaching Artist

Teaching artists are professional artists, deeply involved with their art form, who engage in exhibits, performances, and other art practices. They identify themselves as artists who are educators. Teaching is essential to their growth as an artist. They infuse their own artistic process into their teaching, and in turn, their teaching inspires and informs their own work. Many teaching artists view the art classroom as a laboratory for experimentation, inventing new ways of thinking and making connections. They place their teaching in a larger context, outside the arena of the art world, to bring the art experience to the public.

Teaching artists are self-employed, working as freelancers. They may work in a few places at once, managing a balancing act between multiple teaching locations, positions, and their work as an artist. Collaborative projects with another teacher integrate the arts experience into other subject areas. By making these connections, visual arts help diverse learners understand a wide range of other subjects. Teaching artists also work with participants on group projects, often for the benefit of an entire community. They are integral to every area that we have discussed so far: pre-K, K–12, museums, higher education, community organizations and for-profit education businesses. Teaching artists are currently discovering many new areas that can benefit from art education.

Teaching artists are on the vanguard of the field of art education, due to their adaptability, flexibility, and creativity. During this exciting time for the profession, teaching artists are in the process of articulating a collective voice. The world is becoming the teaching classroom, as people realize that the arts are fundamental to any educational experience. Research has revealed that art fosters creativity, making connections, collaboration, problem solving, and critical thinking. Teaching artists embrace the different learning styles of the participants, central to raising students' self-esteem, and learning subjects such as reading, writing, science,

and mathematics. They use art to reach those who are marginalized or disengaged from traditional education.

If you have an entrepreneurial spirit, enjoy flexibility, and need time to work in your studio, enter the world of the teaching artist. A career as a teaching artist allows you to carve out a livelihood tailored to your talents, personality, and interests.

EDUCATIONAL SETTINGS

A teaching artist usually works through a nonprofit organization, which partners with a school or another location to provide educational services. These organizations place the teaching artist in the location, such as in a school, community site, or a partner organization's home base. As a teaching artist, you may be working in a variety of locations.

Schools

Many teaching artists work in a school, filling a separate role from the K–12 arts specialist. One of the main differences is that the teaching artists are either employed by an outside organization, or self-employed, instead of working directly for the school. They are placed in the schools on a temporary, short-term basis. While teaching artists may develop long-term relationships with a school, they are not a permanent part of it. Ideally, teaching artists work in addition to the art specialists, rather than replace them, because both are necessary for specialized arts instruction and arts integration. Unfortunately, this is not always the case due to budget restrictions.

In a school, you will be working with a full-time art teacher, a general classroom teacher, or a teacher of a specific subject such as mathematics or English. Many schools hire teaching artists to improve performance in mathematics, reading, and other core subjects, by making connections with art. They engage students who are otherwise bored and inattentive. They actively involve the students through participating in hands-on projects, improving not only the level of each class, but also the entire school environment. In addition to working with students, they also instruct teachers in their art form, so the projects can continue after the teaching artist has left.

After-School and Camp Programs

Teaching artists also work in schools outside the hours of the regular school day. You may be working directly through the school, school district, or through a partnering organization. For example, you may be teaching in an after-school

program, a short-term vacation camp during the school year, or a summer camp. You may be the teacher, educational director, or coordinator of different types of activities. As a camp art counselor, you would teach, design, and implement activities for day or sleep-away camps. As you gain experience, you may be asked to take on more administrative responsibilities if you return year after year.

Museums

Teaching artists in a museum usually work with studio-based programs. Museums often hire teaching artists to work with school groups, family programs and other hands-on art activities. They teach studio art classes or one-time workshops. You could be an independent contractor or work through a partner organization.

Social Service Agencies, Public Agencies, and Other Community Sites

Currently, most of the work for teaching artists is in the public school system. However, growing opportunities include community sites, such as senior centers, after-school programs, pre-K programs, and community centers. Teaching artists are also employed in parks, libraries, hospitals, public housing, museums, zoos, police departments, district attorney offices, religious organizations, and correctional institutions. These agencies either hire teaching artists directly, or work with nonprofit community-based arts organizations to bring teaching artists to their locations.

Detention and correctional centers offer interesting and challenging opportunities for teaching artists who wish to aid at-risk youth. For example, the New York State Literary Center, in Rochester, New York, in partnership with Rochester City School District's Youth and Justice Program and the Office of the Sheriff, County of Monroe works with incarcerated youths. Special training for teaching artists is offered by the sheriff's department. Visual arts, writing, and music, in conjunction with other subject areas, raise self-esteem, a sense of identity and community awareness, and increase skills in core subjects such as literacy and history. Core standards, in both social studies and English language arts, are deeply imbedded in the process. In creating the Rochester History Mural, the inmates researched local history relating to their culture and neighborhoods before embarking on their artistic journey. This process helped them to connect with the outside world, learn about their identities, and improve their self-expression.

Hospitals are discovering the potential of the arts to help with healing. Partner organizations place teaching artists to work with patients with long-term or short-term illnesses. Art is used as a vehicle for self-expression, and to provide a positive, productive experience to help healing during a time of crisis and chal-

lenges. It helps the patients to formulate a voice and individual identity apart from their illnesses. For example, the Children's Healing Art Project (CHAPS) in Portland, Oregon, offers art classes and projects for hospitalized children. The Creative Center Arts in Healthcare, based in New York City, employs artists to hold workshops for patients with cancer and other chronic illnesses in hospitals throughout the northeastern United States.

Senior citizens are among the fastest growing audiences for teaching artists. Many organizations working with senior citizens hire teaching artists. Senior centers, assisted living residencies, and nursing homes are all excellent places to seek a teaching artist position. Some organizations devote themselves solely to working with older adults, such as Lifetime Arts, in Pelham, New York.

Parks and Recreation departments also hire teaching artists. Battery Park City Conservancy in New York City is one example of an organization that hires teaching artists to work in the parks. It has structured, sequential art classes, such as portfolio development for teens, and drop-in art classes for preschool children during the summer. They also coordinate arts components for special events. For example, Go Fish Day includes a visual art project and performance to complement educational fishing activities and learning about the New York waterways. In Chicago, Oak Park offers a schedule of classes for different age groups throughout the summer. If you are a student or teacher in a school, with summers available, this can fit into your schedule.

Public Spaces

You may be involved in a community art project in a public space, which may be outdoors, in a park, on the wall of a building, or indoors such as school or library.

TEACHING OPTIONS

Most teaching artists work as freelance or independent contractors, even if they are working through an organization. Less frequently, they can be full-time or part-time employees.

Length of Employment

The length of employment can vary greatly. Teaching artists give short workshops or lessons lasting for an hour, a few hours, a day, or a weekend. They can make multiple visits to the same location, or work for a year or part of a year. Teaching artists can maintain long-term relationships with schools and organizations.

WHAT YOU WILL BE DOING

Teaching Through an Organization

Teaching artists usually work for an organization, linking it to the community. The organization is a liaison between the artists and the placement location: establishing partnering agreements, scheduling and planning the programs, and supervising and coordinating individual projects. It may provide training and mentoring, and help to resolve issues that may come up along the way. Most teaching artists work through nonprofit organizations, but they can also teach with art education businesses, such as a store offering art classes, or a small business.

Once established in the organization, teaching artists can participate in training others and become an education or program director. At the organization's home base, they may teach classes, run workshops, train volunteers and teaching artists, or develop curriculum.

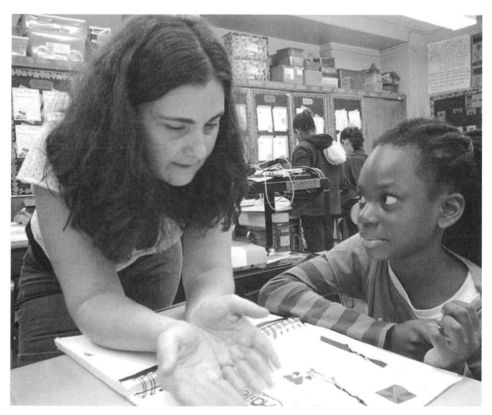

PS 9, Brooklyn, 4th grade, Teaching Artist, Emily Gibson, Learning Through Art program, Solomon R. Guggenheim Museum. Photo by Seth Caplan.

Teaching Independently

If you live in a small town, rural community, or a recently expanded city, there may not be a complex arts infrastructure already in place for training, hiring, and placing teaching artists. Art educational partnering organizations may not be established. Your ideal teaching artist job may not exist, and you may need to create one for yourself.

While it is easiest to start out working through an organization, one of the benefits of being a teaching artist is that you can also approach places to work on your own, such as a school, museum, or other community site. Using your creativity, you can initiate projects as well as get funding for them. You'll discover new ways to apply teaching art and new places to do it.

Arts Integration

Arts integration, also known as arts infusion or arts-in-education, belongs to the realm of the teaching artist. Art projects are implemented in other subject areas to increase cognitive ability, critical thinking, reflection and engagement. The teaching artist utilizes art skills and concepts to raise levels of learning in other subject areas, such as mathematics, English language arts, history, and social studies. This leads to the understanding of an idea or topic in many contexts. In a school, it reaches underperforming students who would otherwise not participate.

In a museum, art workshops teach the history or culture represented by the museum's collection. A public art project in a park can incorporate environmental issues, natural science, or local history.

Initiating the process

The typical process begins by the arts organization working with the school or other site to determine the project's goals. They designate specific areas that could benefit most from integration with the arts. The organization then assigns a teaching artist whose professional expertise and teaching qualities are best suited for the endeavor. The teaching artist works with the school to develop an appropriate project. In some cases, an individual teaching artist works with the school or community site directly, without an intermediating organization.

Your project will likely be a residency, including ten to twenty sessions, and often a collaboration with another teacher. Usually, throughout the residency, the teaching artist comes in one or two periods a week, rather than being present for every class period.

The teaching artist is placed with a teacher of another subject, or another arts teacher, such as music. The teaching artist collaborates with that teacher to create a

project that will address the curricular needs of the class or group. Alternatively, the teaching artist can be placed with a team of teachers, including other art teachers or teaching artists who specialize in different media. The project can involve a class, an entire grade, or an entire school. The teaching artist can work with others to create an exhibition space from a hallway, an unused classroom, or even a storage closet.

Developing course content

Ideally, in an educational site, you and the collaborating teacher design the lesson and unit plans in advance, before the class starts. The teachers usually meet to decide on a concept or theme that will incorporate an art project to complete the objectives of the lesson or unit. In addition to making art, the project might incorporate research, and viewing and discussing the work of professional artists, either contemporary, or from art history.

Evaluation and assessment

Assessment, reflection, and overall evaluation will occur throughout the process, both for teachers and students. Incorporate critiques and other forms of students' self-reflection and assessment as ongoing activities. It is important to maintain flexibility and adapt and change as needed. The final documentation is also impor-

New York Cares and Community Roots Charter School coordinated a family painting day where the participants designed an abstract map based on drawings they made after learning about street safety. Photo by NYC DOT.

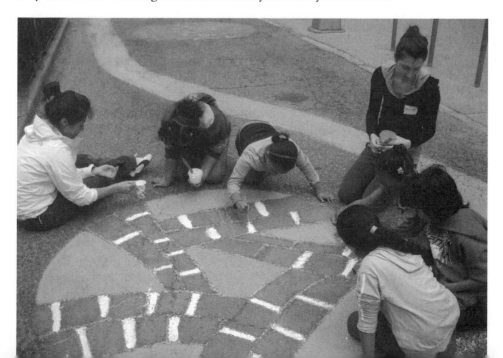

tant for the school, the partnering organization and for your own records—not just photos of the artwork, but also the interaction of students, teachers, and other participants.

Community Art

As a teaching artist, you may be leading a community art project in which participants work on one project, which is publically displayed. The process can be activist in nature, with the main purpose to improve the community. Painted or tiled murals, films, quilts, and online projects showcase local histories and themes of local importance. The process and principles of community art can be implemented in many situations that the teaching artist might encounter, such as using paper or tempura paint for a collaborative classroom project. Community art projects are often intertwined with arts integration.

A community arts project might incorporate a theme that needs to be researched, incorporating academic subjects. For example, in IS 136 in Brooklyn, teaching artist Ellie Balk, in conjunction with BRIC Arts Media Brooklyn, and the classroom teacher, created a project for an eighth grade class, with mathematics and art, using geometric patterns. This project culminated in a stained glass window, which is permanently installed in the front of the school building. Creating the Barrio Central Neighborhood Mural, the Tucson Arts Brigade, in Tucson, Arizona, incorporated learning about local history and color theory.

To further understand the subject with which you are working, you may also want to bring in other members of the community. For example, when Brooklyn-based Groundswell (www.groundswellmural.org) created Piece Out/Peace In, they brought in community activists, as well as elected officials, anti-gun advocates, and family members of gun violence victims to speak on gun violence. This helped the participants to understand many sides of the issue. The history of gun violence, laws, and regulations and consequences were expressed in the finished piece.

You will be overseeing participants with little or no prior art knowledge, and advising them rather than directing them, using your experience as a professional artist. With your knowledge of elements and principles of art, art history, art concepts, and art technique, the group will look to you as the expert. Even though much of the work will be planned and executed by the consensus of the group, you will link it to the world of professional art practice. It is your role to make this an experience where the participants will learn about the function, role, and creation of an artwork, will realize their own creativity, and find their own creative voice.

You will guide the participants in creating the content, theme, and design of the project. In the beginning, you may work with them individually so they can

develop their own ideas, which will provide the foundation for the final group project. For example, if you are creating a mural, sketching exercises may be utilized to develop their ideas for the final mural. You will need to give instruction on drawing or other imaging techniques, and give some explanation of the creative process. You will need to include technical training, such as techniques specific to mural arts, or media arts. Other artists may assist you if necessary.

Documentation, evaluation, and assessment

Throughout the process, keep in mind that you will need to document your project.

As with documentation, it is important to evaluate on an ongoing basis. Assessment is an integral part of the group's learning process and also for the artist leaders to see how they can improve for the next program.

Public presentation

When the project is completed, it is time to celebrate! This is an opportunity for the participants to show their achievement to their family, friends, and community members. To experience the reactions of others to their work is an experience not to be missed.

Grants, fellowships, and fund-raising

You may be involved in seeking funds for your own projects, or those of the organization that hired you. If you are looking to fund your own teaching artist project, you will find that more opportunities are available for organizations, rather than for individuals. Online crowdfunding, also called microfunding, is an increasingly popular way to get donations, both from friends and strangers, for your project. The online organizations providing service take a small percentage, and you give a thank-you gift, such as a T-shirt or print, to the donors. You can also apply for a fiscal partnership, a legal arrangement to partner with a nonprofit organization so you can receive grants.

ESSENTIALS TO INCLUDE

Teaching Skills

You will have to understand all aspects of teaching, including creating curriculum and differentiating lesson plans for students with different learning styles and special needs. You should be able to incorporate many views and opinions during

critiques and discussion and work with diverse populations. You will need skills in classroom management, and an understanding of the developmental stages for ages you will teach. You should be able to understand and apply state, national, and professional standards for the subjects you are teaching. Many teaching artists' projects are participatory in nature, rather than solo endeavors.

Knowledge of Advocacy Studies

Many research studies are being published to advocate for arts education. These studies prove with statistics how arts have raised cognitive ability, participation, and learning in schools. Studies have also shown an increase in collaboration, forging connections between disciplines, fostering creativity, and increasing self-esteem. Knowledge of these outcomes can help you to convince principals and others why your art educational program is important.

Standards

If you work with schools, you will need to be familiar with professional, national, and state educational standards in art and other core subject areas as well. You will need to know how to apply them creatively to your ideas. It is important to understand what they mean and how to use them, matching them to your teaching, rather than memorizing them. Keep current with the standards, as they change every few years.

FURTHER IDEAS TO EXPLORE

Intellectual Property

Stay abreast of intellectual property issues, including copyright and fair use laws. Issues of concern especially pertinent to teaching artists include how much of others' teaching methods can you adapt and what happens if you work somewhere and they take your methods in house after you stop working there.

Be aware of what is "copyrightable" and what is not, and what you can use under the fair use copyright laws. For example, if you use a magazine image in a collage that ends up in a public mural, you may be violating the artist's copyright. Understand when and how you can use other lesson plans that are posted on the Internet. Consider how you would like your own work to be used by others. Be prepared and have a contract ready if you utilize teaching methods or a workshop format that you think is unique. Know how to file copyright with the U.S. Copyright Office.

Business Matters

The more you know about business, the better off you will be. Any business aspect you apply to your professional art practice will be useful in your career as a teaching artist as well. For example, you will need to understand tax laws, bookkeeping, and liability issues. Marketing yourself will help you to be paid adequately for the unique program you have created, and allow you to gain more opportunities. You will need to know how to make contracts with the people with whom you will work.

Pros and Cons

Many teaching artists love the opportunity to work with a variety of schools and neighborhoods, and students of all ages and backgrounds. You can maintain your identity as an artist, because the flexible schedule grants you the time to work on your own artwork.

Teaching artists work in programs that are intense, and often of shorter duration. In a school, you are a special person entering the class, and the students will be more receptive to the novelty of your presence.

However, there are some drawbacks. For example, you will not receive a regular paycheck or benefits such as health insurance. Your position may require travel among multiple locations. You will need to convince others of the value of learning about art, and that your program is something for which you should be paid. Because you are not a full-time employee of the school, you will not have the rewards of working with the same students long-term and seeing their development over a period of time. As you advance, you will specialize and carve out more opportunities for yourself, but it is difficult to reach a higher pay scale after a certain point.

In this era of budget cuts, many schools have lost their full-time art specialists. The teaching artist's inclusion in a school program is often criticized for being an inexpensive solution to maintain an art program. The teaching artist in a school fulfills a different purpose than the art teacher and should be in addition to, rather than as a replacement.

WHAT YOU NEED TO GET THERE

Professional Artist

To be a teaching artist, you must be a practicing artist. This can be shown by a current body of artwork, professional art exhibitions, participation in artist's residencies, and by receiving fellowships, grants, and awards. You must demonstrate profi-

ciency in your art form. You should be knowledgeable about the history, cultural, and sociopolitical background of your chosen medium, and be able to adapt it to new situations. Try to have a firm grasp of related historical and contemporary artists and art movements. It is useful to have a basic knowledge or interest in additional subjects, and be able to make connections between art and other disciplines.

Education

Academic degrees

An undergraduate degree in studio art or art history is preferred, but not necessarily required. A graduate degree is not required. However, many teaching artists have a master's degree or Master's of Fine Arts (MFA) degree in their art form. A few have degrees in education.

An MFA that includes public or collaborative art could be interesting to you, especially if you wish to pursue community art. Any coursework in this area, whether as part of an undergraduate degree, graduate degree, or noncredit or continuing education will be very useful. Some MFA degree programs include teaching artist training, general teaching training, and offer teaching assistant positions. Seek out these opportunities if they follow your interests.

Teaching artist training

Teaching artist training, while not always required, can help pave your way to a successful first teaching experience. It can provide you with a foundation on which to base your first practical teaching experience. Some organizations have a built-in training program for their teaching artists. They offer workshops and classes for teaching artists, often during the summer or weekends. Also, many nonprofit community-based arts organizations provide teacher training as part of their volunteer programs. Volunteering with a small organization that can mentor you is a wonderful opportunity. You can also approach a veteran teaching artist and ask to shadow him or her.

Teaching artist certificate

The first teaching artist certificate program was launched in 2009, at the Continuing Studies at the University of the Arts, and Philadelphia Arts in Education Partnership, in collaboration with Pennsylvania Council on the Arts. While at the moment there are only a few of these programs, by the time you read this, there will likely be more. One reason behind this is to provide teaching artists with recognizable credentials. For example, if you approach a school principal with

an after-school arts program you would like to offer, a teaching artist certificate would ensure that you have basic knowledge and qualifications. It is possible that in the future, a teaching artist certificate may be required to work in certain areas, such as the public school system.

The other reason for a certificate is to give artists a faster and cheaper alternative to the state visual arts certification, while offering much more education than a typical teaching artist training workshop. It takes less time to complete than the state visual arts certification, but provides a solid foundation. It does not give you certification to teach in public schools, however. Teaching artist certificate programs are usually in effect for one year, often including an online portion and a supervised teaching placement.

Visual arts teaching certificate (pre-K–12)

Public school certification is not usually required, but is helpful, especially if you are involved in curriculum design for schools and after school. It will also help you to partner with K–12 programs in the local schools. It will give you more flexibility in the classroom, because noncertified teachers are not allowed to be in the classroom without a certified teacher being present.

Teaching Experience

Most, but not all, teaching artist positions require some teaching experience. Most organizations placing teaching artists in public schools require teaching experience, particularly in a public school. If a job posting requires two years' experience, keep in mind that those years do not need to be consecutive. Sometimes, if you are the right match for their organization, you can learn on the job. However, if you do have previous teaching experience, you will have an idea of the age and population with whom you would like to work, and how to manage a classroom and present material effectively.

Some organizations have mentoring programs where you can shadow an experienced teaching artist, or teach under the supervision of one. Some of these require previous experience, but again, not always. Many community-based organizations have volunteer programs, sometimes requiring as little as one session a week, which can fit into your schedule. You can offer to give a short activity in a local school for example, to gain experience, or you can volunteer in a camp.

If you would like to teach through an arts or community organization, research community-based organizations in your area. Find one whose mission and programs resonate with you and intern or volunteer to get experience. Most have internships or volunteer programs in place, but if they don't, offer to help out

and show your willingness to get involved. There are many opportunities during the summer when children and teens are on school vacation. Once you demonstrate your commitment to them, they will place more emphasis on your training, mentoring, and other forms of professional development.

Careers within an Organization

Many teaching artists launch their careers through nonprofit, community-based organizations. You may work your way up through an organization, including training other teaching artists, and overseeing and planning curriculum. You may wish to stay with this organization throughout your career, join another one, or start your own. Countless full-time educators, education directors, program managers, and other staff of community-based arts organizations, universities, and arts and cultural institutions started their careers as teaching artists, often at the same organization.

Careers as an Independent Teaching Artist

Over time, you will develop your own pedagogical ideas, projects, and programs. Eventually you may wish to become your own boss, either by starting your own organization or by becoming an independent contractor. As you gain experience, you will focus your practice and specialize in a particular aspect that interests you and features your talent.

Develop an area of specialization that correlates with your own artistic practice. For example, if you are interested in portraits, you could develop a few projects based on that as your particular area of expertise that you use to market yourself. Some teaching artists focus on a medium, such as oil painting, collage, or online storytelling. You may specialize in working with a particular population, such as preschool children, older adults, corporations, or particular cultural groups.

Learn about the issues important to the place you are approaching. Do your research beforehand: investigate online what is important to that particular school, or by having a brief conversation with someone who works there. If you have a personal connection to a teacher, administrator, or involved parent in that school, seek him or her out and discuss the school's philosophies and areas of interest. Find out what terminology they use, and speak the language of the people who work there. If you are working with schools, understand the language of test scores and standards. Show how your art project can help to raise test scores in mathematics and English. Understand how to utilize twenty-first-century learning skills and common core standards so you can show the principal how your program is relevant to her or him. Articulate how your art teaching contributes to each particular standard.

If you want to go out on your own, don't be hesitant to adapt language from the business community, such as "consultant" or "specialist." Learn and use self-promotion and marketing tools. Begin by designing a professional-looking website. Make sure you document all of your accomplishments and activities and publicize them through a blog or social media. If you are just starting out, volunteer to create a project at a local business. Then, publicize your work—you do not have to say that you did it for free or that it was in the window of your local wine shop. With persistence, you will gain a reputation that will lead to paid work. Publications, brochures, websites, and social media will all help to spread the word about your project to get funding, sponsors, and partners. As you get experience, you can market yourself as consultant in an area of specialty.

Recommendations and Skills

As with all careers in art education, written and oral communication skills are essential. You must be able promote your skills and communicate the rationale for your projects. You will be communicating with organizations, principals, teachers, parents, and students. Online and social media are important parts of your communication skill set. A second language may be useful, and often essential, if you are working with a community that is not English-language based.

If you are interested in community art, specific media are particularly useful for a teaching career in this field. Mural painting is one of the most popular forms of collaborative, public artwork. Any experience you can get in this area, whether through courses or volunteer work, will help you not only to get a job, but to succeed at it. Mural tiling is also popular, so any basic knowledge of how to make tiles or create a tiled wall will be useful. Digital murals are becoming increasingly more common, so knowledge of digital processes and large format printing will soon be essential. Quilting and embroidery are also useful in creating collaborative projects. Media arts, such as video, web design, photography, and graphic design also lend themselves to community projects as they are used for storytelling and interviewing, and can be shown to many people.

You need self-confidence, and belief in yourself. You should be independent, with the conviction to follow your own voice, doing what you think is right, rather than what is merely expected. You must have a positive attitude and see all challenges and setbacks as learning experiences. For example, if you need to be a waiter to support your fledgling teaching artist project, see it as a valuable lesson in customer service. Learn business skills, and take advantage of networking opportunities. Being flexible is the key to your success as a teaching artist.

You should be able to take initiative in proposing classes or projects. You should have strong leadership skills: be able to build a community and resolve conflicts. You must be resourceful, able to think on your feet, and willing to change and adapt your views throughout the duration of a long-term project. Keep an open mind, and accept a variety of outcomes to your project. Organization and time-management skills are required, because you will need to keep a complex schedule and calendar, in addition to managing multiple venues and projects at once. If you have great adaptability, flexibility, and enjoy changing work environments, you will enjoy the creative, rewarding opportunities as a teaching artist.

ᘒ7ᘏ

Your Job Search and Application

Y ou now have a good understanding of the teaching careers available in art, and how to prepare for them. The next stage is to pull your materials together and begin your job search. This process provides an excellent opportunity for you to reflect on your achievements and focus on your purpose and goals, both as an art educator and artist.

This chapter will explain how to find employment in the art education field. You will learn how to apply for specific positions. This includes writing your resume, tailoring cover letters for specific positions, even when a vacancy isn't listed, and determining your teaching philosophy. At the end of the chapter, you will find sample position descriptions, accompanied by corresponding cover letters and resumes.

BEGINNING THE SEARCH

Think about what you want to do careerwise. Make a list of every type of teaching position you would consider: Are you looking specifically for teaching art in an elementary school? Are you considering a variety of options, including adjunct teaching at a college, or being a teaching artist in a museum?

When you start the job search, the first step is getting organized. If you begin the process with a planning method in place, you will save yourself a lot of time and hassle, and prevent costly mistakes. Maintain a record to keep all aspects of your search in one place. Keep track of ideas from brainstorming sessions. Write down all contact information and dates from each communication. This way you will remember what positions you have applied for and the specific people you have contacted. Keep a bookmark folder in your browser to keep track of every place you have researched. Add to this list as you come up with more possibilities and ideas throughout the process.

Decide if you want to work where you live or live where you work. As you look at what jobs are available, consider the location. If you are not planning to move, put a pin on a map where you currently live. Then, draw a circle around that point, up to an hour away or whatever distance you are willing to travel. Now, look at all of the possibilities within your area.

Some positions, such as full-time college teaching, or museum work, may take you to a new geographical region, so consider whether you're willing to relocate for a job. If you are, check out the areas and see whether you could see yourself settling down there, and whether it is affordable to do so, considering the salary and cost of living expenses.

Example of job search records

Date	Contact Person & Info	Location	Position	Place Advertised
10/19/12 phone call	Admin Assistant Mary McGuire 423-535-7821	New School, Providence	Middle School Art Teacher	Sunday Times 10/18
10/24/12 faxed letter and resume	Principal Lance fax# 423-535-8822			
11/1/12 follow up call to principal re status	McGuire, Lance, confirmed receipt of fax			

Research

As you search for positions, research the place of employment carefully. This will help you to decide whether you want to pursue a job at this particular organization or not. Most importantly, it will help you to prepare your cover letter and interview. If there is a teaching opening at a school, find out about the school and the district. Learn about the mission of the school, museum, or organization. Investigate what you can about its history and recent developments.

Additionally, search for assessments and reviews of the organization. Some public schools and private schools are evaluated with online "report cards." These rating systems give information on the level of education of its teachers, the student-teacher ratio, the ethnic and socioeconomic background of its students, and often the results of local and state test scores. If it is a museum or community orga-

nization, look for articles about recent exhibitions, projects, and events. Online reviews can also help you formulate a sense of what the place is like.

Contact the appropriate administrators at the places from your list. Make sure that your information is up to date. Even if an opening is not advertised, sometimes you can get lucky, and there may be a vacancy that has not been announced. If there is nothing available, you may still get an interview and be considered for a position if one should arise.

When to Look

Art education jobs are posted throughout the year. Museums and organizations often hire in late summer to prepare for the school visit season in mid-fall. For school positions, when contracts are up for renewal, positions may open. This usually occurs around April, but can extend through until June. Summer jobs and early fall positions are available as well. Art educators may decide late in the school year to resign, retire, or go on leave. Sometimes openings occur late in the summer. Be ready to take advantage of any last-minute openings.

Where to Look

There are many places to look for a job—come up with as many possible resources as you can. This process will require that you do research, and use your creativity and strong communication skills. Don't rely on just one of these strategies—use many or all of them. As you read the job announcements, make sure that you have all or most of the qualifications. Consider all opportunities, but do not apply to those that are not a good fit, because that will be obvious to the potential employer. If you apply randomly, you will also become frustrated by the lack of responses for the effort you expend.

Online Sources

Job listing websites are great places to start. However, don't be discouraged if you do not see your dream job listed; many employers do not advertise on these sites, fearing that they will be flooded with applicants. Professional associations, such as the National Art Education Association (NAEA) and College Art Association (CAA), are excellent sources of job postings. Search for individual organizations that interest you. Often, individual schools, school districts, museums, and other organizations have sections devoted to job vacancies.

If you are applying for an art teaching position at a public school or in higher education, there may be an online application system. When you apply for jobs

online in this fashion, there are specific guidelines to follow. Sometimes the template limits your submissions and you must write generic cover letters and resumes. For public schools, check your state education department website. This will often list job announcements and current vacancies throughout each state through an online application system (OLAS). These sites are worth checking a few times a week.

Printed Sources

Professional publications list vacancies through newsletters, local, and national newspapers, and professional magazines and journals. Although most have online counterparts, some do not, especially the smaller, local publications.

In Person

Go in person to the school or organization to inquire about a position. Talk to the administrative assistants. They are the ones who really run the daily operation; they are the most important people there. So make sure you are dressed professionally, show up without food or drink in your hand, and do not bring anyone with you into the building. Find out from someone in the office whether it is possible to meet and converse with someone, or make an appointment for another time. However, be advised: refrain from coming across as pushy. Be deferential when you are there. Just walking in for the first time will help you form an idea about the place. Focus on your gut feeling whether you can see yourself working there. This visit will help you to tailor your cover letter, and subsequently provide you with information for your interview.

Many colleges, universities, and art schools post current job listings outside their department office. If you are a student or work in higher education, visit the art and education departments to see what is available. You may be able to visit even if you don't attend there.

Networking

Networking is an important aspect of professional development throughout your career and can lead to many opportunities. Some say that it is who you know that gets you the job, and what you know that keeps it.

Make a list of all who could be helpful to you, even if they are not art educators or directly connected to you. For example, a relative's friend may be a high school principal, or a friend's friend may run a local art supply store. See if these

connections will introduce you, so that you can then follow up by email or phone with questions. They may know about an opening, or be interested in hiring you to teach a class.

Stay in touch with people with whom you have worked or studied. If you are currently in school, talk to your professors. If you have graduated from college, get in touch with your professors. The department chair and faculty are often contacted about open positions before they are posted elsewhere. They may keep you in mind when they need to hire someone, or may know someone who does.

Go to different art or education events, such as art openings and artists' talks, even if initially, they don't seem directly related to job searching. You will be surprised who you will meet and what you may find out about potential opportunities. This is your chance to step out of your comfort zone and invent and explore new possibilities. You never know where this will lead you.

Online social networking can help launch your career. Create an online professional profile and join online communities related to art education. Make sure that everything you post is appropriate to obtain and keep a job. Search for yourself online and see what appears. The last thing you need is to have compromising photos of yourself online. That is what prospective employers would see as well.

University Career Center

A university career center can be helpful to both current students and alumni. You can begin and maintain a credential file with the office. Check with the office to find out what can be in your file. At the least, keep a list of names and contact information of your supervisors from jobs, practicum, and student teaching to use as references, with their prior permission. Include written recommendations in your file.

The center may offer career counseling and workshops or individual assistance with resumes, cover letters, and mock interviews. They often provide job counseling, listings of current job vacancies, and networking opportunities.

Alumni Associations

An invaluable resource for you can be the alumni association from your college. The association, as well as their individual members, may have leads to potential jobs. Many alumni associations have important opportunities for networking, mentoring, and volunteering. Some allow you to connect with others in your field through their website, social networking websites, and live events.

Professional Associations

Every profession has at least one professional association, including art education (see the resources section). Often, you can post your resume on their website, as well as search for jobs, if you are a member. They also have national and regional conferences, which are excellent opportunities to network. Keep in mind that some of these associations draw from a large, national base and will permit all members as well as potential employers to view your resume. Attend as many meetings as you can. Stay current and bring up your attendance and participation at upcoming interviews.

THE RESUME

As you begin to network and seek information, make sure your resume is in order. A resume is an advertisement to market your skills and achievements to a potential employer. This compilation of your accomplishments and experiences must capture his or her attention so you can rise to the next step—the interview. Because the employer will only spend about thirty seconds looking at your resume, it must be clear, short, and easy to read. Even though one-page resumes are recommended, two-page resumes are common, especially if you have a great deal of experience to include.

Creating and Customizing Your Resume

First create a master resume, which will include everything you have done professionally. Begin by listing your education, certifications, and then your experiences and accomplishments. When you apply for a specific job, read the position description carefully, and modify your resume accordingly. You will customize it for individual positions by selecting and highlighting different achievements.

Note: Hold on to this master resume, and add to it every time you accomplish something new. That way you won't have to rely on your memory again!

If you are applying for an academic position, such as college faculty, or a position that is abroad, you will need to submit a curriculum vitae, or CV. The CV is very similar to a resume, except that you do not have to limit your experiences to the last ten years. It includes more categories and details, such as publications and grants. Sometimes the two terms are used interchangeably.

Resume Design

In addition to the content, the visual presentation of your resume is important. As an artist, you will probably want it to stand out and reflect your style and person-

ality. This puts you in a difficult position: how to be different, without being "too different." Whatever you decide about the design, remember that your resume may be reviewed by other artists and designers with strong opinions about layout and fonts, or a principal or human resource director with no knowledge or interest in the style of presentation. Be sure to maintain a professional, clean look at all times.

The most common typeface is Times New Roman, 12 point. Whether or not you want to stick to that is up to you. Use your judgment to determine which size font looks most appropriate and is clearly documented and readable. Stay away from curly fonts and clichéd graphics, such as artists' palettes and paint brushes. Decide whether you want to enlarge your name so it will stand out and use capitals, indentations, bold, underline, or bullets to highlight terms or headings. However, do not use all of these tactics. *IT* WILL **defeat the purpose,** *and nothing* will then be •EMPHASIZED•!

If you are sending a resume through email, be aware that the recipient may not have the font that you used. Save and send your resume as a PDF to preserve fonts. Make sure you date and keep the original file, because you will need it to update and customize for other jobs.

Resume Categories

The resume has separate categories defining each section. It's up to you to decide exactly which categories to use, what terms to use, and how to organize them. In general, these sections are: personal information; career objective or career profile; education; certification; work experience; and other categories such as honors and awards, extracurricular activities, exhibitions, publications, bibliographies, community service, academic committees, task forces, civic affiliations, and skill sets.

Personal information

The first part of the resume is always your personal contact information: name, address, telephone number, and email address. Include your website, if you have one.

Make your name stands out, but do not go overboard, because that will make you appear to be arrogant or self-centered. If you are a student, include your campus address and permanent address. Use a professional email address based on your first and last name. Do not use your employer's email address, or a cute or funny one. Include the phone number where you can be easily reached, with reliable voice mail. Have a courteous, short message, without jokes or music. For resumes posted online, still include street addresses or phone numbers, and not just an email address.

Career objective or career profile

Underneath the contact information, you have the option of including a career objective or career profile. A career objective briefly states your short- or long-term career goals in one to two phrases or sentences. If you include this category, it should clearly reflect the position for which you are applying. However, if it is too specific, you may be limiting yourself from consideration of any other positions. Alternatively, a career summary states your current position, achievements, skills, and areas of interests. This can be bulleted, listed, or written in a brief phrase or sentence. However, be aware that this can take up additional, valuable space on the resume you are trying to keep brief.

Education

List your degrees in reverse chronological order, starting with the highest qualifications, such as graduate degree. If you are a student, write "degree expected" and give your anticipated graduation date. You can include your GPA if it is 3.5 or higher.

Certification

If you have teaching certification, include all the information on it: the type and subject of certification, the state, and the date, or date expected.

Work experience

This part details the responsibilities from your current and previous jobs. It can include more than one category, depending on the types and amount of work experience you have had, and the position for which you are applying. Highlight your teaching experience as much as possible. Include the information about the number of students, classes you have taught, and any innovative teaching methodology adopted by you for teaching the students. Emphasize your work and skills as an artist.

There are a few ways to organize your work experience. If you do not have very much experience, you can simply use one general category. You can have a category for *teaching experience* if you have more than one teaching position to list. Otherwise, you can have *work experience* or *employment experience* for paid employment directly related to art education. Other experience can be put in a separate category, such as *related experience*. Under this category, you can include volunteering and internships, and list tutoring or camp counselor positions. A category called *other experience* or additional experience can include employment that is

not directly related to art education, but shows valuable skills such as leadership, training, communication skills, and time management. Avoid listing any positions that would be considered too political or provocative.

Other categories

After you have detailed your work experience, there are many other categories from which to choose. Select ones that clearly highlight your most relevant experiences. If you are creating a CV, then you have room to include more sections.

Honors and awards can list scholarships, art residencies, grants, teaching awards, and any other recognition.

Extracurricular activities can show your involvement and responsibilities outside of a school setting.

Exhibitions list your work as a professional, practicing artist. These are especially important for teaching artist and college faculty positions. If you are including your own exhibitions as a student, give the title, dates, and location.

Publications include articles, reviews, catalogs, brochures, or books you have written, online or in print, or are in the process of publishing.

Bibliography lists articles, reviews, catalogs, brochures, or books that mention you or your artwork.

Community service, committees, task forces, or *civic affiliations* show leadership and community involvement.

Skill summary, or list of skills, highlights art skills, languages, and computer skills relevant to art.

Professional preparation lists relevant workshops, courses, or seminars you have taken recently to show that you are keeping current in your field.

Lectures and presentations you have given will augment your teaching experience.

Professional memberships show your involvement in professional organizations.

References either include a list of two to three names of references (who gave their prior permission), and their title and contact information, or the statement "References furnished upon request."

Filling in the Details

The next step is describing exactly what you did at each position. For your work experience categories, list each job, in reverse order chronologically, with the name of the institution, company, or school, the job title, and the location and dates. Some sections, such as skills, do not need to be chronological.

Write a brief description of your responsibilities in each position you have held. This can be a list, a bulleted list, or a phrase, without using pronouns such

as I, me, or we. For teaching, it should highlight any innovative teaching methodology adopted by you for teaching the students. It may include the number of students. Include tasks that show your art skills, teaching skills, classroom management, leadership, and initiative. Keep your descriptions short, but when possible, list activities as well as the results.

Resume for career changers, or for those returning to work

Consider a "functional resume" format, which is organized according to skill categories, rather than listing work experience chronologically. Under each category, give examples of what you did and where you did it, to demonstrate each skill. Try to keep limited work experience to the past ten to fifteen years.

A skill summary section, in addition to a career profile, keeps the focus on skills from your previous career that may be applied to your new one. Do not include unnecessary details, such as why you did not like your old career, or why you were not employed for many years. The skill summary does not have to include dates.

The 50+ resume

If you are over fifty, you will have to adjust your resume to avoid any age-related bias your employer might have. Follow the advice in the previous section. One option is to omit the dates on your education. However, know that this may raise eyebrows as to why you left out important dates. If you have taken any coursework or earned any certificates, highlight those and include the dates if they are within the past fifteen years. Include the date of a recent graduate degree. This will prove to your employer that your education remains current. Be careful not to have glaring gaps of time in your resume that will look like you are hiding something.

Employers often assume that workers who are no longer recent graduates have not kept up with technology, so highlight your knowledge in this area at every opportunity. If you can, consult with someone in the field to make sure that your resume includes current terminology. For example, terms such as "word-processing," "multimedia," and "World Wide Web" seem dated, not to mention "floppy disk." Refer to "opportunities for differentiation" or "differentiated instruction" when referring to one to one or small-group teaching methods, not "individualized instruction."

Tailoring your resume for specific art education positions

Customize your resume for each job that you are seeking. For example, a resume for a teaching artist position would include additional information about your career in studio art, such as exhibitions and reviews.

For a museum education position, you would focus on previous museum experience, including internship and volunteer positions. Highlight any art history coursework, in addition to your teaching.

For an adjunct instructor position at a college, emphasize any higher education experience and include advising, committee work, or any other aspect of college teaching in which you participated. For this type of position, include more detailed information about your work in the art profession, such as any writing, curating, design, awards, residencies, and participation in organizations.

Tailor each resume and cover letter to respond directly to qualifications requested. If a prospective employer seeks someone with leadership skills, provide specific examples where you were in charge. If they ask for someone who is bilingual, show not only that you have that skill, but also be able to back it up with examples where you have used it.

Important Tips

Do

- Use a high-quality ink-jet printer or laser printer.
- Use high-quality paper, in white, ivory, or light gray.
- For emailed resumes, save the file as a PDF to maintain formatting and fonts.
- Proofread carefully and ask others to help you.
- Allow plenty of white space so it is easy to read.
- Use bold, capitals, italics, and bullets but don't overdo it or nothing will stand out.
- Use a clear font about 11 or 12 points. The most common is Times New Roman, 12 point.
- Write in first person, but drop the "I." For example: "Designed class online gallery" not "I designed the class online gallery," and not "Designing the class online gallery."
- Keep tenses parallel (for example, avoid "I designed and draw . . . ").
- If you do use color, be very conservative and use it sparingly.

- Use industry-related terminology.
- Match the terminology in your cover letter and resume to the language in the job announcement.

Do NOT

- Invent, lie, or pad your resume
- Use your employer's email address or letterhead
- Give an email address that could be construed as inappropriate
- Use fancy or curly typefaces
- Include salary history, salary requirements, or scholarship amount
- Mention anything from high school
- Include personal information, such as names of children, marital status

THE COVER LETTER

The cover letter seems like the simplest part of the package to complete, but you may find it the most difficult. A basic letter consisting of a few paragraphs can be a deal-maker or breaker. With the cover letter, you spark the interest of the employer to look at your resume. The cover letter is your introduction to a potential employer or place of study. It takes the information from your resume and highlights the parts that you wish to emphasize. It should reflect a positive attitude, self-motivation, and enthusiasm. The content, the presentation, and your writing skills are of utmost importance.

Whether you apply online, through email, or through postal mail, your cover letter (and if applicable, the information in the addressed envelope) needs to be properly formatted, readable, and free of mistakes in spelling, punctuation, and grammar. The cover letter is viewed only briefly, so keep it relatively short. At first glance, the letter gets up to about a minute of attention by a potential employer.

Each cover letter should be tailored to an individual position. The cover letter can be for an advertised job, or a request for potential openings. Be as specific as you can in all areas of your cover letter—do not use vague generalities that could be used for any job. Identify the name of the school or institution. Read the job description carefully, and use the same or similar terminology in your writing. Briefly underscore any aspect of your background, education, skills, and accomplishments that would most interest the employer, and explain why your qualifications are a good match for the job.

The Cover Letter Format

All cover letters follow a similar structure and format. They are comprised of several parts: contact information, a salutation, the body, and closing.

There are few variations on the business letter format, but we suggest that you put all information flush left, aligned with the left margin. Include a one-inch margin, so people can write notes on it, and it will be easier to read.

Contact information

The cover letter begins with the contact information. Start with your address. Write it out fully and do not use abbreviations: use "Road" rather than "Rd." Put the address flush left. Place your phone number and email address under your street address. Be sure to use the phone number and addresses at which a prospective employer could reach you.

Date

Skip one line and type the date in full, with the month spelled out and no abbreviations.

Salutation

Skip another line, and put in the name, position, and address of the person who will receive your letter. Do your best to find out if you don't know who it is. Check online or even call the organization itself to find out who is currently in charge, and make sure you have the correct title and spelling of the name. "To Whom it May Concern" should be used as a last resort.

The opening

A strong opening paragraph will spark your prospective employer's interest to read the rest of your cover letter, rather than tossing it aside. This short paragraph forms the reader's first impression of you. It is like your entrance into the room—attention is focused on you for this brief moment. State the position for which you are applying, explain how you heard of the position, and briefly introduce yourself. If you have already contacted the employer, remind him or her: "I called yesterday and we discussed . . . " List any personal connections that led you to this place of employment. Demonstrate, in one sentence, your qualifications. If you cannot

come up with a catchy opening right away, write down the basic information and come back to it later, after you have written the body of the letter.

The body

In the body of your cover letter, explain why you are interested in this specific position and particular school, museum, organization, or other place. Demonstrate why you would be a good fit for the job in one or two short paragraphs.

Show that you respect and admire this institution, that you know something about it, and that you are not applying randomly. For example, if you are applying to a museum, explain why you find the collection interesting. Point out any special qualifications you have related to its collection. For example, if it is a museum of contemporary art, point out any related coursework you have had. You can name a particular exhibit, event, or part of the permanent collection, and explain why it was significant to you. Better yet, share why you admired any aspects relating to education, such as a gallery tour, an activity, or brochures. Read the mission statement on the organization's website. You can point out any part of their philosophy or purpose, and state how it relates to your own goals and experiences.

Highlight an example or two from your resume of what makes you stand out from the other candidates. Show how you fit the criteria for the position. Then, describe whatever part of that experience shows off your skills. If you are applying to a high school with a popular ceramics studio and a photography lab, for example, stress your knowledge and experience in these areas. Mention that you ran the photo lab in college, or helped to fire the kiln and mix glazes. You can detail particular coursework, such as wheel-thrown and hand-built ceramics. If you have taught these subjects, provide details. You can mention a particularly successful project and its outcome, such as a photography project that culminated in a well-attended exhibit of family portraits at the local library.

Mention any other related skills; if you are applying for an education position to an organization that works with people of Latin American heritage, stress your Spanish language ability and knowledge of Latin American art history. Choose these details carefully and appropriately: make them short, and keep in mind the needs of the organization. With pre-K–12 teaching positions, administrators are always looking for teachers who can manage a class well. If you refer briefly to your effective classroom management skills, you will have an edge over other applicants. Omit any qualifications that you do *not* have. You do not need to list everything, your resume will do that, and, if you are interviewed, you will have the opportunity to elaborate further.

The closing

The final paragraph is very brief, thank the employer for considering your application, and offer to come in for an interview or to provide further information. State what you have included with your letter, such as your resume. You may also let them know if you will follow up in the near future to check on the status of your application—then remember to do so.

Sign off with something formal, such as "sincerely." Then, skip four lines and print your name. Write your signature above it. You can also add your phone number or email after your name. Doing this will make it easier on the prospective employer, he or she doesn't have to look back to the top of the page to find your contact information.

The email cover letter

In addition to sending printed cover letters in the mail, sending the cover letter by email is becoming more common. While the content will be the same, there are technical considerations when applying online or through email. In the body of your email, use the same formatting as for a printed cover letter. In the subject line, write something appropriate and specific such as "Pre-K art teacher position." Include your contact information in the email, including your postal mailing address.

Avoid attaching large files, which will take a long time to download, unless the employer requires it. Save your resume and send it as a PDF so the formatting and fonts will be preserved. Before you send it to the employer, email it to yourself first. Print it out, and proofread everything before you send it to the employer. Then BCC to yourself for your records.

Important Tips

Do

- Use short sentences.
- Apply the correct grammar: pay attention to subject–verb agreement (He/she is, not they are when referring to a particular person).
- Use topic sentences and organized paragraphs. Each paragraph should be about one topic and sentences and paragraphs should flow from one to another. Use transitional sentences to change ideas.
- Use active voice: "I am writing this letter" not passive voice: "The application is being sent."

- Stick to a clear font and style. Twelve point Times New Roman is most typical.
- Show, don't tell, and give brief examples to support your statements. For example, rather than "I enjoy working with children," say, "When I worked with fourth grade students, I found them to be creative and willing to take risks with their work."
- Convey enthusiasm, willingness, and a good attitude.
- Be mature and confident: avoid silly, funny, or cute writing. Write formally even if you know the person.
- Review the job position carefully and use the same terminology that is in the advertisement.
- Know the difference between a principal and a principle.

Do NOT

- Be careless with "cutting and pasting" text (As you customize your cover letters, make sure each one is written to the correct person, and has the title of the corresponding position.)
- End sentences with a preposition (e.g., "This is the school in which I want to work," not "This is the school I want to work in.")
- Rely solely on spell-check or auto-correcting text programs, where the wrong word may be inserted to correct a misspelling (Spell-checking may insert an unintended homonym, such as "I taught their for four years.")
- Use a general salutation such as "To Whom it May Concern," or worse, "Dear employer" (Find the person's name and check to make sure this is the current and correct administrator.)
- Be demanding (e.g., "I'll call you this Tuesday 2:15 PM to set up an interview.")
- Be picky (e.g., "I don't work on Fridays," or "I'm allergic to sawdust.")
- Be hesitant or apologetic (e.g., "I'm sorry, I don't know everything about teaching art because I'm only a student," "I don't have experience but I will try very hard.")
- Brag (e.g., "I'm the best person you could hire for the job." If you feel that you are bragging too much, then you probably are.)
- Be too general (e.g., "I have excellent experience for your position," or "I've always wanted to work for Disney because I love their movies.")
- Use words such as "thing," "a lot," "misc.," or "etc."
- Begin more than three sentences in a row with "I"

STATEMENT OF TEACHING PHILOSOPHY

When you apply for art education positions, or for enrollment in a graduate program in education, you may be asked for a statement of teaching philosophy. Even if it isn't specified as part of an application, it is important that you are prepared with one for your interview. It should also be included in your portfolio. When interviewed, you need to be prepared to articulate your theory or approach to teaching, your goals and motivation, and methodology.

Writing a philosophical statement is a useful endeavor that you will use in all aspects of getting a job. Developing a teaching philosophy is beneficial, not only to your prospective employers, but also to yourself. Articulating why and how you teach is a good way to excel in an interview, and also to gain understanding of your own teaching style. Don't be surprised if your philosophy changes as you gain more experience. It is usually short, under one page. It can be a few sentences or a few paragraphs. You may also adapt your statement slightly to reflect a particular position for which you are applying.

By reading your statement, the readers should be able to visualize your classroom, and get an idea of what it might be like to be one of your students. Have them imagine what kind of learning environment you will create by communicating your enthusiasm and passion for teaching. Demonstrate your knowledge of learning theory, cognitive development, curriculum design, classroom-management strategies, and special projects. You may include what you have learned in the past and what you plan for the future.

Your statement should be easy to read, not didactic, and keep the reader in mind. Don't be too adamant. For example, instead of pronouncing, "I do not believe in lecturing," say that you include hands-on experiences as much as possible. Instead of saying, "Coloring books are damaging to children," you can give an example of how you stimulate students' creativity by having them choose what to draw. Also, make sure you do not restrict yourself to a certain age or grade. Then, if something else comes up, you will not be considered for the opening. Finally, keep your statement short and refrain from being provocative.

The Writing Process

First, read Chapter 10 to familiarize yourself with a variety of historical, theoretical, and curricular perspectives. Then consider the following questions. Some will inspire you more than others. You do not need to address them all. After you have answered them, figure out which ones you want to concentrate on and begin

to organize your ideas into paragraphs. Then, write as many drafts as you need. Have both education professionals and others read it over to make sure it is error free and understandable.

- Why do you teach? Give examples of something you found rewarding.
- What is the purpose of art education? And how do you go about achieving it?
- What do you teach? Which art media and projects would you use for different age groups?
- What methods do you use to teach? Demonstrations, lectures, hands-on, and group and individual work are just some examples of teaching methods.
- What are your goals for each unit you do? What are the objectives you wish to achieve by the end of each lesson session?
- How do you adapt your procedure for different ages, situations, or abilities? Explain broadly how you differentiate instruction for your varied learners.
- What is your style of classroom management? Give an example of a technique you have developed that has been successful.
- What do you consider to be excellent and effective teaching practice?
- Who inspired you to teach art, and which philosophers or teachers have influenced you?
- Describe your ideal student/teacher relationship and what you do to foster this.
- What motivates your students? How do you do this?
- If you have not had teaching experience, describe methods and styles of your most influential teachers that you would want to implement.

Review the following examples of art education position announcements, cover letters, and resumes.

ART SPECIALIST POSITION DESCRIPTION

Atlanta, GA, Public Schools is seeking highly qualified Art Teachers. Please submit resume, three (3) letters of recommendation and application online to Mr. Tom Marsh, Chair, Art Department JLHS, through Applitrack. Deadline for submission is Monday, April 12.

High School Art Teacher

Location: Jacob Lawrence High School, Atlanta, GA
Certification Areas: GA State Certification in Art Education P-12
Description: HS Art Teacher for advanced studio art, including web-based and graphic arts
Teacher must be able to differentiate instruction, provide computer-based instruction using Adobe Photoshop and other media
Grades: 9–12

Latoya Johnson
latoyajohnson.com • latoya@latoyajohnson.com
501 Peach Street 6B Atlanta, GA 11373
917-688-3231

Mr. Tom Marsh
Chair, Art Department
Jacob Lawrence High School
5200 Roades Way
Atlanta, GA 30301

April 1, 2013

Dear Mr. Marsh,

I wish to apply for the art teaching position at Jacob Lawrence High School, as advertised on Indeed.com. I have a bachelor's degree from Valdosta State College in Valdosta, and will complete a master's degree in Art Education from Gadson University in Atlanta this June. I will also receive Georgia State Certification in Art Education (P–12), and Special Education General Curriculum (P–12). The arts-integrated curriculum and student-centered approach make this position at Jacob Lawrence High School a wonderful opportunity for me.

My teaching experience would greatly benefit your school. The excellent programs at Jacob Lawrence would allow me to use my passion for both new and traditional art media. While student teaching, my projects included graphic design, still-life drawing, and ceramic sculpture. As a full-time substitute teacher, I am honing my valuable classroom management, instructional, and assessment strategies.

Prior to becoming an art educator, I was a graphic designer. Subsequently, I decided to become a teacher after realizing that I preferred working with people rather creating a product. My proficiency in current arts technology enables me to instruct with current graphic arts software and design websites for the class. In my teaching, I implement many strategies from my design work, such as time management, organizational skills, and team work.

My philosophy of teaching is that art is essential for all students, not only to develop art, but also to promote critical-thinking skills, and to create connections across disciplines. I strongly believe in using arts learning to carry out Jacob Lawrence School's mission of preparing students in character education and citizenship.

My resume is attached. Thank you for your consideration of my application.

Sincerely,

Latoya Johnson
latoya@latoyajohnson.com

Latoya Johnson
latoyajohnson.com • latoya@latoyajohnson.com
501 Peach Street 6B Atlanta, GA 11373
917-688-3231

CAREER PROFILE

Creative teaching professional specializing in the visual arts with a passion for helping students of diverse abilities reach their full academic potential. A collaborative instructor who designs a dynamic art curriculum addressing educational standards and core subject areas.

EDUCATION

Expected June 2013	**Gadson University**, Atlanta, GA M.S. Art Education, Special Education General Curriculum (P–12)
May 2005	**Valdosta State College**, Valdosta, GA B.A. Graphic Design, Minor: Spanish Graduated Magna Cum Laude

CERTIFICATIONS—STATE of GEORGIA

Expected June 2013	Art Education Certificate (P–12)
Expected June 2013	Special Education General Curriculum Certification (P–12)

TEACHING EXPERIENCE

September 2012–present	**Atlanta School District**, Atlanta, GA SUBSTITUTE TEACHER—JUNIOR HIGH and HIGH SCHOOL Provided instruction in the event of teacher absences in a variety of subjects including Art, Special Education, and English Language Arts.
January-March 2011	**Carter School for the Intellectually Gifted and Talented**, Atlanta, GA STUDENT TEACHER, ART Designed and taught a rigorous series of units for sixth, seventh, and eighth grade students, including self-portraiture, still-life drawing and ceramic sculpture. Utilized classroom management techniques.

March–May 2011	**Fresh Start School**, Atlanta, GA STUDENT TEACHER, ART Implemented teacher's plans on color and shape for kindergarten students. Designed and taught unit on puppets. Utilized classroom and time-management techniques.
Summers 2009–2010	**YMCA Summer Camp,** Atlanta, GA TEACHER, ARTS and CRAFTS Taught group of 12 grade 1 children a variety of arts and crafts projects.

RELATED EXPERIENCE

2007–2009	**Southern Fried Magazine**, Atlanta, GA ART DIRECTOR Supervised teams of editors and designers, conceptualized layouts, directed photo shoots. Responsible for print production and digital content. Managed several projects simultaneously in deadline-driven environment.
2005–2007	**Southern Cuisine Magazine,** Atlanta, GA JUNIOR DESIGNER Designed advertisements, layout, illustrations, digital photo-retouching and copy-editing.

EXHIBITIONS

2012	**Gadson University Art Gallery,** Atlanta, GA, "Me, Myself and I," solo exhibition
2011	**Galerie Quincampoix,** New Orleans, LA, juried art exhibition

LANGUAGE SKILLS

Proficient in Spanish, conversational French

ART AND COMPUTER SKILLS

Web and blog design, Adobe Creative Suite, ceramics, drawing, painting, digital and traditional black and white photography

MEMBERSHIPS

National Art Education Association
Georgia Art Education Association
Council for Exceptional Children

REFERENCES Available upon request

MUSEUM EDUCATOR POSITION DESCRIPTION

Museum Educator
Majestic Museum of Art, Los Angeles, CA
51234 Majestic Blvd.
Los Angeles, CA 91235

The Museum Educator will create, implement, and evaluate a broad array of educational programs relevant to collections and exhibitions in collaboration with museum staff.

Classroom responsibilities include developing, teaching, documenting, and assessing studio art lessons and gallery talks for diverse visitors. The successful applicant will develop community partnership programs, work with docents, and the public relations and fund-raising departments. The Educator will be responsible for planning and coordinating family festivals and events. Additional weekend and evening work required.

The Museum Educator reports to the Director of Education.

Museum and teaching experience, as well as a Master's degree, is preferred. Bachelor's degree in Fine Arts, Education, Art History, Museum Education or Museum Studies is required.

Full time with benefits, salary commensurate with education and experience.

Send resume and cover letter by June 10, 2013 to:

Ms. Susan Samuels
Director of Human Resources
humanresources@mma.org

Nora T. Dorman
555 Surf Avenue
Costa Mesa, CA 92626
ndorman@dmail.com • 512-349-2912

May 28, 2013

Ms. Susan Samuels
Director of Human Resources
Majestic Museum of Art
1234 Metropolitan Avenue
Los Angeles, CA 90210

Dear Ms. Samuels:

I was excited to see your advertisement for a Museum Educator at the Majestic Museum of Art, on May 14, 2013, in the American Museum Association's online job bank. This position particularly interests me because of the Majestic Museum's unequalled collection of 20th-century modernist works, which I have studied extensively. This opportunity would allow me to utilize my knowledge of 20th-century art and my experience in teaching studio projects with contemporary themes.

I recently completed an MFA degree in Painting at California University, and I have a BFA in Art from Arizona College, with a minor in Art History. My coursework has given me an excellent background to design and implement education programs at Majestic Museum of Art. My art history coursework focused on mid-century modern art and design, as well as contemporary art theory. My studio art background, which includes a full range of studio art practices, provides me with a strong knowledge base for designing an inspiring curriculum for modern and contemporary art in a museum context.

My professional experience has also prepared me to create inquiry-based projects for diverse participants of all ages. During my internship at the Guggenheim Museum, I had the extraordinary opportunity to introduce modern art to teens with autism. For adult audiences, I designed gallery talks African Art's significant contribution to the Modernist aesthetic. I worked with museum staff and community partners to organize public programs for families. At the LA Senior Center, I received the Volunteer of the Year Award for my innovative teaching methods in my weekly painting class, which introduced digital painting to older adults.

I look forward to a possible interview for the Museum Educator position with the Majestic Museum. Thank you for taking the time to review my attached resume.

Sincerely,

Nora T. Dorman

NORA T. DORMAN
555 Surf Avenue, Costa Mesa, CA 92626 ndorman@dmail.com 512-349-2912

EDUCATION
California University, Los Angeles, CA May 2012
M.F.A. Painting, GPA 3.9
Related coursework: Aesthetics, 20th C Art History, Painting, Digital Design

Arizona College, Tempe, AZ May 2010
B.F.A. Studio Art, minor Art History GPA 3.9 Cum Laude
Related coursework: Art Theory, Art History, Painting, Sculpture, Spanish, Anthropology

EXPERIENCE
Googleheim Museum, Los Angeles, CA January–June 2012
Intern
• taught modern art to 2 classes of teens with autism
• designed gallery talks about the influence of African art on Modern art
• assisted in developing public programs, for monthly family days and holiday events
• engaged families in art-making activities in the Education Center

LA Senior Center, Los Angeles, CA 2010-present
Instructor Volunteer
• received Volunteer of the Year Award 2011
• created and taught innovative Digital Painting course, introducing computer art to older adults
• worked with Education Committee to design, purchase and install new computer lab

Peter Andrew Contemporary, Laguna Beach, CA Summer 2009
Gallery Intern
• provided information to visitors during regular gallery hours and openings
• wrote text for exhibition labels and brochures
• wrote artists' bios and exhibition statements
• compiled and updated client database
• updated web site and created new artist profiles pages

RELATED SKILLS
Language: Spanish, Creole
Computers: Adobe Photoshop, Corel Painter, MS Office, HTML, CSS, Filemaker Pro

SELECTED EXHIBITIONS
Blank Slate Gallery, *"From Pixel to Paint,"* solo exhibition, California University,
 Los Angeles, CA 2012
Boom Box, *"LOL,"* group exhibition, Pasadena, CA 2011
The Tack Factory, *"The Eames' Meme,"* 2-person exhibition, Venice, CA 2011

TEACHING ARTIST POSITION DESCRIPTION

Art for All, a nonprofit 501(c)(3) art education organization, seeks seasoned Teaching Artists to teach elementary grades in Chicago public schools.

Background
Art for All provides Chicago residents with access courses, workshops, and hands-on programs that enable them to use the arts to enhance learning in core subjects.

Project Scope
Teaching Artists are contracted to provide a complete "residency" (educational program) at a public school. This will include:
- Meeting with school staff to determine their needs
- Customizing media curriculum for the school's program
- Delivering classes to students and assisting with their final projects
- Report outcomes and assessment
- Obtaining and transporting materials & equipment needed for classes

Qualifications
- Expertise in drawing, painting and three-dimensional media
- Experience teaching school-aged children
- Knowledge of curriculum development and assessment
- Familiarity with classroom management techniques
- Working knowledge of curriculum design, state and national academic content standards in the fine arts and other disciplines and concept of arts integration
- Ability to work well with diverse populations

Schedule
School-based residencies are during the school day and after-school hours.

Compensation
To be determined based on the nature and term of the school residency.

How to Apply
If you are interested in this teaching opportunity, please e-mail a brief cover letter and attach resume, to jobs@Artsforall.org attn: Ms. Jenkins. Please write Teaching Artist in the subject line. No phone calls, please.

From: cory@dominguez-varet.com
Subject: Teaching Artist
Date: May 15, 2013
To: jobs@artforall.org

Dear Ms. Jenkins,

I would like to apply for the position of Teaching Artist at Art for All, as listed on your website. I am a teaching artist with experience in working with students of all ages in schools and nonprofit community arts organizations throughout Chicago and Illinois.

My education includes a BFA degree in Studio Art from Illinois College, Naperville, Illinois, and an MFA from Indiana College, in Gary, Indiana. In 2008, I participated in an Arts Cultural Exchange program in Guadalajara, Mexico. This international education underscored the importance of understanding people of all backgrounds and cultures.

My goals in teaching include collaborative education, differentiated instruction, creative problem-solving, and innovative cross-disciplinary teaching. I honed my skills in arts integration, classroom management, educational standards, and assessment as a teaching artist at the Reach for the Stars Elementary School in Chicago. I learned how to create and deliver curriculum to a diverse student body. I gained further experience as an after-school teacher at the Barack Obama Middle School in Chicago. In addition, I took workshops at the Community Art Center in Joliet, Illinois, in teaching art.

During the past four years, I have had experience balancing a teaching and art career. I maintain an active art practice, creating and exhibiting work, while working as a teaching artist. My work as an artist focuses on drawing, painting, and printmaking, and is exhibited locally and nationally. I draw upon my creative process as inspiration for my exciting projects with school-aged children, who, in turn, inspire me.

Thank you for considering my application, and I look forward to discussing my work with you. My resume is attached to this email, and my website, www.Dominguez-varet.com, has examples of my own and my students' artwork.

Sincerely,

Cory Dominguez-Varet

Cory Dominguez-Varet
5912 5th Avenue #1
Chicago, IL 60617
312-539-1394
www.dominguez-varet.com
cory@dominguez-varet.com

Education
Arts Cultural Exchange, Guadalajara, Mexico 2008
Bachelor of Fine Arts in Studio Art, Illinois College, Naperville, IL 2004

TEACHING EXPERIENCE
Teaching Artist, *Art in Schools,* Joliet, IL
Reach for the Stars Elementary School, Chicago, IL, Fall 2010–Present
Introduced grades 2 through 5 students to drawing, painting, and printmaking practices. Collaborated with classroom teacher on unit and lesson plans. Worked closely with art chair, principal, and *Art in Schools* coordinator to create teaching objectives and assessment methods. Incorporated National Education Standards. Worked with classroom Math teacher on projects incorporating geometry and proportion. Produced end-of-semester displays of student work.

After-School Teacher
Barack Obama Middle School, Chicago, IL, Summer 2009–Present
Working as an after-school teacher in grades 6–8 and inclusive classrooms. Implemented art projects reinforcing literacy and history.

Teaching Artist
Chicago Public Library, Chicago, IL, Fall 2010
Taught collage workshop, resulting in a mural displayed in the entrance foyer. Worked with senior citizens in individual and collaborative artworks involving memory, local and personal histories.

RELATED EXPERIENCE
Artist's Assistant
Book Arts Press, Evanston, IL, 2006–2007
Assisted Visiting Artists in all aspects of printmaking, papermaking, and book arts. Documented projects and led tours for school groups.

Graphic Designer
Z Design, Chicago, IL, 2004–2006
Designed and produced books and brochures on scientific subjects.

VOLUNTEER EXPERIENCE
Technical Assistant
GreenWorks Community Mural Program, Springfield, IL, 2003
Provided technical assistance with painting and design of community murals, surveyed community, documented ongoing work.

Teacher's Assistant
ArtLab Afterschool, Booker T Washington Elementary School, Chicago, IL, 2004–2006
Assisted grades 3–5 students with projects in after school program. Helped set up materials.

SELECTED EXHIBITIONS
The Nature of Impermanence, Green Gallery, Chicago, IL, 2013
The Void Examined, Owl Press, Chicago, IL, 2012
Torn/Folded, Gallery Y, Chicago, IL, 2012
Book Arts Invitational, Peoria, IL, 2011
Arts Midwest, Des Moines, IA, 2010
Boise Right Bank Gallery, Boise, ID, 2008
Best New Artists, HSBC Bank, Chicago, IL, 2007
Marlyn Seton Memorial Show, Dubuque, IA, 2006

GRANTS AND AWARDS
Residency, Mural Painting, Academy of Arts, Chicago, IL, Summer 2009
Artist Workspace Residency, Stockholm School of Art, Stockholm, Sweden, Summer 2008
Residency, Colony for the Arts, Boise, ID, Summer 2004
Exhibition grant, Artists Space, Chicago, IL, Fall 2004

PROFESSIONAL DEVELOPMENT
Teaching Artist Workshop, Community Arts Center, Joliet, IL, July 2011
Seminar in Mural Arts, Community Arts Center, Joliet, IL, October 2011

❦8❧

The Teaching Portfolio

In addition to your resume and cover letter, visual information will communicate your skills and accomplishments. Your portfolio is essential to take when going on an interview. The portfolio is a way that administrators of schools and programs can determine your experience and assess your success as a teacher.

As an artist, you are already familiar with one type of portfolio: a professional compilation of your accomplishments as an artist. You probably already have a collection of images of your own best work across a span of time. For the art educator, the teaching portfolio presents your teaching materials and students' projects in addition to your own artwork. It includes a combination of images and written material. Like your resume, you will continue to add and edit your teaching portfolio over time, as you gain experience and develop new projects.

ORGANIZING YOUR PORTFOLIO

Incorporating Standards

Throughout the United States, there have been movements to standardize common expectations for teachers and students, including art. The format of your portfolio may be directed by these standards, because most states require this structure for teacher certification. Even if you are not a certified teacher, you may be involved in a program that works with K–12 schools. If so, your portfolio should reflect these standards as much as possible. Consider organizing your portfolio according to them, especially if you are pursuing a position in a public school.

Beginning teachers commonly follow their state's standards, as well as the Interstate Teacher Assessment and Support Consortium (InTASC) standards. Alternatively, you may find that National Art Standards are preferable. If you are not directed to use a specific set of standards, choose the one that reflects your

work the best. If you are using this method, list the standards in your table of contents, and organize your materials so they correspond to the appropriate categories. Then, link your unit and lesson plans to the specific standards they address. If you don't organize your portfolio sections according to the standards, you can still address it in your unit and lesson plans.

If you are a student in an art education graduate or undergraduate program, you will be creating a portfolio as part of your requirements. Check with your department at your college to see what is expected. If you are pursuing teacher certification, refer to your state's education department to see if a portfolio is required. If it is, look for a posting of the content requirements, and make sure that your portfolio has these.

Other Methods

There are other ways to organize your material for your portfolio. You can organize your work according to media, methodology, or overall concepts. For example, you can have sections on painting, or ceramics. Your sections can be devoted to projects related to Reggio Emilia, or aesthetic education. You might divide your portfolio into parts on "identity," or "fantasy." You could break up your portfolio according to elements of art and principles of art arrangement such as "line," "shape" or "symmetry." You can organize it according to level of instruction in a particular discipline, such as beginner to advanced. For higher education, in general, they are interested in your work focused in a particular discipline, rather than a broad range. They are not so interested in themes, for example, but rather methodology, the quality of the student's work and your expertise. Whatever method you choose, the most important concept is that you apply it consistently.

The Set-Up

A traditional, printed portfolio is the best resource to bring to your interview. It is easy to pass around and show people. Consider the portfolio container carefully, including the cover, and the way the pages are organized and put together. You can use a binder or portfolio case with page protectors. The most important consideration is ease of use. It must be sturdy and be able to withstand many people handling it and passing it around. It is more effective to have something sturdy and practical than one that is beautifully hand-done but falls apart. That being said, you are an artist, so all visual aspects of the portfolio are important. Every part of it will reflect your organizational ability and visual skill. Like the resume, choose an option you feel comfortable with.

Organize the material into sections so they do not appear to be a random collection. Make sure each section is identified and clearly delineated, with typed tabs or section dividers. Keep in mind that the future employers will most likely be flipping through it in a short amount of time. Make sure you clearly identify all work and offer a brief reflection of each piece you include. If you use plastic page protectors, or sleeves, place all of your work face-up so you don't have to slide the papers in and out. Make sure you know where you have organized your work. If you are asked to explain one of your submissions, you won't have to rummage through it.

Do not include everything you have ever done: select carefully to show your best work. You may tailor it toward a specific position. For example, if the position is for teaching elementary school, make sure you include projects for that age group. If the position is for photography, include work in that media. However, make sure you don't limit your options: include a range of work, you may be considered for other positions that may come up in the future.

Use a scanner, a digital camera, and layout or text-editing programs to create and place the images into a clear design. Touch up and enhance the photos digitally—correct the colors, enhance contrast, crop, delete backgrounds, and fix red-eye. Create labels and brief explanations for the images. For written materials, use a clear and simple format, similar to your cover letter and resume.

In addition, you can create a small brochure with photos, resume highlights, and contact information to give the interviewers when you leave. This will demonstrate your creative and technological skills, and make sure that the prospective employers remember you.

When you put your work together, keep in mind that the employer will probably spend less than a minute looking at your work. Some will not look at it at all. Don't take it personally. Remember, the interviewer will have probably seen a lot of applicants at this point. However, all is not lost. You can fit the portfolio into the conversation. For example, when answering a question, such as, "What is a favorite lesson you have taught?" ask if you may bring out your portfolio, and show the lesson plan and samples of students' art or photos of you working on that lesson with a class.

General Portfolio Components

The following categories are typically included. You may not have examples of every item listed, but you will add to it as you gain experience. You may also create lesson plans, parent letters, and ways to differentiate even if you have never taught before.

Beginning

Consider beginning with an introductory statement or title page, using a brief statement such as a short bio, to introduce yourself to the viewer.

Table of contents

The table of contents cuts down on fumbling for pages and shows how organized you are.

Resume

Bring extra copies and keep them in a separate place to pass around at the interview.

Professional credentials

Make copies of your state certification and your college transcript (if your grades are satisfactory).

Statement of teaching philosophy

You should have this from the last chapter.

Professional citations

Enclose copies of awards you have received, conferences where you have presented, documentation of special relevant training you received, and any publicity announcements of art openings or special activities that you planned.

Evidence of teaching

Enclose the following:

- A unit plan—One is enough. Include six to eight lesson plans or a summary. Do not include too many.
- Two to three separate lesson plans showing a range of grades, materials, and media—Check that at least some match what the prospective employer is seeking.
- Follow a lesson plan template within lessons.
- A parent letter if you have taught, or intend to, showing an example of how you would communicate.

- If you have done any multidisciplinary teaching, highlight it. This shows that you can incorporate students' general classroom lessons on humanities, science, social studies, mathematics, and reading. This also shows that you can collaborate with the other teachers.
- Include any work with technology. Show lessons or work where you have used a SmartBoard, and other ways you have incorporated technology, such as using digital cameras or computer arts software.
- Link state, national, and professional standards for art to specific steps in the overall projects and lesson plans.
- Include photographs of the students' work from each project. Show a few examples of different interpretations and levels, and include captions.

Reflections

Reflect briefly on each piece that you have added to the portfolio.

Visual documentation

Photographs of you interacting with the students will greatly enhance your portfolio, and give the employers a sense of how engaging and stimulating your classroom or program would be if you were hired. If you are photographing or filming the work of your own students, check on the school or organization's procedure first and make sure you have permission. Participating students and families may need to sign a waiver first. Often, students' faces are not included in the photographs. Be aware of what is showing in the background, and try not to include any projects or wall displays you don't like.

You can also include photos of the following:

- Community art projects, including work-in-process and participant interaction
- Hallway bulletin board displays and other student exhibitions
- Extracurricular activities such as yearbook or art club
- Openings and other celebrations

Commendations

Include awards you have received and honors you have earned.

Recommendations

Include letters of support from parents, cooperating teachers, students, and the principal, if you taught at a school.

As a rule, the references from supervisors will be the most valuable to prospective employers, who will want to speak to them directly. Leave those letters out of your portfolio, and only provide them when asked.

Your own artwork

- Include your artist's statement (especially for teaching artists and higher education positions).
- Do not include anything too provocative. Do not include nudes or politically charged work.
- Include artwork that is related to your lesson plans; for example, if you teach a self-portrait project, show some self-portraits that you have done.
- Show a range of media and subjects, especially if the position announcement calls for them. For example, if the position wants a photography teacher, show work in that area. If they want someone who can teach diverse media, demonstrate your versatility.
- Include a few postcard announcements of any exhibitions you were in and include some reviews of your work. This is especially important for higher education, as well as teaching artists. Be careful not to overpower the teaching section, you do not want to come across as an artist who really wants to be in the studio, rather than teaching.

Online and Digital Portfolios

While the print portfolio is still the mainstay of art educators, and an essential part of the interview, consider digital options. Online portfolios are becoming increasingly more prevalent for every arts professional.

Online portfolio

The online portfolio is effective because you can include a link in an email or printed cover letter, with no need to send bulky files. The potential employer can view it at his or her convenience, and see if he or she wants you to come in for an interview. The information can be easily updated. However, you have to make sure that everything works, and that it looks professional. It must have clear navigation on each page and reasonably sized images that upload quickly. These are becoming increasingly popular.

This is a wonderful way to present your technological skills. There are many online services that offer templates, so you do not have to be an expert in web design. Some of these are even free. Register an inexpensive domain name for yourself rather than use a long and awkward URL.

For online portfolios include:

- video clips of you teaching, if you have them
- photographs of you and your students (make sure you have official permission)
- links to articles or reviews about you and your work
- image gallery of students' artwork
- image gallery of your artwork
- clear navigation
- teaching philosophy
- lesson and unit plans
- artist's statement

Portfolio on disk

The digital portfolio can be on a CD, DVD, or flash drive. This has the following advantages: the artwork will look impressive on screen, parts of it can be printed out, and if it is a disk, you can leave it with them. It is also useful for video projects, or video documentation of performance and installation art. The disadvantage is that if you leave or send a disk, especially unsolicited, there is a large possibility that no one will view it. Also, you have to be sure to make everything accessible by all computers, including old and slow ones, or new ones without disk drives.

Present this as professionally as possible, with a sleeve, and with your name and date clearly printed on it, with no handwriting. Make sure that the images are easily identified, and include an image list that corresponds to the images. Use file formats that everyone can view, such as jpg, pdf, and plain text.

A CD or DVD portfolio may be required for advertised higher education positions, especially full-time, although online submissions and portfolios are becoming increasingly preferred.

Higher Education Portfolio

For positions in higher education, focus on this level as much as possible. If you do not have experience in higher education, include courses that you have taught in the appropriate art discipline, and show experience in teaching adults. Demonstrate experience or ability in the area described in the position description. Include:

- syllabi and project descriptions
- examples of students' work

- your own artwork (you should present a unified body of artwork, rather than a large range of subjects and media)
- documentation of exhibitions you have participated in, and other relevant professional work
- reviews of your artwork and other publications you were included in

Important Tips

Remember, the portfolio is like the taste of something—not the entire meal. You will be asked to elaborate on some of the work that was included.

- Do not include graded work.
- Proofread!
- Get permission from schools, museums, and organizations before you photograph them. Many places do not allow it or have policies you must follow.
- Stay away from nudity, profanity, and any political opinions, especially for elementary school.
- Have a printed portfolio no larger than 13 × 19—not huge floppy 18 × 24.
- Select the work carefully—do not include everything.
- Type every label. Only student work can be handwritten, if clear.
- Make sure every aspect of your portfolio is clear and organized.
- Do not include papers with rips or frayed edges.
- Practice presenting your portfolio and explaining it; make sure you do not have to pull out papers to support your responses, or appear disorganized.
- Have friends look at it and see if they understand sequencing and can readily see the organization.

Now you are ready for the interview!

9

The Interview

After you have submitted an application or contacted a prospective employer, consider a normal wait time of a few weeks. In the meantime, keep searching and applying for other positions. Feel free to follow up briefly, just to make sure that your materials have been received.

With patience, you will get the interview. Sometimes, this process will include one, two, or even more interviews for the same position. Here's what you need to know to prepare for this crucial next step.

Research

In Chapter 7 we discussed researching potential places of employment. Go back and review your research carefully, and delve deeper into the details. Preparing for your interview is the key to your success. Look carefully at the mission statement of the school, museum, or organization. Think of how your experience and teaching approach would fit. Articulate ways in which your experience can help to fulfill their mission.

Investigate the key members of the organization and the administrative hierarchy. If it is a school, then discern whether there is a principal and assistant principal. If it's an art department, then find out if there is a chair or head. In a museum, find out who is in charge of education and his or her title. Determine the size and structure of the department. For an organization, research the staff and teaching artists. Find out what programs they offer and how they are structured. Find out who will be doing the interviewing and familiarize yourself with their names and titles. Before you go, make sure that you have the correct names of the administrators. Once you are there, make a note of the names and positions of the interviewers.

Investigate the demographics of the people you will be teaching: the number of students, racial make-up, and socioeconomic group. If the position will involve moving to another location, research that as well. Be sure to look up any recent special exhibitions or projects they have had.

All of this information will familiarize you with the school, museum, or organization. When you are contacted, by phone, letter, or email to come in for an interview, make sure you call back as soon as possible to confirm. Make sure that your voicemail has a brief, professional message on it—no music! Once you return the call, avoid having any sounds in the background. Speak in a quiet place.

Phone Interview

Your first interview may be by phone. While this may seem scary, it gives you the opportunity to be comfortable and not worry about your appearance. You can also have notes right there in front of you to use as prompts. In advance, find a quiet place for the interview, where there will be no noises or interruptions. Make sure your phone is charged. Have the following in front of you: paper and pen, the position description, your resume, point for discussion, and if possible, the names and titles of interviewers. Have a glass of water ready too!

There may be more than one person present on the phone for the interview. It will begin with a round of introductions—make sure you write these names and titles down right away. They may start out with some friendly chit-chat—be friendly, but also be brief. They will begin with some general questions, which will become more specific as the interview continues. See later in this chapter for example questions.

Follow up with a brief thank you letter within twenty-four hours. A successful phone interview will lead to the next step: interviewing in person.

In-Person Interview

You may be invited to come in for an interview, without being screened on the phone. Once you have an appointment, strive to arrive fifteen minutes early for the interview. Bring ten copies of your resume, in case it is a group interview. Bring your portfolio, cover letter, and teaching philosophy. If you are unsure of how to get to the location, make the trip beforehand, but do not let anyone see you!

Attire and Presentation

Depending on the position and the organization, the attire can vary. So, make sure you dress appropriately and professionally. It is better to err on the side of

dressing too formally than the reverse. Even if you will dress in jeans when you are teaching, do not wear them for the interview. Avoid cologne, anything tight, low cut, or too short. Cover tattoos and avoid facial jewelry. Whatever you decide to wear, make sure you look neat and that everything is clean and ironed. Special note: administrators who are not used to artists will frown if they see paint or clay under your fingernails.

The Day of the Interview

Make sure you do not bring a friend or relative to the interview. If you need that support have them drop you off and pick you up later. Before you go in, turn off your cell phone and do not use it until you leave the building. Then, chit-chat briefly with the secretary. This is an important person—she or he has connections with everyone there. The secretary will direct you into a waiting area or into the interview itself. Do not use this time to turn on your phone and use it.

When you go into the interview itself, look directly in the eyes of the interviewer and anyone else at the table. Shake hands with everyone using a firm handshake.

Writing Sample

Sometimes, you will have to fill out an application before you go for the interview, or while you are waiting to be seen. A writing sample may be asked of you as well, especially for a school position. Often, your teaching philosophy is the subject of the writing.

The Interview Committee

Usually, this interview could be with one or two people, or even with a committee of five to nine people. In a school, for example, it may be with the principal, superintendent, or both. Alternatively, it could be with many stakeholders: an art teacher, chair of the arts department, sometimes a parent, general education teacher, principal and/or assistant principal, and sometimes a member of the school board.

The Group Interview

This same group may interview you along with other applicants vying for the same position. If you are among several other applicants, often each one will try to outshine the other. Keep your cool. Just answer the questions as confidently as

possible. Make sure you do not sit, and wait quietly. Participate, but don't talk over anyone else or interrupt others.

For a teaching artist position, don't be surprised if they ask you to interview the person sitting next to you, or engage in a seemingly unrelated activity with another candidate. This is a little tricky—this is not about answering questions and formulating responses. Instead, it's about your listening skills and your engagement with other people.

INTERVIEW QUESTIONS

Despite the variety of the positions and situations, the following interview questions will address general categories that will be asked of you. Prepare and practice answers to these questions before the interview. Answer them out loud and in front of a friend.

No matter where you will interview, prepare at least three good questions to ask. They may answer one or two during the interview. These questions should reflect your knowledge about the position and school, museum, or organization. You can ask about class size, art budget, if they have an art room, possibilities for collaboration or coteaching, what extracurricular activities you can get involved in, and which businesses or companies outside the organization support its endeavors.

Find a way to show the interviewers your portfolio, even if they don't ask. Use your portfolio as a way to show an example of how you would answer a question. For instance, if asked about the state art standards, you may reply that you incorporate standards in all of your lessons, and ask if you could show an example from your portfolio.

General Questions

- Why do you want to work at this school?
- Tell us about yourself.
- Tell us your greatest strength and your biggest weakness. (For a weakness, come up with something that is not really bad, and show how you have overcome it. For example: you are told by your supervisor that you work too much.)
- What hobbies do you have?
- What book are you reading now?
- How would you describe the layout of your ideal art classroom?
- Who is your favorite artist? (Try to show a range from a well-known artist to a less well-known one to demonstrate your knowledge. Do not say, "Picasso.")

- Why did you want to become an art teacher?
- Describe the person who most influenced you.
- Be prepared to address a variety of "what would you do if . . ." questions.

Knowledge of Content and Skills

- What art media can you teach?
- What art equipment can you use and maintain, such as kilns, photography, printmaking, and computers?
- How do you use technology in teaching art?
- How do you display or share student artwork with the school and local community?
- Describe one of your most successful art projects.
- How can you work with a small art supply budget?
- Why is art important to education?
- Give an example of one of your projects and how it fits with Common Core Standards, National Arts Standards, State Art Standards, or INTASC.
- How would you integrate art standards with a theme studied in an academic subject? (For example, if they gave you a topic of Native American Art, come up with a standards-based lesson for second grade.)
- Here are three paintings from the Chicago Institute's collection. Create a lesson plan that incorporates all three.
- How do you adapt an art lesson for students with special needs, or with a range of talent, skills, and interests?
- How could you use art to help with other skills in other subjects, such as reinforce reading, writing, and mathematics?
- How do you grade art?
- What assessment methods would you use to give pre- and post-tests?
- Describe your teaching style.
- What would I, as your supervisor, see when I enter your art class on a typical day?
- What teaching methods do you use?
- What is your philosophy of teaching art?
- What different art media would you use?
- Describe an example of a field trip.
- What extracurricular activities would you offer to this school?
- What would be a typical introduction to your lesson?
- Describe your procedure—what type of closure would you do? How do you handle set up and clean up?

For a higher-education position

Full-time college and university positions have their own intense interviewing process. Your first interview is likely to be on the phone. If you are attending the College Art Association (CAA) conference in February, you may have a preliminary interview there if you already applied for the position. Universities generally bring three of their top candidates to their campus for an intense series of interviews. They will organize at least one full day, including meals, and perhaps an overnight visit. While you are there, you will speak with faculty, students, and administrators. You may teach a class and present a lecture on your work as an artist.

- Describe your experience on the college level.
- What is your grading policy?
- What are your criteria for evaluation?
- What are your teaching methods? (They may be looking for a combination of lecture, presentation, discussion, and guided work.)
- Aside from the courses we assign you, what else would you like to teach?
- What technology do you incorporate in your work?
- Have you had any experience with online teaching, hybrid courses, or a course management system?
- Describe accommodations you have made for diverse students, including those with special needs, full-time jobs, first-generation college students, advanced students, or non-native English speakers.
- What committees have you been involved in, or would you like to join?
- For a full-time position involving relocation: Why do you want to move to this town or city? How would you get involved?
- They will ask you specific questions about your art work and other professional work.
- They will read your syllabi and ask you questions about them.

Interview Tips

- Dress professionally and conservatively, even if you will be dressed more casually once you get the job.
- Be yourself, but don't express any extreme or provocative behavior. They are looking for someone who can work with others, and who is kind and caring, but can also lead and manage a class.
- Do not say, "I don't know" or confess weaknesses during the interview. Ask them to rephrase the question—if you cannot come up with an answer right away, this will buy you a little time to think about it.

- Do not ask about salary or vacations.
- Even though you will be nervous, relax, smile, and show a sense of humor—let your true personality shine.
- Don't forget to have two to three questions for them.
- Be enthusiastic!

After the Interview

Any interview can take ten minutes to two hours. Shorter interviews may occur for a multitude of reasons that the administrators would have. Don't despair. This does not necessarily mean that you are not still a contender for the job. This could mean that the schedule of the day is crammed. If they feel that you would be a good match, you will hear back in a week or two, usually to have a second interview or do a demo lesson. Regardless, do not stick around and chat. This is not the time to be social. Thank them all, shake hands again, and leave. Thank the secretary, and leave the building.

Once you leave the interview, jot down notes of what was asked of you, and the answers you gave. These may be handy if you are brought in for an additional interview.

Write a short thank-you note. Email is fine, but handwritten ones are thoughtful, especially if you have nice handwriting and perfect spelling and grammar. Make sure to refer to the names of all who interviewed you—another reason you need to know their names. Make sure you see the correct spelling of the administration members.

Do not call to ask if you got the job. Wait to hear from them. However, if the administrator(s) said you would hear back in a few days or weeks, and you have not heard, wait a week or two after that point, and then call and ask what the "status" of your application is. If you do not get the position, chalk it up to practice, and prepare for your next interview.

Demo Lesson

You may be asked to come back and teach a demo lesson, especially for a teaching position in a school. Often, you will teach a sample lesson for a class that is in session or a class made up of student or faculty volunteers. If they are students, find out the grade level, and if you can, their names beforehand. Find out how long a lesson they would like. Come overprepared with materials. Bring copies of the written demo lesson plan, following the procedure outlined in Chapter 2.

You can also ask if there is a theme that is being taught at the moment, and if they would like a lesson based on that. Find out if they would like you to use

the materials already there and find out the amounts that they have. Don't assume that the school has any materials for you. Bring your own, even sharpened pencils and paper.

Make sure the interviewers see the set-up and clean-up sections. Incorporate strategies that could address a variety of skill levels and backgrounds in the class. Show your teaching skills through the motivation, introduction, and procedure. Have some sort of pre-assessment to determine what your "class" knows about the subject you will teach. At the end of the lesson, have a post-assessment. This could be a conversation about what they learned. Don't forget to have closure in the lesson, even if you don't get to finish what you planned. A five-minute summary is sufficient. Dress professionally, even if the materials are messy. Bring a neat, clean apron if necessary.

Christina Miles, a first year teacher, went on her interview during the summer. No classroom students were available; the panel that interviewed her acted in place of the students. Her lesson was on the topic of ink blots. She created a video presentation to start off the class, which included directions for the project, and background information on interpretation. She brought in ink, and had the participants make inkblots and interpret them as different animals. Then, she had the "students" write a response to one another.

YOUR NEW JOB

If you do get the position, congratulations! Now it's time to ask what you really want to know: health insurance and other benefits, for example. Inquire as to whether you should expect cost of living raises in the future. If the position is in a school, college, or university, find out about the tenure process and requirements. Find out about the "teaching load," and how much service and advising you will be doing. For teaching artists, find out what kind of support exists at your teaching site, and if they will pay for planning time, and for professional development. For all jobs, find out about opportunities for advancement, and mentoring and support. Investigate what technological assistance is available.

There may or may not be room for negotiation. If there is, it probably won't be much. If you are asked to sign a contract, don't wait too long to sign it. You can say you are being interviewed in several other places and will get back to them in a few days. Once you sign your contract, do not break it because that will reflect poorly on your professionalism.

Note: For all written communications

For your resume, cover letter, teaching philosophy, artist's statement, and all other communications, be very careful to use correct grammar and proofread everything. Accuracy is essential for every aspect of your application, from the cover letter to the thank-you note. Even one small error could prevent you from landing an interview or job.

Allow yourself enough time to put your writing aside for a few days or more, and then return to it. You will notice many typos, grammatical mistakes, and weak organization that you did not realize at first. Do as many drafts as you need. Reading your work aloud also helps you to spot typos and other mistakes. When you are ready, have other people read your work, not only to find errors, but also to see if the writing makes sense to them. Do not rely on spell-check because many times, errors are actually inserted by mistake or ignored by the program. Keep in mind that the employer may be reading hundreds of resumes and cover letters.

❧10❧

How We Got Here:
The Foundation of Art Education

THEORETICAL BACKGROUND

Now that you have had a chance to learn about different opportunities in teaching art, there is still one part that is missing: the different ideas behind the teaching itself.

In this chapter, we discuss some of the influential philosophers, important historical events, and resulting curricula. To begin, we have a little quiz for you. With this, you will see what type of teaching styles you would use in your classroom or organization. After you read the chapter, you will see that these techniques were based on theories developed by educators and psychologists. Place a check in the Yes or No box to reflect which statements match your beliefs.

Your beliefs	YES	NO
I believe that hands-on experiences are the best ways students should learn.		
How you look at art can impact how you perceive other aspects of your life.		
Understanding specific levels of growth can help you to find figure out what students should do.		
Students follow specific age-appropriate, developmental stages when they create art.		
Students should choose their ideas for topic, medium, and genre rather than have it decided by the teacher beforehand.		

Art is not suited to collaborative activities.		
Art should be incorporated with other academic subjects to make for better understanding of all subjects.		
Artwork should be used as models in a classroom.		
Traditional works of art should be copied.		

Now, imagine you are in an art class with your favorite teacher. What were the projects? What did you do during the class? Next, imagine the class of the teacher you didn't like. Do you remember any of those lessons or projects? What was the difference between the two educators?

When you think of the best art teachers you had, how they became great educators is not on your mind. Instead, you acknowledge that these wonderful art educators influenced you to become one yourself. You want to give back, and teach a new generation the way you were taught. Conversely, you may have had a terrible teacher, whose teaching was an example of what not to do. All of your teachers, good and bad, had teaching practices that were grounded in beliefs. Their influences came from their own teachers, philosophers, other thinkers, and experiences. Many art educators who were interviewed for this book spoke about specific inspiring writings of the philosopher, psychologist, or educator who influenced them. They read extensively, drawing from areas outside of visual art and education, to include poets, scientists, social philosophers, and playwrights.

Historical and political events have also impacted philosophies of art, as well as cultural and social movements within the context of a specific, current, or past era. Like art itself, teaching art is never stagnant—new ideas are introduced, and other principles are set aside or principles and theories are combined. Some of these theories may have seemed revolutionary when they were first introduced. Yet, years later, in retrospect, these beliefs seem to have been absorbed as common thinking in classroom teaching without a thought to their origins.

Why Should You Bother to Learn These Ideas?

What does philosophy have to do with starting an art education career? To begin with, when you go for an interview, you may be asked how you teach, or what your pedagogy is. You may be asked to submit a written teaching philosophy or describe the philosopher's theory that most likely matches yours. That's because administrators are getting a feel for you and checking whether your beliefs in teaching art match their perspective, as well as the mission of their institution.

Furthermore, this framework provides you with a variety of multiple per-spectives and approaches to art that you actually can use in your curriculum and lesson plans. You can stand back and look at the art through multiple lenses, as an artist, critic, or student. When you read different theories and methods of teaching, you are starting to accumulate important teaching tools. Then, when you actually teach and use instructional models, you will gain a foundation for your own thinking. It will be a launching pad for your own curriculum and projects.

HISTORICAL PERSPECTIVES

Major historical, political, social, religious, and even economic events have not only affected movements in art, but art education as well. These trends have a wide range, and it follows that if they impact individuals, they will impact teacher-directed curricula, where the teacher is the instructor and facilitator.

The art education models of today are reminiscent of the past. The atelier, from the French word for workshop, was prevalent from the Middle Ages through the nineteenth century. Education of that time was different. Young apprentices trained and lived with master blacksmiths, goldsmiths, and masons in local guilds or workshops where they produced fine or decorative pieces in the master's name. Later, academies gained popularity as the place to train artists and artisans. The apprentice model continued through the Renaissance and has continued through to modern times—with some changes. For example, apprentices are usually no longer bound to their masters, nor dependent on them for room and board. Other models have prevailed, such as the child-centered model and specialized instruc-tion model of the late 1800s, or the constructivist model of the 1970s.

Education from 1750–1900

In the eighteenth century, education, in general, followed a rigid model. It was largely comprised of reading and mathematics instruction. It was set aside for the wealthy, and their children were taught usually by tutors. Schooling was first seen as a privilege, not as a right. The masses were largely left uneducated.

Looking for a change in lifestyle, many Europeans came to the American colonies to practice their own way of life and religious beliefs. Meanwhile, others remained in Europe following the social and religious values of the day. With the challenges facing the colonists, again, education was kept for a select few. Skills such as farming or building were taught instead. Gradually, however, more young students were included in the teachings of basic mathematics and reading skills as the world around them became very different.

During this time, industry was changing. The Industrial Revolution began in the mid–1700s and lasted about a century. In the mid–1700s, vast changes in the ways goods were manufactured subsequently affected agriculture, textiles, transportation, and machinery.

Throughout the Industrial Revolution, many children not trained as apprentices in ateliers were put to work in mines, cleaning train engines, or picking crops. At this time, some reformers stressed the importance of a basic education. Although limited to white male students of the middle and upper classes, schools provided the basics in mathematics, science, and limited reading to prepare the students to be successful working citizens. Yet, thanks to Johann Pestalozzi (1746–1827), drawing was introduced as a form of a visual language, and his influence on art as a part of formal education spread throughout Europe and America. At the same time that students were beginning to learn to draw in this style, art was being collected from overseas and brought back to the United States. This art also ended up in various colleges and affected arts education offered at universities.

During the Industrial Revolution, the wealthy took advantage of the easier travel systems and went to Europe. There, they viewed the art of the time, and brought back much art work to begin their own private collections. Soon, the different styles of various European artists were shown throughout the country. Not surprisingly, universities began to offer fine art instruction. Harvard College, Yale, Princeton and Columbia University, for example, offered specific art classes. Art teachers had their students study works of European artists.[4]

In subsequent decades, more and more schools throughout America were established to teach the populace; and finally the majority of children could receive full education. Art was included in the curriculum. Not surprisingly, illiteracy decreased substantially, and the citizens became a more-informed society.

1900s–1950s

Before World War I, the schools emulated the factory system of producing good citizens. Afterward, with the social rebellion against the strict Victorian order, art education went through transformation as well. Instructors could follow the new trends in art. In Europe, in the early 1900s, there began the groundbreaking styles of Cubism by Picasso and Braque. In America, painters Thomas Hart Benton and Edward Hopper were developing individual and unique styles of art.

[4] Arthur D. Efland, *A History of Art Education: Intellectual and Social Currents in Teaching the Visual Arts.* New York: Teachers College Press, 1990. pp. 63–68.

Simultaneously, the education system in the United States went through a reform again, after the Great Depression and World War II. The Works Progress Administration (WPA) of the 1930s created numerous public artworks rather than providing direct support for art in education. However, murals and sculptures that came out of this time period did influence the expansion of the arts in communities throughout the country. Also, libraries and cultural centers throughout the United States supported programs that enhanced art.

1950s–1960s

A few decades later, education in schools went through a shift again. With more educational reforms of the late 1950s and early 1960s, emphasis was put on all academic subjects. When the Russian satellite Sputnik was launched in 1957, beginning the space race between Russia and the United States, the United States responded with more science and mathematics programs in schools. There was a push for standardized tests to determine suitable academic pathways of students. This kept students to the same level of high expectation. They were lead to higher levels of performance, and school programs were expected to be more effective in instruction. The goal was for students to achieve success in school and beyond. Streamlined curricula pushed forward a factory system of graduates of the basics: reading, writing, mathematics, and science. Art, although included in school programs, was pushed to a secondary, rather than primary focus. However, a change was about to occur. Along came a group of theorists who wanted students to pay attention to the process of learning, and not just to focus on being the best in science and mathematics.

1960s

An educational reform in the 1960s can be traced to Jerome Bruner. This American psychologist, known for his work in cognition, wrote *The Process of Education* (1960), which came out of a conference of scholars and educators brought together to discuss how science education could be improved in K–12 programs. Yet Bruner's book did so much more: It set the stage for educational reform, in particular, in his chapters entitled Structure, Readiness for Learning, Intuitive Thinking, and Motives for Learning. Within the text, he described children as problem solvers, ready to address challenging problems. He posited a spiral curriculum so that the teachers and students could consistently revisit basic skills taught, and build upon them. [5]

[5] Jerome S. Bruner, *The Process of Education*, Revised ed. (Cambridge, MA: Harvard University Press, 1977).

1970s

Not surprisingly, some states had massive budget cuts in arts education, especially in the 1970s with the energy crisis and decreased populations of school age children. As a result, many arts educators became activists and advocates for putting back or initiating programs for the arts in education. Yet even with cuts in programs, private organizations, such as the well-established Carnegie, Rockefeller, and Ford Foundations, continued to support programs in art along with their other endeavors. Project Zero, begun in 1967 at Harvard's Graduate School of Education, and led by Howard Gardner, was founded as an educational research organization devoted to the study of the cognitive development, learning, thinking, and creativity in the arts, as well as in humanistic and scientific domains.

1980s

When the *Nation at Risk Report to the Committee of Excellence in Education* came out in 1983, based on an eighteen-month study of secondary schools, it shocked the country. Its findings revealed the poor state of schools in this country—the curricula in most schools did not unify all subjects, and many schools lacked good programs that focused on mathematics, science, and English language arts. The report noted that a significant number of students were illiterate, and when compared to other countries, findings showed that U.S. students spent less time on homework. The report outlined suggestions to implement specific content and standards of performance in the basic subjects. It also suggested that fine and performing arts would advance students' individual, educational, and career instruction.[6]

1990s–2010

During this time, state education reforms reflected changes in school finances and budget allocations; teacher training and school resources; school-choice options for children; and specific standards, assessments, and accountability of what students should and do learn. Further standards came out of federal initiatives, such as Goals 2000 (1994) under President Clinton, and No Child Left Behind (2001) under President Bush. Race to the Top (2009) under President Obama offered competitive grants to states to adopt standards and assessments for students, develop data

[6] David P. Gardner, and Others. *A Nation At Risk: The Imperative For Educational Reform. An Open Letter to the American People.* A Report to the Nation and the Secretary of Education. Superintendent of Documents, Government Printing Office (Washington, DC, April 1983).

systems to track students' successful performance, recruit, nurture, and hold on to effective teachers and principals, and turn around schools that are not achieving.

As a result of these initiatives, it seemed that testing of students increased. These assessments, often called high-stakes testing, have large ramifications. The states look at the Adequate Yearly Progress (AYP) of schools and districts to determine whether or not students improve their school performance each year based on the established annual target. Without documented yearly success in core subjects, consequences can be serious. For administrators and teachers, it is the threat of job loss or delayed tenure. For students, they may have to attend summer school, or repeat the same grade. *Rigor* was a term commonly linked to curricula across the country.

2012–Time of Publication

With a nod to previous decades—and centuries—to improve the quality of education, the Common Core Standards under President Obama (2012) were established.[7] Their goal is to nationalize common, rigorous curricular requirements in subject areas to prepare students as best as possible to be successful graduates and contributing citizens prepared to work in the twenty-first century. At the time of this publication, forty-five states and three territories have supported this movement.

There has been an infusion and integration of technology in virtually all areas of education. At the same time, the arts and classics are becoming more visible and integrated in curricula in many schools. The world has become smaller, and through globalization, this has led to a convergence of concepts. New teaching ideas and influences from international sources can make their way into your teaching.

SOME PHILOSOPHICAL PERSPECTIVES

Today, in art classes, it's common to hear a conversation along the following lines:
 Student: I like that painting.
 Teacher: Why do you say that?
 Student: Because I do.
 Teacher: Could you say more about it?
 Student: Well, I like the color.
 Teacher: What is it about the color that you like?

[7] www.corestandards.org (accessed September 25, 2012)

This type of dialogue came from the philosopher Socrates (469–399 BC). He was known for his questioning methods to elicit an answer to a problem. This style is still a popular one used to teach students of all ages.

John Locke, an English philosopher from the late-1600s, believed that children should learn about the world in which they live. This idea laid the foundation for the movement of inquiry and discovery in art education. Following in the path of a Socratic dialogue and problem solving in art, Locke's method relies on students to discover the world through learning experiences. Students are motivated to develop problem-solving skills and independent thought. Creativity is supported as students actively engage in learning. His ideals, as well as others of that era, sparked the Enlightenment period of the next generation, which fostered individual thought and reason that led to changes in thinking about political, religious, social, and educational ideals.

This is pervasive in teaching today. For example, if you are teaching touch-sculpture in class, you may ask, "What do you think of the materials used in a Brancusi sculpture?" Your students may respond by relating their own experiences with different media. This may seem like an ordinary response now, but long ago, it was not.

A few decades later, during the Enlightenment period, Jean-Jacques Rousseau, the Swiss philosopher (1712–1778), maintained that people are born good, and remain so until their environment and the evils of society corrupt them. He theorized that people maintain a natural state. One of the primary principles of Rousseau's political philosophy is that politics and morality should function together, and that children's emotions should be taught before reason. He supported learning by experience, and felt that the progression of science and art affected morals of individuals adversely, claiming that they challenged basic tenets of uncomplicated and happy lives. They could corrupt. The power of his philosophy strongly influenced society at that time. We have come far since his teachings. Rousseau would be amazed at the students of today creating something such as an online group drawing project, entitled *Technology for Peace.*

The movement from a society-centered to a child-centered philosophy can be traced to the influence of American philosopher John Dewey (1859–1952). Dewey greatly affected education, and continues to have a significant impact on art education today. Nearly every book about art education includes at least one quotation from Dewey. As a passionate advocate of democracy, he believed in the educational system as a force for social change. As the leader of the Progressive Movement, his theories enlightened teachers and students to move away from the authoritarian educational models of the later nineteenth and early twentieth

centuries. His beliefs continue to stimulate and inspire individuals to generate original work in all forms of education.

Dewey believed that if students could have real-life experiences in a learning environment, they would develop critical-thinking skills they could use and apply in their future lives, rather than offer rote lessons based on memorization and drills. In order for the curriculum to relate to the students' experiences, Dewey came up with a unique plan. Rather than have students work on lessons while sitting in rows of desks, he believed that students could work in groups on projects and other activities. Yet, he also believed that the students should not solely drive this curriculum. He felt that the teachers should support, guide, and emphasize the learning process in their instruction. Students should learn how to reach their full potential and realize their talents and abilities in school. Students should be actively involved in their learning rather than being passive receivers of information. Dewey believed that students who participated in their own education would then create an informed public, which could be involved in democratic community.

Dewey's seminal work, *Art as Experience* (1934), is particularly influential in art education. He promoted a democratic view of art as a vital experience for all people, rather than as an elite activity for a select group. Supporting the process of art making as a valuable educational learning experience, he advocated for the hands-on and object-based teaching models that are common practice today.[8] He was one of the first to promote aesthetic experience as it pertains to and enhances daily life.

Dewey suggested that when studying art, school-age students could be guided to use their imagination to shape their own experiences, thus becoming active in their role as learners. Rather than memorizing facts about art objects, he advocated that students learn critical thinking by observing, questioning, categorizing, and analyzing their art and the art of others. He believed that art had an important role in articulating and affirming the social and cultural values of a community. Taking a field trip and making sculpture from found objects (approved by you) could be an activity supporting an art unit for any grade.

What Dewey has accomplished for education, Piaget has contributed to psychology.

Swiss-born Jean Piaget (1896–1980) is known for studying knowledge or epistemology. He identified basic stages of cognitive development, or stages of psychological growth, that all individuals go through from birth to adulthood. He defined four such sequential stages that correspond generally with chronological

[8] John Dewey. *Art as Experience*. New York: Minton, Balch, 1934.

ages of individuals. A basic understanding of these stages can guide you to develop or choose age-appropriate art activities and materials.

Sensorimotor (birth to two years)

In the beginning, children experience their world through their five senses and movement.

Preoperational (two to six or seven years)

During this time, children are more abstract learners. They create symbols or stand-ins that represent actions, or objects or activities that are meaningful to them. For example, popsicle sticks could be animals in a zoo.

Concrete operational (six or seven to eleven years)

In this stage, children do more complex thinking and take more actions, moving from literal to abstract thinking.

Formal operations (twelve years through adulthood)

By this point, children now look at challenging situations and can imagine possible solutions.

Late-1960s–1970s

The late 1960s and 1970s signaled the era of Constructivism. In addition to Piaget, Lev Vygotsky and Jerome Bruner held students responsible for constructing their own knowledge. Lev Vygotsky was a Russian psychologist. His theory was that communication was the key, and that verbal thought, emotion, and self-regulation were the first steps to effective communication with others. The American psychologist Jerome Bruner (1915–) was influenced by Vygotsky. Known for his work with human cognition, Bruner posited that the changes in the mind and how the mind is used are what determine developmental stages of intelligence.[9] This learning could be organized and structured in the best sequence to be understood most readily by learners. Later, Bruner included social, cultural, and legal components to gain knowledge.

[9] Jerome S. Bruner. *The Process of Education*, Revised ed. (Cambridge, MA: Harvard University Press, 1977).

A set of principles that are evident in most art education texts are the theories of Viktor Lowenfeld (1903–1960). He was an Austrian art educator best known for continuing the work introduced by Dewey. He described the developing stages of art in children. As a famous art educator who believed that children's art expresses how they feel about themselves and their own environments, he supported children creating art as an extension of their inner voice. This freedom of expression was a way to develop their creativity.

He was not concerned about whether children's artwork was anatomically correct or incorrect, nor did he care if children created "incorrect" representations of the outside world. Unlike other philosophers at that time, he did not think it would be helpful to have children copy objects and paintings and have their work "corrected" by adults. He considered coloring books harmful to children's development, as he felt it stifled their inner art voice. He strived to support children's art and their imagination. In 1947, in *Creative and Mental Growth,* he outlined six new strategies that are focused upon today.[10]

Lowenfeld felt that although children can develop new skills through independent exploration, students can also stop themselves from pursuing their artwork if they do not find ways to improve their drawing skills. Teachers can show students new forms of art, or use other media and genres, such as crafts and design to encourage them.

Benjamin Bloom, the American educator (1913–1999), is known best for his 1956 work, Bloom's taxonomy.[11] This classification system shows the levels from a basic to deep understanding of a concept. Bloom's taxonomy shows how a student progresses through prerequisite lower levels to attain deeper knowledge. In the art classroom, referring to Bloom's taxonomy is helpful to organize lesson and unit plans, from the introduction of a theme through its completion. There are useful questions and "measurable verbs" accompanying each learning stage, which can be applied to your teaching strategy.

Maxine Greene (1917–) is considered a national treasure as well as one of the most famous American educational philosophers. She combines history, literature, science, sociology, and philosophy to do so. She is credited with bringing aesthetic education to the forefront, and uses art to capture imagination. She is often quoted

[10] Viktor Lowenfeld and W. Lambert Brittain. *Creative and Mental Growth.* 6th ed. (New York: Macmillan, 1987).

[11] cft.vanderbilt.edu/teaching-guides/pedagogical/blooms-taxonomy/ (accessed October 12, 2012).

for her theories of the advancement of social justice, and the essentials of living in awareness and "wide-awakeness" in order to do so. [12]

Maxine Greene stresses that all individuals be well-informed. She has included imagination and the arts as integral parts of children's education. She believes that education teaches individuals to explore ideas about themselves and their environment to ask questions, to embrace ambiguity, to make connections, and to observe what is not usual and what is new.[13] She has influenced art education programs internationally by leading individuals to become critically aware and thus form a conscious engagement with the world.

Many art educators also cite the work by Mihaly Csikszentmihalyi (1934–). He is a highly regarded theorist known for his work in creativity and flow. His work centers on building human strengths, and on creativity. He researched creativity for many years, studying the unique characteristics and jobs held by creative people, and asserted ten antithetical tenets connected to creative people, such as one can have physical energy, but be at rest.

He describes the wonderful sense of continuity in his book *Flow: The Psychology of Optimal Experience* (1990).[14] Flow is like being in the zone. It describes when you are doing something well, you keep going as if nothing can stop you— not time nor dialogue nor event. You are completely engrossed in an activity where your thoughts, action, and movement follow from previous ones. This is a book cited by artists, and an impressive one to share at an interview.

Howard Gardner (1943–) is a highly regarded American psychologist, and quite a force in all areas of education, including art education through his theory of multiple intelligences. These nine types of learning strengths can help you to understand the different types of talents and abilities that you will find in the classroom. This will help you to develop teaching methods that can reach all students in the classroom, despite their diversity of learning styles. Be familiar with each of these, and be prepared to explain how you would incorporate them into a lesson. His intelligences include: linguistic; logical/mathematical; musical rhythmic; bodily/kinesthetic; spatial; intrapersonal; interpersonal; naturalist; and existential intelligence. More details of his influential theory can be found at www.howard-gardner.com.

[12] Maxine Greene, "Toward Wide-Awakeness: An Argument for the Arts and Humanities in Education," *Teachers College Record*, 79:1, September 1977, p. 119–125.

[13] Ibid.

[14] Mihaly Csikszentmihalyi. *Flow: The Psychology of Optimal Experience.* New York: Harper and Row, 1990.

Elliot Eisner (1933–) is well known as a supporter of the arts in arts educa-
tion. He has written extensively on arts education and its affect on learning. He
is also a strong supporter of disciplined-based art education. Eisner has written
extensively about art as a basic foundation for education. His theories are articu-
lated in "Ten Lessons the Arts Teach."[15]

CURRICULUM MODELS

Different models of education design throughout history have developed trends in
art education, and key figures represent these movements.

Surprisingly, in the rigid education system, art became a subject to be taught
and learned. The Industrial Revolution's effect on schools produced the study of
art, specifically of drawing, within the academic subject of science. During this
time in Europe, Swiss educational reformer Johann Heinrich Pestalozzi (1746–
1827) devised a method of drawing. He theorized that drawing was a type of
visual language. He used it to document visual properties of what one observed.
He taught how to draw by dividing objects with parallel lines. This led to under-
standing mathematical concepts of division and fractions. His work became known
as "object study." This type of drawing became a part of the curriculum used in
Prussia and then adopted by schools in America.[16]

Today's four- and five-year-olds often work with shapes and forms. It is inter-
esting that centuries ago, Frederich Froebel (1782–1852) followed Pestalozzi's
method, and is responsible for starting the first kindergarten. There he had stu-
dents study shapes and forms and do hand work. He felt that starting in preschool,
teachers must lay the foundation for children's creativity and their engagement
with society and their world.[17,18]

Walter Gropius started the Bauhaus movement immediately after World
War I, in 1919, with a group of teachers in Germany. The Bauhaus's curriculum
focused on the basic materials and rules of design. These fundamentals led to new
definitions of what beauty was. Instruction included architecture, painting, and
sculpture. In this method, students are trained in a craft; drawing and painting;

[15] Elliot Eisner, "The Arts and the Creation of Mind," In Chapter 4, *What the Arts Teach and How It
Shows*. (New Haven: Yale University Press, 2002), p. 70–92.

[16] Arthur Efland, *A History of Art Education: Intellectual and Social Currents in Teaching the Visual Arts*.
(New York: Teachers College Press, 1989), p. 76–83.

[17] Ibid., 10.

[18] Gerald L. Gutek, *Historical and Philosophical Foundations of Education: A Biographical Introduction*. 5th
ed. (Upper Saddle River, NJ: Pearson, 2010), p. 264-283.

and science and theory. [19] According to Gropius' Manifesto of 1919, students are trained in a craft, in drawing and painting.[20]

In the late-1800s to early-1900s, programs began to crop up over the country that showcased art programs along with social programs specific to certain populations. Settlement houses such as Hull House in Chicago (1889) were set up by Jane Addams and Ellen Gates Starr for immigrants.[21] The Henry Street Settlement House, founded by Lillian Wald (1893) to serve families, children, and the poor, created a foundation for after-school and training programs.[22] Moving from after school to during the school day, Elizabeth Farrell (1870–1932) worked with Lillian Wald and lived at the Henry Street Settlement House. She extended the idea of social programs to start the first ungraded classroom serving special-education individuals, and founded the Council for Exceptional Children.

Three approaches from Europe that have had a strong influence on American education are the Montessori Method, the Waldorf Method, and Reggio Emilia. All three support programs of peace. They offer holistic approaches to students to be nurtured in their individual development, and in their potential as creative intelligent children who can improve society.

Maria Montessori (1870–1952) was born in Italy. As one of very few female doctors in Italy, she went on to establish a specific education method in the early 1900s. The core philosophy behind the Montessori Method is that all children are unique, and that their individuality must be respected throughout the educational process. Independence is the goal for students. If they are nurtured in the appropriate environment, children will develop a love of learning by discovery, concentration, motivation, and self-discipline.

Along with the exposure to academics, children learn how to take care of themselves and each other through basic skills such as cooking, cleaning, gardening, using proper manners, and being considerate and helpful at home and in the community. Learning is achieved through individual learning styles by using all five senses. Students learn at their own pace and according to their individual activities from many choices. Children are placed in classes with a three-year age range, and there is constant interaction among all children.

[19] www.bauhaus-dessau.de/index.php?The-bauhaus-building-by-walter-gropius (accessed September 20, 2012).

[20] www.scribd.com/doc/29190078/Architecture-Article-MANIFIESTO-BAUHAUS (accessed September 20, 2012).

[21] Patricia M. Amburgy. Culture for the Masses: Art Education and Progressive Reforms, 1880–1917 in *Framing the Past: Essays on Art Education* (Reston, VA: NAEA, 1990), p. 105–108.

[22] www.henrystreet.org/about (accessed October 1, 2012).

There are work centers in every room, and the class environment is set up by subject area. Children can move around the room and spend as much time as they want on one subject—at different levels—that is of interest to them. These include art, music, mathematics, language, science, history, and geography. The subjects are interwoven rather than taught in isolation.

The teachers go through extensive training and certification before they can become Montessori teachers. In addition to the curriculum they must prepare, they learn to provide ongoing assessment of students through observation and record-keeping, and to keep portfolios of individual projects worked on by each student.[23,24]

The Austrian educator Rudolf Steiner (1861–1925) founded the approach named after himself and the Waldorf school models. This movement is steeped in spirituality, and is known as anthroposcophy. His movement led to an inclusion of the arts, which focused on drama, architecture, and his creation of eurhythmy, a combination of movement and verse. In 1919, he founded the first Waldorf school in Germany, which later spread internationally. Waldorf schools share specific goals to cultivate in students' strong moral character and social awareness through collaborative behavior.

The curriculum underscores Steiner's intent to foster a healthy society. As a result, Waldorf students have a relationship with nature through experiential learning. This stresses the study of art, music, literature, and mythology, and other subjects, and exposes learners to perspectives of varied cultures and religions. In kindergarten, activities focus on supporting the world as interesting and good. In lower elementary grades, all of the arts are studied: visual art, recitation, song, and music are experienced in an attempt to understand and relate to the world. This curriculum is further developed scientifically through experience and personal decision making in upper elementary grades and high school. The curriculum has a very particular use of color study, which relates to Steiner's philosophy of education and child development. Other aspects of this education include limiting television, delaying computer usage until high school, and beginning reading later than traditional curricula.

Reggio Emilia was started by Loris Malaguzzi after World War II. Named after an historical town in Southern Italy with a special, city-run preschool program, it is the inspiration behind many preschool and early elementary schools

[23] Gerald L. Gutek, Maria Montessori: Proponent of Early Childhood Education in *Historical and Philosophical Foundations of Education: A Biographical Introduction,* 5th ed. (Boston: Pearson, 2011), p. 386–408.

[24] www.mariamontessorischool.org (accessed July 1, 2012).

in the United States. There are Reggio Emilia schools throughout the world, modeled after the original Reggio Emilia philosophy that children learn by discovery, while developing a strong sense of responsibility and citizenship. The curriculum is generally project-based. The projects are often initiated by the students and then followed-through by the teachers. The teachers are researchers as well as guides. The teachers document students' progress and completed projects. This includes exhibits of work and portfolios of information gathered. The design of the environment and materials available are very important. Children experience specific activities within workshop areas (ateliers), such as clay, paint, or dress-up, or they go on field trips. Parent participation is essential and required in the classroom. The relationships between the parents, teachers, and children are considered equally important, and the key to the success of this method.[25]

APPROACHES

The work of notable theorists has also contributed to specific arts curricula.

Betty Edwards (1926–) is an art education innovator. As an art teacher, she noticed that some skills in art were not easily gained by students. She became interested in brain research and wrote *Drawing on the Right Side of the Brain* (1979) to share how one could teach students to develop the visual perceptual, rather than the verbal analytical hemisphere of the brain.[26] She found that specific art instruction should be geared toward developing five perceptual skills of art—edges, spaces, relationships, lights and shadows, and the whole, or gestalt. She also supported five stages of art development—scribbling (eighteen months to two years old), mostly in a circular fashion as it is easier physically to do; symbols, representing real objects to the child (two to four years old); pictures that tell stories (four years old); landscape (five to eight years old), symbols that create a landscape; stage of complexity (nine years old), creation of more details; realism (ten to eleven years old); and the crisis period (twelve to thirteen years old), trying to get it right and feeling the frustration when unable to do so.[27]

[25] Lella Gandini. A History of the Experience of the Reggio Emilia Municipal Infant-Toddler Centers and Preschools, North American Reggio Emilia Alliance, 2008. www.reggioalliance.org/reggio_emilia_italy/history.php (accessed July 12, 2012).

[26] John A. Michael, *Art and Adolescence: Teaching Art at the Secondary Level* (New York: Teachers College Press, 1983), p. 130–131.

[27] Betty Edwards, *Drawing on the Artist Within: An Inspirational and Practical Guide to Increasing Your Creative Powers*, New York: Simon and Schuster, 1986.

Abigail Housen (1944–), a cognitive psychologist, and Philip Yenawine (1942–) an art educator, are co-founders of Visual Understanding in Education (VUE), a nonprofit educational research organization that focuses on methods of teaching visual literacy and of using art to teach thinking and communication skills. They are cofounders of Visual Teaching Strategies (VTS), a teaching method that became popular in the 1960s, which focuses on teachers facilitating discussions of visual art. This open-ended dialogue helps students to find personal meaning in the art. This curriculum significantly increases students' critical thinking, creative thinking, and transference to other subjects. This system supports thoroughly examining visual art for meaning.[28,29]

Another method, which complements VTS, uses the capacities of imagination generated by the Lincoln Center Institute (LCI) when addressing a work of art. LCI upholds imaginative learning to instruct educators of elementary grades through college to use this method of arts education with their students. The capacities help the learner become informed about the piece of art by a series of steps: Noticing deeply; embodying; questioning; making connections—identifying patterns; exhibiting empathy; living with ambiguity; creating meaning—taking action; reflecting/assessing.[30]

Discipline-based art education (DBAE) refers to appreciating and learning about art through a comprehensive arts curriculum. It has four components: creating art, aesthetics, art history, and art criticism. It is the model on which many art standards are based. DBAE evolved from ideas in the 1960s; however, it wasn't until the J. Paul Getty Trust was founded in early1980s, that the term became famous and the approach was adopted. Elliot Eisner and then Secretary of Education William Bennett further publicized DBAE at Getty conferences.

Arts integration incorporates music, visual arts, theater, and dance with other core subjects, including mathematics, reading, and language arts. This approach has been successful for elementary through high school programs.

Most art education programs include the principles and elements of design, such as line, shape, form, space, color, and texture, and balance, emphasis, movement, pattern, proportion, repetition, rhythm, variety, and unity.

[28] Philip Yenawine, "*Jump-Starting Visual Literacy*," originally published: *Journal of the NAEA*, January 2003. Reprinted with permission from the National Art Education Association. www.vtshome. org/research/vts-downloads (accessed April 4, 2012).

[29] Yenawine, Philip and Abigail Housen, *Visual Thinking Strategies: Understanding the Basics*, 1–10. Nd (accessed April 4, 2012) www.vtshome.org/research/vts-downloads.

[30] Lincoln Center Institute, lcinstitute.org.

RESEARCH

Current research in the field is fascinating, and more and more information is being made available, along with recent advances in brain imagery and technology. The Dana Foundation focuses upon the brain and brain research. One consortium studies about learning, the arts, and the brain, by Dr. Michael S. Gazzaniga of the University of California at Santa Barbara (2008), poses the question, "Are smart people drawn to the arts or does arts training make people smarter?"[31] Another three-year study, "How Arts Training Influences Cognition" by Posner, Rothbart, Sheese, and Kieras (2008)[32] linked different brain areas in which researchers could identify likely cognitive processes that would be influenced by arts training. In the near future, it is expected that more universities and institutions will research brain functioning and its relation to art education.

What is exciting about learning the different theories of art education is that no one has the correct answers about how to teach art. There are no right answers, only questions. Art is a lab, open for experimentation. You, with the students, are the scientists, testing old theories, trying and challenging current ones, and developing your own!

Reform Movements

Events	Year	Immediate impact	Long-term results
Civil Rights Movement: Started with landmark case, *Brown vs. Board of Education* for equal rights for all	1954	More attention to equality of schooling and rights for minority students; later, special education students	Began reform movements for special education students, deaf population, elderly populations, and gay and lesbian populations

[31] Michael S. Gazzaniga, "Arts and Cognition: Findings Hint at Relationships," *The 2008 Progress Report on Brain Research in Learning Arts and the Brain*, eds. Carolyn Asbury and Barbara Rich. *The Dana Consortium Report on Arts and Cognition*, 2008.

[32] Michael Posner, Mary K. Rothbart, Brad E. Sheese, and Jessica Kieras, "How Arts Training Influences Cognition Learning Arts and the Brain," eds. Carolyn Asbury and Barbara Rich. *The Dana Consortium Report on Arts and Cognition*, 2008, p.1–10.

Sputnik, Russian satellite launched	1954	The race for the top began; United States increased focus on mathematics and science, and gifted programs	Continued higher expectations on American students to perform well in schools and in their careers in mathematics, technology, and engineering
Nation at Risk report to Committee of Excellence in Education: Outlined failing schools	1983	Increased focus on specific content and standards of performance	Precipitated Goals 2000; increased attention on accountability of teachers to provide content; increased high-stakes testing
Goals 2000 Educate America Act (P.L. 103–227): By 2000, students will demonstrate school readiness, achievement, and high school completion; be leaders in mathematics and science; be literate; and have safe and drug-free schools. Pushed for professional development for teachers and parental participation	1990	Raised expectations of children	NCLB; increased accountability of teachers and students; increased high-stakes testing

No Child Left Behind Act (NCLB): Standards-based reform act involving raising standards to improve student outcomes; aligned with testing, teacher accountability, and federal funding	2001	Increased testing, more supervision of teachers' work and assessment of effectiveness	Race to the Top; Common Core standards; increased testing and research-based curricula to support positive student outcomes
Race to the Top: Challenged states with financial grants stimulus to prepare students to graduate high school and be ready for college and careers, so they could compete in the global job market in the 21st century	2009	Push for new education programs, more accountability on students, teachers, and schools	Increased standardization and testing; evidenced-based practices in schools
Common Core Standards initiative: Begun in 2009, expected to be adopted by most states in 2014, to level the academic field in mathematics and English language arts so students will be ready for college and career beyond in the global economy of the 21st century	2012	Push for common curricula throughout the country; standardized test preparation and testing	What will the changes be in the 21st century?

❧11❧

In Their Own Words: Interviews with Art Educators

We've told you everything we have learned in our quest to seek out career information in art education. During our process, we spoke with many art educators and others involved in art education. We asked some of them to share their experiences with you directly. What follows is a discussion of their diverse career paths, daily experiences, and gives you their own career advice.

SARAH LOTFI-HENE, Full-Time Elementary School Visual Arts Specialist at P.S. 89, New York City

How did you decide to be an art educator?

When I first thought about college, and choosing a major, or even a career path, I had always thought computer graphics/animation was the way I would go. I had taken my first computer graphics class in tenth grade, where I had to "draw" a picture pixel by pixel and I was hooked! College was all that I hoped it would be, preparing me for my future glamorous career in broadcast animation. I immersed myself in learning not only the latest computer programs, but the current design trends, the code, and programming lingo behind the commands I was executing on the screen, and the "hot" companies to send my resume to. After graduating with my BFA, I landed a job as an animator for a local television station and felt fulfilled.

Fast-forward five years later, I was miserable! I spent my days alone in a dark room, fulfilling orders that were often barked at me, and feeling lonely, taken for granted, and completely out of touch with the creative, artistic, messy, colorful, tactile world that the arts always were to me. I will never forget the morning

my parents sat me down in a booth at the local diner and said to me, "You are miserable and you need to change paths. You are going to go back to school and become a teacher." All I remember was staring at them, nodding, and saying, "Ok."

My first course back in graduate school was an art history course on the Italian Renaissance. I signed up for only this one course, to make sure being a student again was the right thing for me. I was in love. I loved being on a campus, sitting in lectures, discussing anything and everything with fellow students, and in the cheesiest, most fairytale way—I felt alive again! In my art ed courses not only did I get to paint, print, weave, draw, construct, and get *messy*, but I got to do it with some of the most talented, creative, and passionate people I have ever met. I felt constantly inspired and so connected to my professors, classmates, and myself as an artist.

I was fortunate enough to be hired as a maternity leave replacement immediately after being certified, and then lucky again to be hired in a Manhattan public elementary school right as the leave replacement position ended.

Would you advise another person in your position to follow the same course or change it?

This is tricky to answer . . . I suppose yes . . . So many people I know ended up in their profession because they weren't sure what to do when they were in college. I knew, I tried it, and then I made an educated adult choice to do something different. I could have chosen any path after being a computer animator and I chose to become an art teacher. It is empowering to feel that I changed the course of my life and now love the way I get to spend every day.

How have you used your previous experiences in your current position?

I'm not so sure that I do . . . except for perhaps a unique firsthand knowledge of the career paths one can have with an education in art. I teach elementary students, and I do not have access to computers for my class, but a good eye for design and the ability to make some really cool signs for my room on the computer never hurts!

Where do you get your inspiration for your art projects?

Believe it or not, many of the core projects that have become favorites amongst my students, administrators, and parents are ones I gathered during my grad school observation hours and student teaching. I like to challenge my students and push

them to do their personal best. Often I can break down art lessons that are meant for high school and middle school students and make them accessible to my elementary students. And of course, blogs, blogs, blogs! Thank goodness for the explosion of art teacher blogs on the Internet these days. I don't like to take ideas straight from a blog, but I love to take elements from a site, or perhaps look at a final product (without looking at the step by step) and figure out my own way of constructing the artwork. I pride myself on bringing fresh, exciting projects to my students each year, with the hopes of keeping art-making as wonderful and enticing to them as it is (and always has been) to me!

J. BROOKE MULLINS DOHERTY, Adjunct Professor of Studio Art at Cape Cod Community College, Hyannis, MA

What was your own pathway to becoming an art educator, and working at Cape Cod Community College?

After earning a BFA in Studio Arts at the University of Oklahoma (where I grew up), I attended the University of Massachusetts Dartmouth and received my MFA in Sculpture in 2008. Two of my classmates at UMass Dartmouth were hired at CCCC right after graduation as adjunct instructors, and they recommended that I contact the program head about an upcoming position teaching Sculpture as an adjunct instructor. That was in the spring semester of 2009, and I've been at CCCC ever since, though I teach many more classes than Sculpture now. I also teach part-time at Lasell College, in Newton, Massachusetts, and the Community College of Rhode Island. To get these jobs, I sent out cover-letter emails to the art department coordinators with my CV and a link to my website and a list of classes I would like to teach at their school. Most of the department heads did not reply, but a few led to interviews. I was hired at each school I interviewed at.

What training did you have?

The BFA in Studio Art and the MFA in Sculpture were my best credentials. I had received a graduate assistantship for my first year at UMass Dartmouth, which allowed me to become the sculpture shop technician, where I learned how to maintain equipment and I assisted individual students during my shop hours. During my second and third years at UMass I was lucky enough to receive teaching assistantships, which allowed me to teach one three-D concepts class each semester to university freshmen. This experience was definitely helpful both in getting jobs after graduation and helping me be a better teacher in later classes.

During the first semester I was teaching at UMass, I took an education class for first-time graduate instructors in the art department that helped us navigate a multitude of classroom and curriculum development issues, which was very helpful. I also taught a children's art class through a local museum the summer after graduation, and I was a substitute elementary teacher for the first year and a half after graduate school, which taught me a lot more about classroom management and presenting curriculum in a variety of different ways.

What skills would you say were the most helpful in attaining this position?

Interest, enthusiasm, and persistence, though I think these would not have helped me as much if I had not also had prior teaching experience. For students who don't get to teach in graduate school, networking is the next best thing. One of my own friends did not get to teach in graduate school, but I was impressed by her enthusiasm and by her own artwork, and I wrote a letter of recommendation for her at one of the schools I teach at when another position became available. I encouraged her to contact the department head before the position was officially posted. She did and got the job.

Every summer, I send out new cover-letter emails to department heads at nearby art programs, and every once in a while these result in a new teaching job. It's also important to keep making and showing artwork.

I participate in quite a few exhibitions every year and am constantly updating my website with new artwork, and I think this matters to department heads who are interested in hiring practicing artists rather than just art teachers. I have been asked to bring images of my own work to every job interview I've had, and impressing department heads with my own work seemed to help me get those jobs.

What advice would you have for students/returning students who wish to become art educators? Are there specific steps that you would recommend they take?

Try to get whatever teaching experience you can, even if you are not getting paid much for it; if you can't find a paying teaching job, volunteer to teach a once-a-week children's class at an after-school program or day-care center. For one of my friends, this led to a full-time teaching position at a charter school within the first year she volunteered. Save syllabi for every class you think you even remotely could imagine teaching someday, as this can help you put together your own curriculum. Make a website for your artwork (or hire someone else to do it for you) and update it regularly so that you can have an easy way to show potential employers your work. Research who is in charge of art programs you want to

teach in (this is usually found on the college websites), and send out emails with your CV and website link even if no positions are listed at that school. I have been asked to teach classes that started the next week, and it never hurts to send emails just in case. Be equally active in pursuing exhibition opportunities for your own artwork, and pursuing curatorial opportunities doesn't hurt either. If you can speak passionately about the work you are currently making in your own studio and sharing that love of art-making with your students, this shows art department heads the kind of motivated, enthusiastic teacher you will be in the classroom.

SHARON VATSKY, Director of School and Family Programs, Solomon R. Guggenheim Museum, New York City

Describe your career path and how you got to your position as Director of Museum Education.

With an undergraduate degree from NYU, I began my career as a K–8 art teacher in the Hartford (CT) Public Schools. After completing an MA in Education, I concentrated on creating and showing my own work, served as the director of a co-op gallery, and wrote art reviews for a local newspaper. After a move to upstate New York, I taught drawing and design courses at a division of Russell Sage College and completed an MFA at SUNY Albany. When I moved back to the New York City area more than twenty years ago, I landed a job as Curator of Education at the Queens Museum of Art, heading a department of eight. It was my first job in museum education. In 2000, after a decade at QMA, I moved to the Guggenheim, as they were opening a new education center, and was able to formulate new programming. The position has provided opportunities to write and work both locally and internationally.

What exactly is museum education?

A museum education department works to amplify the meaning and relevance of collections and exhibitions for its audiences. This might mean formulating public programs, like panel discussions, symposia, performances, or family days. It can take the form of creating curriculum materials for teachers, or didactic materials within the exhibition. Although museum education departments are most frequently thought of as serving children and school groups, their reach is much broader. They are also providing programs for audiences who need special accommodation to fully participate, such as visitors with hearing impairments,

low vision or blindness, autism, or Alzheimer's disease. We are also reaching home-bound seniors through video conferencing.

What are your responsibilities as Director of School/Teacher and Family Programs?

I oversee programming for K–12 students, teachers, youth, and families that occur both at the museum and in the community. I also work closely with the Guggenheim's international affiliates.

What are the benefits of working in a museum?

You are always learning and thinking about how each new exhibition relates to the audiences you serve. The Guggenheim's exhibition schedule is varied and there are always new exhibitions coming up. I have created materials for exhibitions as diverse as Aztec art, 500 years of Brazilian art, the history of Russian art, as well as modern and contemporary art. Because the Guggenheim's primary focus is modern and contemporary art, I have also had the opportunity to collaborate directly with artists to create programs and events.

Many people find contemporary art difficult and dismiss it. Sometimes, through a conversation, workshop, or tour you can provide the tools that allow the visitor to discover meaning in a work they had previously dismissed. Being part of these "breakthrough" moments is very rewarding.

You also teach at the college level. How is that different from teaching in a museum?

Although there are some extended, multivisit museum programs, many are of short duration. Teaching a graduate course in museum education allows me to work with a group of students over the course of a full semester. You can see the skills and insights that are developed and in some instances students decide that museum education is the field that they are interested in pursuing.

What knowledge, skills, and experience should someone have who wishes to enter the profession?

- Whether you are interested in working at an art, history, or science museum, having a deep knowledge of the content area is important.
- A knowledge of current educational approaches and methods
- Excellent communication skills both verbal and written

- An enthusiasm for working and communicating with varied audiences from first-time visitors to scholars
- A gift for multitasking and working collaboratively

ALEXA MILLER, Founder and Consultant in Arts and Clinical Learning, Arts Practica, LLC

Alexa Miller runs Arts Practica, a medical education consultancy committed to improving quality in health care providers' attention. She focuses on the aesthetic components of attention that are often overlooked in technical training, such as observation, metacognition, empathy, and communication. She uses an arts-based approach, and often fosters educational partnerships between hospitals and art museums. Informed by extensive experience with visual thinking strategies, Alexa provides arts-based training to medical faculty, consults on educational partnerships, and runs workshops to forge common languages between experts in the arts and in medicine. She is a cocreator of Harvard Medical School's Training the Eye program, and also serves as adjunct faculty in Brandeis University's education department. Read her blog at: www.clinicalattention.com.

How did you get started in this career?

I have always been interested in health and the human body. This was the primary focus of my artwork for a long time. While in art school, my research brought me into the world of medical images. I spent a lot of time in London's Wellcome Collection, which houses an incredible medical library and image archive. My experience with this research, and the artwork that followed, a series on scars, was the beginning of my curiosity about representations of humanity in medicine and in art.

A few years later, I got into museum teaching, and had the privilege to acquire training in visual thinking strategies. This training allowed me to develop skills in facilitating intense interactions with art, and also to learn deeply about human intelligence in relation to art. It provided a hands-on way in which to explore the roles of education in museums and of museums in their communities. Around the same time (2003), I met a group of students and MDs from Harvard who were interested in beginning an arts-based course on visual diagnosis. Needless to say, we had a lot to talk about! They hired me to be the teaching artist for the pilot of what eventually became Training the Eye, and we have worked together since on the class and on academic collaborations.

Working in art museums was the other critical ingredient to my start in this work. I spent a year as an educator at the Isabella Stewart Gardner Museum. This was an immersion into the impact of multivisit art experiences; I learned so much about children's intelligence through intensive gallery teaching. My experience at the Gardner also exposed me to the field of museum visitor studies, and showed me how critical it is to develop educational programs hand-in-hand with skilled evaluators. From 2006–2010, I served as Curator of Education at the Davis Museum, Wellesley College, which was invaluable experience in management and in teaching. It also gave me a lot of compassion for the unique situation that art museums face right now in relationship to the economy and to the education landscape. This is the key in my work with clients now, because museums are at a crossroads when it comes to evidence-based practice, and are often in conflict around taking on healthcare organizations as new partners. My experience at the Davis Museum helped me understand the complexity of museum stewardship.

How did you develop your business skills?

I am always learning business skills—there is so much to learn! There are some resources that have been particularly helpful to me. I took (and still take) classes at Boston's Center for Women and Enterprise, a nonprofit dedicated to helping women start and grow their own businesses. I have a few mentors who I admire and trust (*The Missing Mentor* by Mary Stutts is an excellent book on mentorship—essential to career growth and too often unpracticed among women). I read a lot. I enjoy following blogs to learn about business development (like *Seth Godin* and *Blue Penguin*), in addition to blogs related to my interests and fields. I talk with other business owners. I meet monthly with a group of self-employed friends in my community to support one another and to share resources. I did a six-week program with a business coach, which was transformative.

What is the best advice you have gotten? What advice do you give to students?

I love to remind students in the arts: *Take your own advice.* If you are studying artist practice or training as an artist-educator, chances are you are becoming well versed in the enterprise of helping others to: make stuff, think critically, develop a voice, observe the world, take risks, play, explore the unknown, reflect, exercise persistence, experiment with new forms and new media, and nourish curiosity. Seriously, this is some of the best stuff in life! What lucky students you have! But it does not apply only to teaching others—you have permission to put it into practice yourself.

CARMEN JULIA HERNANDEZ, Artist and Community Activist

Carmen Julia Hernandez is an artist and activist involved in several organizations that use art education as a medium of expression, learning, and community building. She is Founding Director of New York City Gives Back.

Tell us how you started your career in art education. Had you planned on this career when you were in college?

I grew up in the South Bronx and emigrated from the Dominican Republic with my family to New York City in 1989, when art was an integral part of the New York City curriculum. I could not live without art. I knew I wanted to make art forever at an early age. I had art class sporadically throughout elementary school and when it disappeared from the curriculum entirely in middle school, I remember thinking that I would become a doctor or lawyer so that I could make a lot of money and buy my own art supplies—that way I could make art whenever I wanted.

I did not know I was an artist or that it was a real thing that one could become until I left the Bronx as a young adult to pursue higher education and enrolled in a pre-med program. I started taking art classes as an elective, which led me to pursue art full time. I enrolled at The College of New Rochelle for an art therapy degree, after attending two other universities, and there I found an artist community led by an amazing group of professors who reassured me that I was indeed an artist and should focus on developing myself within the field—so I did.

I still loved science and wanted to continue learning, so I picked up an academic counselor gig, which I went back to every summer during my four years at CNR. I tutored incoming first-year students at Barnard College through a program called STEPS—Science, Technology and Engineering Program. After graduating, I found myself not wanting to take on the struggling college graduate role, and immediately decided I would teach art in public schools until I found my path. In the summer of 2005, I received a visual arts and bilingual certification and was hired to teach grades 5 through 8, first at Maritime Academy in the North Bronx, and then at PS 166 Roberto Clemente School. After two years of teaching, I realized I would never be able to make the impact I wanted to make in my students' lives—I wanted to teach them about life through art, know about their family lives, and help them cope with circumstances that they were born into—but instead I had to test, grade, and fail the most talented of children.

It became clear that I needed to work outside of the public school system to make these connections with my community, so I walked into the Bronx Museum and explained to Sergio Bessa, Director of Programs, why the museum and the

community needed me, and then I asked him when I could begin. Two weeks later, I was hired as the Education Programs Coordinator in January 2008.

Later in 2009, I had another revelation. I had become a museum administrator and although I was writing all of the museum's curriculums, and managing the teaching artists and museum educators, I still felt a couple of degrees removed from our program population. I began seeking out teaching artists opportunities, and typed 'art, children, families, and mentoring' in my search bar. Free Arts NYC popped up. I interviewed and got a gig as a Parents and Children Together with Art program facilitator and I had never been happier. Three nights a week I met with groups of families and helped them make art together. The program is a collaborative sequence that prompts families to work as a "family design team" and problem solve art making as they would real-life problems. The work was rewarding and meaningful and I fell in love. The partnerships director came to one of my groups to observe and offered me a job managing the very same program I was facilitating. In January of 2010, I began working with Free Arts NYC as the PACT program manager and got rehired by Bronx Museum as an instructor leading tours for children, families, and special events.

How has your career progressed at Free Arts?

When I first began at Free Arts, my responsibility was to implement a ready-made curriculum to families and lead five volunteers in my team. Now, I develop the curricular themes, create an eight-week sequence every season, and hire, train, and manage seven program teaching artists and about 200 volunteers a year. I also handle our partnerships—the program is delivered to program populations within our partner sites, which include family counseling centers, schools, and community organizations. My program is currently implemented in eight different sites and there are a total of eleven PACT groups scattered in the South Bronx, Harlem, Midtown, and Brooklyn. When the program is launched each season, I get to visit each site multiple times and witness the curriculum in action.

What motivated you to start NYCGB?

I am always trying to increase my expertise—make the service of providing learning, self-exploration, community-building, and family enriching opportunities through the arts better. Last year, I started reflecting about my work and where I would be in another five years.

I founded NYC Gives Back because I'd like for the initiative to motivate all types of New Yorkers—everyone has something to give and everyone can learn

something new. The artist collective has a focus on custom arts-based programming. What most nonprofits have in common is that the organization goes out here and says, "Hey, you have this problem and you need our help. I will help you by giving you X, Y, and Z and it's cool, we want nothing in return. Just implement this perfect plan and proved improvement . . . in X amount of time." NYC Gives Back allows for partners to come to *us* and say, "Hey I have a problem and I don't know how you can help me, but I hear you are willing to work with us just as we are." We then listen and prescribe a collaboration to help the organization or community group move toward a better situation.

The beauty of it all is that NYCGB was created out of a need for this work. After I left my administrator role at the Bronx Museum, some of our partners still wanted to remain connected to me, and in the first couple of months after transitioning to Free Arts, I was receiving requests to design curricula, evaluate a program, and give recommendations to facilitate a professional development day for staff or program population, to fix something that was not favorable within already established partnerships with reputable institutions.

My first project under the NYC Gives Back initiative was a pilot program to engage parents at Highbridge Nursery School in the Bronx. I was brought into the project by Cool Culture, a nonprofit that works toward providing visual literacy and cultural enrichment opportunities to families with children in early childhood programs. The organization was also already working with the Solomon R. Guggenheim Museum in classroom-based projects for the children and providing Family Days at the museum in which both partners desired more parent participation.

RICHARD LEWIS, Founding Director of the Touchstone Center, New York City

Richard Lewis is Founding Director of the Touchstone Center, a nonprofit art education organization (www.touchstonecenter.net) that "creates interdisciplinary arts programs in classrooms that explore the role of the imagination and poetic thought, particularly in relation to the natural world, as pivotal to all learning."

What role did the Touchstone Center fulfill that was lacking in School Art Programs in the late 1960s?

While much of the late '60s, in terms of education, was pushing toward initiating new forms of learning—particularly through ideas about the open classroom— there was still a lack of seeing children as imaginative learners, as learners who can

and should use the arts as central to learning. Much of Touchstone's early work was an attempt to reach out to public schools in NYC and specifically explore the very nature of imaginative and poetic thought in childhood.

How have you modified your programs to fit the changing nature of the school system?

Our programs have not altered specifically as far as content is concerned; what we have to do, though, is find ways to assure and convince teachers, administrators, and parents that the centrality of the imagination is key to overall learning and well-being—and that the arts are not a frill—but an essential means of knowing and understanding.

How has the organization survived social and economic changes?

Because Touchstone has always been maintained as a small organization—and our growth is more about the quality of our work and its ongoing ability to affect both children and adults—we have been able to weather many of the social and economic changes in education. In addition, the Center has had a very low turnover of artists, with most artists working with the Center over many years in a variety of projects.

Describe one of your favorite projects.

It is difficult to choose a specifically favorite project among the many we have done over the course of over forty years of work in schools, but there are some that have been pivotal in our finding new ways to implement much of what we believe as fundamental to children and their imaginative abilities. One such project was the creation of an imaginary "forest" in an empty classroom at PS9 in Manhattan, which took place over an eight-year period and involved many different art forms as well as all the students and parents of the school. It also traced the evolving emergence of life, life forms, creatures, the sun and the moon, and the birth of human imagery in prehistoric myth and art. A full and detailed account of this project can be found in The Touchstone Study by Dr. Lillian Goldberg and published by the Center.

What is your process of hiring and mentoring teaching artists?

Hiring is done on an informal basis—usually, when there is an opening—and more often than not, through referrals and observation. Mentoring is an ongoing

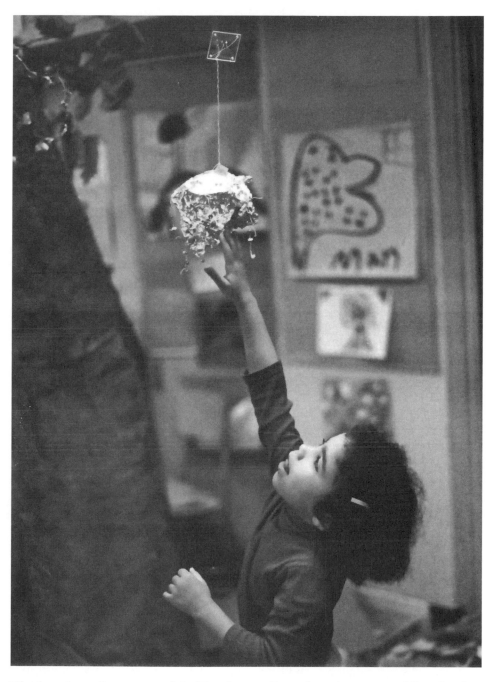

The imaginary forest, one of the Touchstone Center's projects, at a public school in New York City. Photo courtesy of Richard Lewis.

process that we all do collectively since many of the Center's projects involve a team of artists often working together over an extended period of time.

Do you have any other comments?

The arts and education road is as challenging as it is attractive; one needs to be constantly inventing and improvising—and evolving, both through the craft of teaching and as an artist. One should always assume that learning in its depth and possibilities is never-ending, and children in their innate ability to play and imagine are both our guides and inspiration.

DALE DAVIS, Founder and Executive Director of NY State Literacy Center, Rochester, NY

Dale Davis is the founder and executive director of the New York State Literacy Center (NYSLC) in Rochester, NY. She is also the executive director of the Association of Teaching Artists (ATA).

What inspired you to start NYSLC? How has it evolved?

I founded NYSLC because of a commitment to in-depth project-based learning as opposed to bringing artists in for independent residencies. I had worked in NYS Poets in the Schools, and the more deeply I became involved with students, teachers, and the learning process the more I wanted to found an organization based upon a pedagogy I was developing from my own experience.

Also around this time, my daughter was in the fifth grade. Her teacher called me and asked if I could bring in tacos for the class, as they were studying Latin America. I told the teacher I would be more comfortable bringing in poetry rather than tacos. The teacher replied I should bring in the tacos. It was at this point, I designed a project for another school district with the backing of the NYS Education Department, NYSLC's first "Explore Latin America." I brought in Octavio Paz, Homero Aridjis, Emir Rodriguez Monegal, and Eliot Weinberger to work with fifth graders and teachers in the project in the two schools where I was working, and to give a public presentation in the evening. It was a truly remarkable experience and confirmed even more to me why I founded NYSLC. NYSLC published a book of writing by the fifth graders in response to what they had learned from the project and from working with Octavio Paz, Homero Aridjis, Emir Rodriguez Monegal, and Eliot Weinberger.

The next year, in response to a teacher saying, "Homer Simpson" when I mentioned Homer, Homer the poet, I designed "Greece, Greece, Greece" to have

the students read and study the *Odyssey*. I was interested in how the classics were taught in the sixth grade. I designed "Greece, Greece, Greece" to have the students read and study the *Odyssey*, and brought in Robert Fitzgerald to work with the sixth-grade students in the project in the two schools where I was working.

The more I worked and designed programs, student engagement became central and the projects became student centered. I wanted to know about the non-Regents students who I didn't work with in high schools and who wore Metallica T-shirts and kept to themselves in halls. I wrote a chapbook, "From Modernism to Metallica," and went to concerts and interviewed the young people in the parking lots.

I immersed myself in popular culture and listened and read and studied. I wrote plays based upon student writing using theater as dialogue for students to connect with an audience. I wanted learning to be relevant to the students, connected to the real world as they knew it and their lives. The projects were designed to stimulate student inquiry. Projects included the "Aid 'N Us" project and "From Holden Caulfield to Eddy Vedder."

My research and interests led NYSLC to alternative-education programs, residential placement, day-treatment programs, and juvenile-justice facilities and jails.

How does art play a role in teaching literacy at NYSLC?

Art is at the center of all NYSLC programs. It is integrated into subject areas. Art, whether it is poems, visual art, media arts, music, theater, is included and modeled in every unit and in every daily lesson plan.

How did you get involved with the Association of Teaching Artists?

I was invited by the New York State Council on the Arts to a meeting in Poughkeepsie in 1998. NYSCA brought together a group of artists from across the state, who were working in K–12 education, to consider the need and feasibility of forming an organization of teaching artists. In 2003, NYSCA asked if I would bring my experience in running a not-for-profit to the Association of Teaching Artists. I believed—and still believe—the Association of Teaching Artists has an important mission.

How has the profession of teaching artists evolved in the past fifteen years?

We are at a crucial time right now. How do we attract top young artists to consider working in K–12 education, after-school programs, community programs? How do we retain these artists? How do we support artistic growth for those engaged

in teaching? How do we offer a career path for those who wish to pursue a career as a teaching artist?

The artist entering the field is learning business skills, what it means to be an independent contractor, intellectual property. There are now organizations, like Fractured Atlas, where an artist can go for the business side of the work.

There are now many organizations with distinct pedagogies that offer exciting opportunities for teaching artists, rather than a gig here and a gig there. The organizations are committed to the arts and to education.

The landscape has changed. Funding has been cut back. Yet the field continues evolving.

What are the biggest opportunities and challenges facing teaching artists today?

How do I find a place for myself that will challenge me artistically, enable me to contribute to education, to my community, and earn a living?

EMILY WILLIAMS-CAMPBELL, Art Educator and Artist, Brooklyn, NY

Why did you decide to pursue art education?

It was a choice intended to combine something I love (art) with the practicality of a career (education). I had been working in the business of art in auction houses and galleries and felt it was not the right fit for me. I am a people person by nature, as well as a person who values emotions and, therefore, emotional connections made between people. I found the auction and art gallery world to be too far removed from meaningful emotional connections between people.

I felt that a career in art education would allow for the meaningful sort of connections with people as well as an ultimate meaningful purpose to my job combined with practicality: job security. I have learned, however, in the process of my master's program, and now having graduated, that I entered into a field that is currently without job security. The economic climate, in 2012, is such that the arts and, therefore, art teachers are being let go left and right for budgeting reasons. Therefore, I find myself faced with the reality, and in many ways a creative, exciting problem, that being and working as an art educator requires a new approach in how one conceives of job opportunities.

How did your graduate school and student teaching help to prepare you to find a job in today's tough market?

The graduate program placed a strong emphasis on the professional teaching portfolio. This has proven very helpful. Employers value presentation that is organized

and visually appealing. It helps me better describe my accomplishments as well as my overall educational philosophies.

I always have positive feedback when I show my portfolio to employers. It helps them to better understand my teaching abilities and accomplishments while simultaneously helping me to more easily describe them with a visual reference. It acts as "proof/evidence" of my accomplishments.

My portfolio is a "living" series of documents, so it's an organic, unfolding, growing process. I'm trying to add more as I go and as my thoughts about art education and special education evolve. I'm constantly updating it as I gain more professional experience in art education. I also continue to add pictures of my own artwork as I create new work. It's important to add your experiences as you complete them or even as you do them because it can be so hard to remember them or adequately represent them in the portfolio a few weeks or months later. Time management is the key as an art teacher.

What methods are you using to get a job? Which seems to be the most effective?

The transition from graduate school to work is never easy. I'm working on networking and building relationships with people and schools and just doing things more creatively. Going in person is working out best for me. I'm also volunteering in schools and community organizations.

You found a full-time teaching job as a substitute. How is this experience helping you as you continue to look for a full-time art teacher job?

It truly takes time, and a lot of it, to develop an understanding of the students as people as well as develop a rapport with them.

I am building my reputation at the school and there is the potential to be hired full time next year at my current school. I feel acknowledged by my colleagues for my ability as a teacher. The principal is giving me an opportunity to start an after-school interdisciplinary arts/social studies program with a social studies teacher. She is trying to hire me for next year to work as an art and ELA teacher, splitting my time between both subjects. This would allow for me to continue to work individually with students on the one hand and teach art to full size classes on the other.

I'm trying to keep my options open though, first off because the job position is not guaranteed, and also because I am eager to explore other kinds of schools as well as museum settings. Sometimes I want to just set out on an adventure and try my hand at teaching in Peru!

This summer, you are starting to teach art classes for children. What are you doing to launch this exciting new venture?

My decision to launch this new venture and host art classes in my home studio was manifold: first, because I was feeling frustrated by the current job market and how challenging to land an art teaching position can be. After graduating with my degree in art education in May, and after a full year of working as a substitute teacher and teaching everything but art, I didn't want to have to wait any longer to get my hands "wet again." I wanted to start teaching art and working with children as soon as possible. I was eager to get experience that will, in turn, I hope help me to land a regular art teaching position outside of my home in a school/organization.

I have found it very motivating and fun to teach art in my home studio. It is very different from teaching in a school setting yet there are still similarities. I enjoy the opportunity to work in smaller groups and give children the individual attention they need that is not always possible to give in large school settings. I enjoy the sense of independence and freedom that comes with running my own business. I am learning about my local community and the needs and interests of families and their children and in the process building positive relationships with parents, children, community centers, schools, and other small businesses. All of these experiences are contributing to my skills as an art educator as well as entrepreneur, and I feel will ultimately help me to design my career path in a way that makes me feel happy and successful.

I am currently trying to learn how to successfully market my business. I am trying different modes of advertisements. I have posted fliers around my community. I am now trying to advertise on online parents groups. I would eventually like to launch a website. I offer initial free trial classes so that parents and kids can see how they feel about my classes before they decide to commit to a series of classes. I have found this an easy way to get people "in the door" and into the studio. When parents don't feel pressured to commit and have a chance to see how they and their children like a class, they are more likely to feel comfortable considering the idea of it. I have discovered there are currently no visual arts classes offered for children in my neighborhood, so I feel I have tapped into a community need and interest that has the potential to grow.

Do you have any advice for those seeking a position in art education?

Work to develop your networking strategies, and investigate different ways art educators can structure their careers. Learn about different settings such as museum education, teaching artists in schools, community-based organizations, small art businesses, and franchises.

Be willing to volunteer your time at places you are interested in working at. Approach your job search and potential employers with an "informational interviewing" mindset. By this I mean, when you initially visit an employer, tell them you are eager to learn more about their organization and offer to volunteer helping out or simply observe a classroom/gathering, etcetera. I have had very positive results by doing this. It gives employers and you a chance to see if it's a good fit or not without the pressure of hiring on the spot. I was able to land a regular substitute-teaching job this way that may grow into a full-time permanent position. Sometimes it is not practical to do this, but if one has a flexible work schedule, is still in school, unemployed, or underemployed she or he can make time to visit many different organizations and volunteer a limited amount of time. Employers are so much more likely to hire someone they've witnessed "in action" than someone they've never experienced working before.

Also, in student teaching and in all professional experiences in which there is someone who could write you a letter of recommendation: *ask* for a letter of recommendation immediately, as soon as the internship/job is finished or even if it's in progress. Professional recommendations are invaluable when you are job searching, and speak volumes to potential employers.

Save the contact information of all internships and employers, you never know when you will need it! Also, maintain relationships with professional contacts, make a consistent effort to keep in touch and keep each other abreast of your professional involvements and accomplishments. It helps! In addition, it helps motivate you and keeps you current and aware of goings on in your field.

Join professional organizations such as the NAEA. Subscribe to art educators magazines such as *Arts and Activities*. Keep in touch with graduate school colleagues and exchange job search advice and ideas. A supportive community of fellow art educators has been so important to my own job search and motivation toward it.

Get work experience in the field of art education or related while you are in graduate school or even before. Be confident that the field you are going into and the kind of work you will do is something you enjoy and feel good at.

VALEEN BHAT, Director/Founder, Private Picassos, New York City

Valeen Bhat is the director of Private Picassos, which offers in-home and on-site art programming for children and adults throughout New York City.

Why did you decide to start Private Picassos?

I decided to start Private Picassos after working in a variety of educational settings and seeing too much of a focus on adult-oriented art. I wanted to start a program that

focused on the students and let them explore the materials and make their own discoveries. I also wanted to create a program that I could be proud of as an art educator.

How did you start and operate a small business?

I started very small, with just one client that found out about my services through craigslist. From there, that client told her friends and within six months I had five weekly clients. I also quit my full-time job as an art consultant and took on a part-time position with a nonprofit. This was by far one of my best moves, as it not only gave me the schedule flexibility I needed to take on more clients, but also gave me the administrative skills that I lacked and would still use today in operating PP (i.e., Quickbooks and Dreamweaver knowledge, but also working in a small, grassroots office that operated similarly to a small business).

What is your typical day like?

A typical day starts at about 8:30 AM, when I sit down at my computer and go through the many emails that have arrived the previous day or overnight. After about an hour or two of emails, I usually lead two to three lessons throughout the city, all the while checking and responding to client emails, paying bills, and dealing with any issues that may arise over the day. My iPhone and city parks/ Starbucks are my mobile office every day! Once the clients are all done, I come back home and typically spend another hour checking emails, packing up art materials for myself or another instructor, or working on other miscellaneous projects. Usually I'm done with work by 7:00 PM, but there are plenty of long nights where I'm eating dinner with my computer next to me!

What are the biggest challenges and rewards of having your own art education business?

The biggest challenge of owning your own business is that everything falls on you. When you work in a traditional environment, there is usually someone there to help with a big project, cover things when you are away or sick, etcetera. But when you own a small business, especially in the beginning, everything begins and ends with you and it can be very exhausting. With that said, it's also such an amazing experience to control your professional life and work on something you not only truly believe in, but that also directly benefits you, both emotionally and financially. While I definitely have my days of wondering how I can continue doing it all without going crazy, I also have those wonderful days where I know that I am doing exactly what I was meant to do. That in itself is such a powerful thought and it makes everything worth it.

What do you advise anyone wishing to start their own art education business?

I always tell people to start small! In any small business, you're not doing it to make a profit for at least two years. You need to prepare yourself for that financially and also emotionally, as it can take a toll on you. The other benefit of starting small is that you can modify and perfect your product or service over time as you learn more. Some people see the benefit in writing a business plan, getting a business loan, and then opening shop. While this can make things easier in the short term, in the long term, you can be boxed into a corner with a product or service that isn't right, profitable, or just needs tweaking. When you start small, you have the ability to make those changes without rocking the boat too much.

ERIC BOOTH, President of Everyday Arts, Inc.

Eric Booth has become the spokesperson for the teaching artist profession. No book involving teaching artists is complete without his input. Formerly a Broadway actor, and author of many books and essays on teaching artists, he gives workshops to musicians, businesses, educators, and teaching artists, and is the originator of many innovations in the field.

What exactly is a teaching artist?

Although there is no consensus definition in the field, here is the closest to a universal understanding that I know: a teaching artist is a practicing professional artist with the complementary and interconnected skills, curiosities, and sensibilities of an educator, who can effectively engage a wide range of people in learning experiences in, through, and about the arts. The artistic and teaching parts of a teaching artist's career feed and enrich one another, so that work in the art produces new ideas about ways to engage learners and work as an educator deepens artistic practice and passion.

What are some characteristics of a successful teaching artist?

Teaching artists are lifelong "yearners"—motivated to tap the power of the arts in ever-deeper and more rewarding ways, for themselves and others. They are irrepressible inquirers and self-starters, always looking to improve their craft and experiment in their art and teaching. Great teaching artists experiment with ideas in every lesson they teach and attend to the results. They are imaginative, playful, independent (often fiercely so), and highly empathetic—always deeply aware of what it is like to experience something for the first time. And most importantly they live the truth of the Law of 80 percent—*80 percent of what you teach is who you*

are. They know they must *be* their fully open artistic selves with participants, and welcome the responsibility to hear, respond, care, and create with learners in ways that embody the best of the art spirit. At all times, in all circumstances.

In addition to writing and speaking about teaching artists, you also train corporations. Describe what you have to teach them.

The most common work I am asked to do with companies is: creativity but no art. They recognize the importance of employees (particularly leaders) who are thinking and functioning creatively; they know innovative products are the key to their future success. They find the arts fluffy and too emotional, yet they know the arts have something of value. So I lead these business people into the "verbs of art" without emphasizing the "nouns of art," the artistic media in which they are uncomfortable. As a TA, I come in under the radar of their concerns about artsiness, but guide them to make stuff they care about in various ways that are not threatening and are fun. We then unpack the processes and skills they used, which apply to all media. And almost without exception, they are willing to work in artistic media in a short time when they find out artistic media are fun and highly rewarding. We then work to transfer their creative habits of mind and skills to their workplace challenges.

Where do you see the most opportunities for teaching artists and what else lies ahead as the field emerges?

Currently it seems that employment prospects are decreasing slightly in schools, which have been, and continue to be, the primary locations of work. I expect this trend to reverse in a few years, as creative initiatives in schools become more urgent and the suffocating effects of No Child Left Behind turn to new opportunities. Concurrently, there is a steady increase in opportunity in other locations—after-school settings, summer programs, social service settings like hospitals and youth development centers, and especially in the emerging field of "creative aging," where they can't get enough strong TAs to fill the hiring needs.

Professionally, there are issues of getting health insurance (which may be somewhat alleviated with the new national health law), breaking the glass ceiling of hourly pay and work that rewards experience to provide a ladder of more challenging and more remunerative work.

Teaching artists struggle, but sometimes find ways to work together to form a collective voice. Some states and cities are going toward certification—which is about quality control—so the people hiring them can be assured that they have certain teaching and art qualifications. Some veteran teaching artists resist the

codification that certification can bring, but so far the process has been without major battlegrounds, as both sides have been slow in moving forward.

How can someone get started and evolve their career as a teaching artist?

Almost all major artist-training programs include effective ways for interested students to develop teaching artist skills as they develop their artistic skills. (I have a hunch that before long, some programs will make a basic introduction to teaching artist training a mandatory part of their training.) For those who are already out of school, in major cities, there are independent training opportunities that provide good entry points. The most common way to enter is through getting hired by a program that trains TAs, but a frustrating catch-22 is often involved: they want applicants with experience, but how do you get experience without getting hired? The answers are: to volunteer, to create opportunities for yourself, to find a small organization that will give you a shot.

Volunteering: for example, offer a class art project at a school where your friends' children attend, or get an internship, or ask if you can observe and help by providing observational feedback of some kind that would be useful. To create opportunities for yourself, talk to potential clients, anywhere you have a connection or even if you don't, and start to sniff out where their needs and your strengths might meet. Do free workshops or class visits to build your skills and to build a resume. Try marketing any programs that you are really passionate about offering—find out if there are local or state arts agency pathways to booking. See if Young Audiences has a local chapter and might be interested. Perhaps most importantly, talk to working teaching artists.

To work at a school, be able to articulate how your art program will support core standards, and contribute to academic results like raising test scores in particular subjects. Find out what the particular school cares about with a ten-minute conversation with a teacher, perhaps using the phrase, "What part of your curriculum might you be interested in opening up with some artistic explorations I might provide?" Speak the language of principals when you talk to them—they probably like but don't care much about the arts, but they do care about student engagement, student confidence, and teamwork, and student learning.

You will notice that many aspects of a teaching artist's career require entrepreneurial courage and initiative—don't let that scare you off. Entrepreneurialism is a natural extension of teaching artistry—wanting to bring beautiful new things into the world.

And as you get started, know that this field needs and welcomes new leadership—so come blazing your brightest lights and greatest passions.

CELIA CARO, Teaching Artist

Celia Caro is a teaching artist who works with people of all ages, in a variety of schools, senior centers, and higher education.

How did you become interested in pursuing art education as a second career?

My first career was a fashion editor and stylist. I went to FIT (Fashion Institute of Technology in NYC) and studied advertising and communications. I was both an editorial and public relations intern. My first job was as an assistant fashion editor, and then later I became a fashion editor. I came up with editorial concepts and copy art, directed fashion photo-shoots, working with several different creative teams as both a staff and freelance editor/stylist. When I had my daughter, my outlook changed, and I wanted to work in a field with more social impact, something more hands-on. I wanted work that affected people's lives in positive, meaningful ways.

I decided to return to school, to get a BA in Visual Arts at Empire State College. I was inspired to enter the field of art education through two professors. They helped to demystify the artistic process, by asking questions about my work and artistic decisions that I had made. They showed me how exposure to the arts was vital for self-expression and to clarify thinking. I decided to pursue a graduate program, at Pratt Institute in Brooklyn, New York, for an MS in Art and Design Education, to learn specifically about the techniques and theories of teaching art to enrich people's lives.

Was there a link between your first and second careers, or was it a complete switch?

In my first career, I worked with others to execute a visual concept for both fashion editorial and advertising purposes. I follow this same process in the classroom, helping others to develop and execute their ideas in a visual format. I also find the process of getting hired to be similar: putting portfolios together, tailoring resumes, and presenting ideas.

What are your favorite teaching artist projects?

Many of my projects involve storytelling, which also ties into my editorial background. I enjoy projects that involve narratives, with visuals and writing put together. I created a project called Lifemaps with my colleague Paul Ferrera, which was a collage workshop for older adults. We used maps as both a material and as a metaphor for their life journeys. The participants used maps to create self-portraits and they incorporated stories from their lives.

Another theme in my teaching is helping others to become active producers in society, rather than passive consumers. One of my most gratifying projects was a sticker and trading card project at a middle school. I taught the students how to create their own stickers and trading cards, rather than rely on commercially manufactured ones. This way, they became empowered to make their own culture, and share it with others, rather than relying on corporations to create it for them.

You also teach at the college level. What is that experience like?

I am interested in helping committed art teachers define the question: "What kind of art teacher am I?" I help them develop their careers, by pointing them in the right direction, helping them to articulate their research interests, and teaching them how to advocate for the arts in schools. I am considering pursuing a PhD in art education to refine and further my research area, and to expand my opportunities in higher education.

Often, teaching artists are involved in collaborative work. Do you work with other teachers? Do the students work with each other?

I work with classroom teachers, librarians, and other teaching artists. I have a co-teacher who I collaborate with for the projects involving older adults. Many of the projects fulfill core standards and help to increase literary and scientific skills. For example, I collaborated with first grade and kindergarten teachers on a quilt project for BRIC Arts Media that reinforced classroom learning with "small moments" ELA writing and patterns and shapes in early math and the idea of community from social studies.

Student collaboration is also important. In my cartooning classes, students collaborate on comic books and giant action-figure puppets together.

What do you suggest for someone interested in being a teaching artist?

You have to be very committed and be able to articulate what's really important to you. Tie your teaching to your own interests. What are you passionate about? Find a way to teach your passions. Highly motivated teachers motivate students, so teach what you love.

Resources

If you would like to pursue any of these topics further, there are numerous resources easily available for the art educator. It is impossible to list every single reference—that would require many large volumes. So, we consider this a starting point. By the time you read this, there will be new sources, covering new technology and new theories and studies. While a lot of information is available for free online, there are many helpful books that we also recommend.

K–12 Resources

Lesson plans abound online, but they are not all created equally. These are just a start: don't forget that you can adapt and differentiate each one according to you and your students' interests and abilities. Museums are an excellent source of lesson plans. Many include integration with non-art subjects, including standards of both. Here is a sampling:

American Federation of the Arts has educator resources. Visit their site at www.afaweb.org/education/resources.php.

Kennedy Center Arts Edge has lesson plans, arts integration, and standards. Under Lessons, you will find a "lesson finder" where you can select from a menu of subjects, grade, and standards to search for an appropriate lesson and combine art with other subjects. Go to artsedge.kennedy-center.org.

UIC Spiral Arts Education has innovative K–college curriculum ideas from Chicago artist and educator Olivia Gude. See their page at www.uic.edu/classes/ad/ad382/index.html.

Cooper Hewitt, National Design Museum in New York has lesson plans for all areas of design. See educatorresourcecenter.org.

The **Getty Museum** has lesson plans with specifics for each age group. Go to www.getty.edu/education/search/.

The Guggenheim Museum in New York has a lesson plan database, which can be accessed at www.guggenheim.org/new-york/education/school-educator-programs. Under "for educators," go to "find lessons."

Smithsonian Education has a compendium of lesson plans, searchable by subject and education standards. Go to www.smithsonianeducation.org/educators/index.html.

Arts and Activities Magazine, in addition to curriculum ideas, has articles on techniques, methodology, and materials in art education, in a free digital edition. Go to www.artsandactivities.com.

Day, Michael and Al Hurwitz. *Children and their Art: Art Education for Elementary and Middle Schools,* 9th ed. Boston: Wadsworth-Cengage Learning, 2011.

Hume, Helen. *The Art Teacher's Book of Lists,* San Francisco: Jossey Bass, 2010.

_____. *The Art Teacher's Survival Guide for Elementary and Middle Schools,* 2nd ed., San Francisco: Jossey Bass, 2008

_____. *A Survival Kit for the Secondary School Art Teacher.* West Nyack, NY: The Center for Applied Research in Education, 1990.

Linderman, Marlene Gharbo. *Art in the Elementary School, 5th ed.* Boston: McGraw-Hill, 1997.

Art Teacher Blogs

There are too many informative and well-written blogs to list them individually. They give an idea from the teacher's perspective about what their daily life is like in an art classroom. There are many "Top 20 Art Teacher Blog" lists, which are good starting points.

Choosing a College Program

Book of Majors 2013: All-New Seventh Edition. New York: The College Board, 2012

Peterson's Guide to Colleges and Graduate Schools: www.petersons.com.

Higher Education

The Chronicle of Higher Education, online and in print, contains extensive job listings, and useful articles, but some articles are only available with a subscription. See their website at chronicle.com.

Higher Ed Jobs is updated daily and lists available jobs at colleges and universities. See higheredjobs.com.

Honolulu Community College Faculty Development Teaching Tips Index is a very complete compendium on teaching techniques, syllabi, academic dishonesty, ethics, difficulties with students, and more. See their website at www2.honolulu.hawaii.edu/facdev/guidebk/teachtip/teachtip.htm.

Inside Higher Ed has job listings, and other information pertaining to higher education. See their site at insidehighered.com.

Museums

Perusing museum websites is an excellent way to see the variety of endeavors in which they engage. It is interesting to review both large, international museums, and local, small, or midsized museums. Also, look at museums of different types, such as art, history, and science. Books offer additional perspectives, giving you a background of current theories, forming the underlying goals of a museum's educational objectives. If you seek a job or internship, networking opportunities also abound online.

Museumjobs.com
www.museumjobs.com

LinkedIn groups: Museum-Ed Group, Museum Education Roundtable, VTS Visual Thinking Strategies, American Association of Museums

Museum–Ed
www.Museum-ed.org

Falk, John H. and Lynn D. Dierking. *Learning From Museums: Visitor Experiences and the Making of Meaning.* Walnut Creek: AltaMira Press/American Association for State and Local History, 2000.

Johnson, Anna, Kimberly A. Huber, Nancy Cutler, Melissa Bingmann and Tim Grove. *The Museum Educator's Manual: Educators Share Successful Techniques.* Lanham, MD: Altamira Press, 2009.

Villeneuve, Pat. *From Periphery to Center: Art Museum Education in the 21st Century.* Reston, VA: NAEA, 2007.

Organizations

The number of organizations involved in art education can be overwhelming. The following is a sampling of arts organization throughout the country. These are only a few examples out of thousands: do your own exploration and you will come up with many others in your area.

Regional Arts Organizations

National Assemblies of State Arts Agencies
List of State Arts Agencies, programs, funding opportunities. www.nasaa-arts.org.

Six Regional Arts Organizations funded by NEA
Arts Midwest, Mid-America Arts Alliance, Mid Atlantic Arts Foundation, New England Foundation for the Arts, South Arts, and Western States Arts Federation, and state arts agencies. See www.usregionalarts.org.

Organizations for Accessibility, Aging, and Special Education

Meet Me: The MoMA's Alzheimer's Project
www.moma.org/meetme

National Center for Creative Aging
www.creativeaging.org

NEA Office for Accessibility has information on arts and aging, arts in health-care, arts in corrections, and careers in the arts. See nea.gov/resources/Accessibility.

VSA Arts The International Organization on Arts and Disability
www.kennedy-center.org/education/vsa/

Professional Associations

AAM Association of American Museums
www.aam-us.org/

Association of Teaching Artists
www.teachingartists.com

CAA College Art Association
www.collegeart.org

NAEA National Art Education Association
www.arteducators.org

New England Consortium of Artist-Educator Professionals (for teaching artists in New England)
www.artisteducators.org

Teaching Artists Organized (West Coast orientation)
www.teachingartistsorganized.org

Nonprofit Community-Based Art Organizations

This is a very small sampling, to give you an idea of the types of missions and programs nonprofits engage in. Search carefully for ones in your region whose goals resonate with your own philosophy.

Great Nonprofits is a nonprofit organization which has a searchable database of other nonprofits. Go to greatnonprofits.org.

Arts for Aging, Bethesda, MD
www.aftaarts.org

Art Start, St. Paul, MN
www.artstart.org

Alternate Roots, Atlanta GA
www.alternateroots.org

Artists Working in Education (AWE), Milwaukee, WI
www.awe-inc.org

Artworks, Cincinnati, OH
www.artworkscincinnati.org

¡CityArts! Providence, RI
providencecityarts.org

CHAP, Children's Healing Art Project, Portland, OR
chap.name

Community Stepping Stones, Tampa, FL
communitysteppingstones.org

The Creative Center Hospital Artists in Residence Program, New York, NY
www.thecreativecenter.org/tcc

Free Arts for Abused Children, Los Angeles, CA
www.freearts.org

Groundswell, Brooklyn, NY
www.groundswellmural.org

The Heidelberg Project, Detroit, MI
www.heidelberg.org

SanAnto, San Antonio, TX
www.sananto.org

Sister organization: **Say *Sí*,** San Antonio, TX
www.saysi.org

Studio in a School, New York, NY
www.studioinaschool.org

Tuscon Arts Brigade, Tuscon, AZ
tucsonartsbrigade.org

Wonderroot, Atlanta, GA
www.wonderroot.org

Young Audiences, New York, NY (30 regional affiliates)
www.youngaudiences.org

92nd Street Y, New York, NY
www.92y.org

Business Information

Entrepreneur.com
Information on art education franchises and other for-profit art education businesses. Go to www.entrepreneur.com.

U.S. Small Business Administration
National and local resources, for nonprofits and for-profits. See www.sba.gov.

SCORE
Offers business mentoring. Go to www.score.org.

Teaching Artists

The Teaching Artist Journal is published quarterly in print and online Go to tajournal.com.

Teaching Artist Research Project (TARP)
www.norc.org/Research/Projects/Pages/Teaching-Artists-Research-Project-TARP.aspx

Education Standards

The arts education standards for your state are found in the website for your state's department of education.

Arts Education Partnership (AEP)
www.aep-arts.org. Look for the State Policy Database.

Common Core State Standards Initiative
www.corestandards.org

Education World
www.educationworld.com/standards

Interstate Teacher Assessment Consortium (InTASC)
www.ccsso.org/Resources/Programs/Interstate_Teacher_Assessment_
Consortium_(InTASC).html

MCREL (Midcontinent Research for Education and Learning)
www.mcrel.org/compendium/browse.asp

National Coalition for Core Arts Standards
A partnership of organizations and states which has a recently developed website containing newly created grade level standards for the five areas of art education (Dance, Media Arts, Music, Theatre and Visual Arts). Go to nccas.wikispaces.com.

Partnership for 21st-Century Skills
www.p21.org

Funding, Grants and Fellowships

Foundation Center
foundationcenter.org

Institute of Museum and Library Services
www.imls.gov

Liberatori, Ellen. *Guide to Getting Arts Grants.* New York: Allworth Press, 2006.

Resume, Cover Letter, and Portfolio

There are many basic explanations of how to write a resume and cover letter online, and in print as well. You will also find examples of resumes and cover letters—but beware! A lot are good examples of what *not* to do. Use online examples with care and view them carefully with a critical eye.

Teaching Philosophy

Washington University St Louis Office Teaching Center
teachingcenter.wustl.edu/writing-teaching-philosophy-statement

Iowa State Center for Excellence in Learning and Teaching
www.celt.iastate.edu/teaching/philosophy.html

Resumes, cover letter, and other job search tips

Purdue OWL
owl.english.purdue.edu/owl/section/6

Enelow, Wendy and Louise M. Kursmark. *Expert Resumes for Teachers and Educators 3rd Ed*. St. Paul, Minnesota: Jist Publishing, 2011.

Bernstein, Mashey, and George Yatchisin. *Writing for the Visual Arts*. Englewood Cliffs, New Jersey: Prentice Hall, 2000.

Reiman, Patricia L. and Jeanne Okrasinski. *Creating your Teaching Portfolio, 2nd Ed. Presenting your Professional Best*. New York: McGraw-Hill Higher Education, 2007.

Job Search

For jobs in particular areas of art education, see professional organizations, arts councils, the Department of Education in your state, and other listings in individual categories in this section.

The following places have a variety of art education positions listed online:

Artjob
www.artjob.org

Art Jobs
artjobs.artsearch.us

Idealist
www.idealist.org

Indeed
www.indeed.com

Schoolspring
www.schoolspring.com

Art Education Theory and History

In Chapter 10, we gave you a sound briefing on the major theorists influencing art education practices. That was only the beginning! Here's more if you wish to pursue your inquiry further.

Howard Gardner
www.howardgardner.com

Lincoln Center Institute
www.lcinstitute.org and for their Capacities for Imaginative Learning
imaginationnow.files.wordpress.com/2011/03/capacities.pdf

Montessori Schools
www.montessori.edu

North American Reggio Emilia Alliance
www.reggioalliance.org

Visual Thinking Strategies
www.vtshome.org

Dewey, John. *Art as Experience.* New York: Minton, Balch & Company, 1934.

Eisner, Eliot. *Arts and Creation of Mind.* New Haven: Yale University Press, 2004.

Elfand, Arthur D. *A History of Art Education: Intellectual and Social Currents in Teaching the Visual Arts.* New York: Teacher's College Press, 1989.

Gardner, Howard. *Frames Of Mind: The Theory of Multiple Intelligences.* New York: Basic Books, 1993.

Greene, Maxine. *The Dialectic of Freedom.* New York: Teacher's College Press, 1988.

_____. *Releasing the Imagination: Essays on Education, the Arts, and Social Change.* San Francisco: Jossey Bass, 2000.

Mooney, Carol Garhart. *Theories of Childhood: An Introduction to Dewey, Montessori, Erikson, Piaget, & Vygotsky.* St. Paul, Minnesota: Redleaf Press, 2000.

Advocacy

For all areas of teaching art, you will be the advocate for your program. You can find advocacy information from general to specific studies for the specific populations. And most of them are free!
Aside from this list, many more exist: search online for "arts advocacy toolkit" in your state or city.

The **National Art Education Association (NAEA)**
www.arteducators.org/advocacy

Arts Education Partnership (AEP) has research and policy publications in the publication section. It also has a searchable database of art education studies. www.aep–arts.org

The Kennedy Center Alliance for Arts Education Network (KCAAEN) *Arts Education Advocacy Tool Kit* includes studies, sample letters, and ways to contact state representatives.
Go to www.kennedy–center.org/education/KCAAEN/resources/home. html#.

Davis, Jessica Hoffman. *Why Our Schools Need the Arts.* Reston, Virginia: Teachers College Press, NY and National Art Education Association, 2008.

Background Knowledge and Research

Glossary of Art Education Terms
www.giarts.org/article/glossary-arts-and-education-terms

The Greenwood Dictionary of Education, Second Edition. Westport, Connecticut: Greenwood, 2011.

Bibliography

Althouse, Rosemary, Margaret H. Johnson, and Sharon T. Mitchell. *The Colors of Learning: Integrating the Visual Arts into the Early Childhood Curriculum*. New York: Teachers College Press, 2002.

Arnstine, Donald, Gerard L. Knieter, and Jane Stallings. "The Teaching Process & Arts and Aesthetics." *Journal of Aesthetic Education* 16.1 (1982):105.

Bates, Jane K. *Becoming an Art Teacher*. Belmont, California: Wadsworth Publishing, 2000.

Bruner, Jerome S. *The Process of Education*, Revised ed. Cambridge, Massachusetts: Harvard University Press, 1977.

Clapp, Edward, ed. *20UNDER40: Re-Inventing the Arts and Arts Education for the 21st Century*. Bloomington, Indiana: Authorhouse, 2010.

Csikszentmihalyi, Mihaly. *Flow: The Psychology of Optimal Experience*. New York: Harper and Row, 1991.

Dewey, John. *Art as Experience*. New York: Minton, Balch, 1934.

Edwards, B. *Drawing on the Artist Within: An Inspirational and Practical Guide to Increasing Your Creative Powers*. New York: Simon and Schuster, 1986.

Efland, Arthur D. *A History of Art Education: Intellectual and Social Currents in Teaching the Visual Arts*. New York: Teachers College Press, 1989.

Eisner, Elliot W. *Educating Artistic Vision*. New York: Macmillan, 1972.

————. *The Arts and the Creation of Mind*. New Haven: Yale University Press, 2004.

————. *The Role of Discipline-based Art Education in America's Schools*. Getty Center for Education in the Arts, 1988.

Falk, John H. and Lynn D. Dierking. *Learning From Museums: Visitor Experiences and the Making of Meaning*. Walnut Creek, California: AltaMira Press/American Association for State and Local History, 2000.

Gardner, David P., and Others. *A Nation At Risk: The Imperative For Educational Reform. An Open Letter to the American People*. A Report to the Nation and the

Secretary of Education. Superintendent of Documents, Government Printing Office, Washington, DC, April 1983.

Gardner, Howard E. *The Arts And Human Development: With A New Introduction By The Author.* New York: Basic Books, 1994.

Gardner, Howard. *Frames of Mind: The Theory of Multiple Intelligences.* 3rd ed. New York: Basic Books, 1983.

Gerard L. Knieter and Jane Stallings, *Readings for Discipline-Based Art Education: A Journey Beyond Creating Art* (1988). Stephen Mark Dobbs (ed.).

Goldbard, Arlene, *New Creative Community: The Art of Cultural Development.* Oakland: New Village Press, 2006.

Greene, M. (2008). Commentary: Education and the Arts: The Windows of Imagination. *LEARNing Landscape* 1(3) Autumn, 17–21.

Greene, Maxine. *Variations on a Blue Guitar: The Lincoln Center Institute Lectures on Aesthetic Education.* New York: Teachers College Press, 2001.

Gutek, Gerald L. *Historical and Philosophical Foundations of Education: A Biographical Introduction.* 5th ed. Upper Saddle River, New Jersey: Pearson, 2010.

Haskell, Lendall L. *Art in the Early Childhood Years.* Columbus, Ohio: Bell and Howell, 1979.

Hurwitz, Al, and Michael Day. *Children and Their Art: Methods for the Elementary School.* 7th ed. Wadsworth Publishing, 2000.

Isenberg, Joan, and Mary R. Jalongo. *Creative Thinking and Arts-Based Learning: Preschool Through Fourth Grade.* 5th ed. Saddle River, New Jersey: Pearson, 2009.

Johnson, A. and Kimberly A. Huber, Nancy Cutler, Melissa Bingmann and Tim Grove. *The Museum Educator's Manual: Educators Share Successful Techniques.* Lanham, Maryland: Altamira Press, 2009.

Learning, Arts, and the Brain, Johns Hopkins University Summit, ed. Barbara Rich. Dana Foundation, Washington DC: 2009, pp. 1–95.

Lewis, Richard, *Living by Wonder: The Imaginative Life of Childhood.* New York: Touchstone Center Publications, 2006.

Linderman, Marlene Gharbo. *Art in the Elementary School,* 5th ed. Madison, Wisconsin: Brown and Benchmark, 1997.

London, Peter. *Step Outside: Community-Based Art Education.* Portsmouth, New Hampshire: Heinemann, 1994.

Lowenfeld, Viktor, and W. Lambert Brittain. *Creative and Mental Growth.* 6th ed. New York: Macmillan, 1987.

Lowenfeld, Viktor, *The Lowenfeld Lectures: Viktor Lowenfeld on Art Education and Therapy.* Ed. John A. Michael. University Park, Pennsylvania: The Pennsylvania State University Press, 1982.

Majewski, Janice. *Part of Your General Public is Disabled*: *A Handbook for Guides in Museums, Zoos, and Historic Houses.* Washington, DC: Smithsonian Institution Office of Elementary and Secondary Education, 1987.

Michael, John A. *Art and Adolescence: Teaching Art at the Secondary Level.* First ed. New York: Teachers College Press, 1983.

Mooney, Carol Garhart. *Theories of Childhood: An Introduction to Dewey, Montessori, Erikson, Piaget, & Vygotsky.* St. Paul, Minnesota: Redleaf Press, 2000.

Piaget, Jean. *The Origins of Intelligence in Children.* Madison, Connecticut: International Universities Press, 1974.

United States National Commission on Excellence in Education. *A Nation at Risk: The Imperative for Educational Reform: a Report to the Nation and the Secretary of Education, United States Department of Education.* Ann Arbor, Michigan: University of Michigan Library, 1983.

Vileneuve, Pat. *From Periphery to Center: Art Museum Education in the 21st Century.* Reston, Virginia: NAEA, 2007.

Vygotsky, Lev. *The Psychology of Art* (Scripta Technica, Inc., Trans.) Cambridge, Massachusetts: MIT Press, 1971.

_____. *Thought and Language - Revised Edition.* Edited by Alex Kozulin. Cambridge, Massachusetts: The MIT Press, 1986.

Wygant, Foster. *School Art in American Culture 1820–1970.* Cincinnati, Ohio: Interwood Press, 1993.

Yenawine, Philip, *Jump-Starting Visual Literacy.* Originally published: *Journal of the NAEA,* January 2003. Reprinted with permission from the National Art Education Association.

Index

JUL - - 2013

Books from Allworth Press

Allworth Press is an imprint of Skyhorse Publishing, Inc. Selected titles are listed below.

Starting Your Career as an Artist
by Angie Wojak and Stacy Miller (6 x 9, 288 pages, paperback, $19.95)

Line Color Form: The Language of Art and Design
by Jesse Day (7 x 8 ½, 144 pages, paperback, $19.95)

The Profitable Artist: A Handbook for All Artists in the Performing, Literary, and Visual Arts
by Artspire (6 x 9, 256 pages, paperback, $24.95)

Making It in the Art World
by Brainard Carey (6 x 9, 256 pages, paperback, $24.95)

New Markets for Artists: How to Sell, Fund Projects, and Exhibit Using Social Media, DIY Pop-Ups, eBay, Kickstarter, and Much More
by Brainard Carey (6 x 9, 256 pages, paperback, $24.95)

The Business of Being an Artist, Fourth Edition
by Daniel Grant (6 x 9, 408 pages, paperback, $27.50)

Art Without Compromise
by Wendy Richmond (6 x 9, 232 pages, paperback, $24.95)

New Markets for Artists: How to Sell, Fund Projects, and Exhibit Using Social Media, DIY Pop-Ups, eBay, Kickstarter, and Much More
by Brainard Carey (6 x 9, 256 pages, paperback)

Selling Art Without Galleries: Toward Making a Living From Your Art
by Daniel Grant (6 x 9, 288 pages, paperback, $24.95)

The Artist's Guide to Public Art: How to Find and Win Commissions
by Lynn Basa (6 x 9, 256 pages, paperback, $24.95)

Legal Guide for the Visual Artist, Fifth Edition
by Tad Crawford (8 ½ x 11, 280 pages, paperback, $29.95)

Business and Legal Forms for Fine Artists, Third Edition
by Tad Crawford (8 ½ x 11, 176 pages, paperback, $24.95)

The Artist–Gallery Partnership, Third Edition
by Tad Crawford and Susan Mellon (6 x 9, 224 pages, paperback, $19.95)

Fine Art Publicity: The Complete Guide for Galleries and Artists, Second Edition
by Susan Abbott (6 x 9, 192 pages, paperback, $19.95)

Guide to Getting Arts Grants
by Ellen Liberatori (6 x 9, 272 pages, paperback, $19.95)

How to Start and Run a Commercial Art Gallery
by Edward Winkleman (6 x 9, 256 pages, paperback, $24.95)

The Artists Complete Health and Safety Guide, Third Edition
by Monona Rossal (6 x 9, 416 pages, paperback, $24.95)

The Quotable Artist
by Peggy Hadden (7 ½ x 7 ½, 224 pages, paperback, $16.95)

To see our complete catalog or to order online, please visit *www.allworth.com*.